Mike Hagen

# The Nikon Autofocus System

Mastering Focus for Sharp Images Every Time

*The Nikon Autofocus System*
*Mastering Focus for Sharp Images Every Time*

Mike Hagen
www.visadventures.com

Project editor: Joan Dixon
Copyeditor: Jeanne Hansen
Project manager: Matthias Rossmanith
Marketing: Jessica Tiernan
Layout and type: Hespenheide Design
Cover design: Charlene Charles-Will

ISBN: 978-1-937538-78-1
1st Edition (1st printing, November 2015)
©2015 by Mike Hagen
All images ©Mike Hagen unless otherwise noted
Images on pages 104, 108, 110, and 130 ©Dollar Photo Club

Rocky Nook Inc.
802 E. Cota Street, 3rd Floor
Santa Barbara, CA 93103
USA
www.rockynook.com

Distributed in the U.S. by Ingram Publisher Services
Distributed in the UK and Europe by Publishers Group UK

Library of Congress Control Number: 2015944888

This book is printed on acid-free paper.
Printed in Korea

Thank you to my wife Stephanie
for loving me and supporting me
as I continue to follow my dreams.
Stephanie is an incredible woman and
I've been blessed beyond measure with
22 years of marriage to her.

Thank you to my son Matthew who
I dearly love. I enjoy his humor and I
love watching him grow into a wonder-
ful young man.

Thank you to my daughter Allison who
is a blessing to our family. I love her
feisty spirit and her innate curiosity
about the world around her.

Thank you to the amazing team at
Rocky Nook who is supportive, helpful,
and always on the ball. I love writing
books with their company and am
grateful for their partnership.

Most important, I give all glory to Jesus
Christ, my Lord and Savior. He has
immeasurably blessed my life and I am
thankful that He has filled my life with
adventure, love, and purpose.

—Mike Hagen, October 2015

## About the Author

Mike Hagen is an avid adventurer who combines his passion for the outdoors with excellence in photography. He is a skilled digital photography instructor, location photographer, class leader, and editorial writer.

Mike started his photography business in 1998 as a way to share his passion for photography with the rest of the world. He is well known for his intensity, energy, and enthusiasm. If you participate in a workshop with him, you will be pleasantly surprised by his generosity and passion for imparting his knowledge to all participants.

Based in Washington State, USA, Mike has traveled extensively throughout the world. Travel, photography, and adventure are his passions, so you'll frequently find him somewhere far away from civilization, camera in hand, having a ball in the outdoors.

Mike has worn many hats in his lifetime. He graduated from college with a degree in mechanical engineering and worked in the field of semiconductor manufacturing for 10 years. He is currently a small-business owner, freelance writer, and professional photographer. His passions are traveling,

creating, writing, photography, and teaching. He is happily married and the father of two beautiful children.

Mike aspires to live life to the fullest and to help others do the same. His enthusiasm and zest for life are infectious. His devotion to God and family guides everything he does.

Mike can be reached at:

Visual Adventures
PO Box 1966
Gig Harbor, WA 98335
mike@visadventures.com
www.visadventures.com

# Table of Contents

**1 AUTOFOCUS DEFINED** 5

How AF Works **5**

Servos **6**

Multi-CAM Sensor System **9**

Description of Nikon AF Modules **12**

AF Tracking **14**

Three Elements Required for AF **27**

Lens Aperture and Effective
Aperture **29**

AF Drive Systems **34**

**2 CAMERA AND
   MENU SETTINGS** 37

External Switches and Buttons **37**

CSM a1–a12 **42**

Menus f1–f12 **58**

Diopter **69**

AF Shooting Styles and
Back-Button AF **69**

How Shutter Speed Impacts
Sharpness **75**

How ISO Noise and Long Exposure
Noise Impact Sharpness **77**

P, S, A, M vs. Auto Exposure Modes
and Impact on AF **78**

How Frame Rate Impacts
AF Performance **79**

DX versus FX and Sensor
Coverage over the Frame **80**

**3 LENSES AND
   SETTINGS** 83

Lens Barrel Switches **83**

Lens AF Technologies **88**

Using Manual Focus Lenses
on New Bodies **89**

VR System and Sharpness **90**

IF Lenses **93**

Parfocal Lenses **94**

Focus Speed **95**

Cable Releases and Remote
Triggers **96**

**4 FIELD TECHNIQUES,
   METHODS, AND TIPS** 99

Outdoor Sports: Football **100**

Outdoor Sports: Track and Field **102**

Outdoor Sports: Tennis **104**

Indoor Sports: Basketball **106**

Indoor Events: Dance and Bands **108**

Indoor Sports: Volleyball **110**

Birds in Flight **112**

Landscapes **114**

Portraits: Individuals, Groups,
and Weddings **116**

Street **118**

Macro **120**

Aerial Photography **122**

Animals and Wildlife (Safari) **124**

Architecture **126**

Night **128**

Underwater **130**

Adventure Sports: Point of View **132**

Theater, Plays, and Circuses **134**

Panoramas **136**

HDR Images **138**

Tripod Techniques **140**

Event Photography with Flash **142**

Astrophotography **144**

Travel **146**

**5 LIVE VIEW
   AUTOFOCUS** 149

Activating Live View **150**

The Differences between
Focus Systems **150**

Best Practices **151**

AF-Servo Modes and AF-Area
Modes in Live View **152**

Video AF versus Still Photo AF **158**

Using Zoom Buttons to Achieve
Critical Focus **158**

**6 ACHIEVING GREAT
   FOCUS IN VIDEO** 161

Difficulties with AF While
Shooting DSLR Video **161**

Pulling Focus **162**

Follow Focus Rigs **163**

Presetting Focus Distance **165**

Using a Crew to Assist with
Focus **166**

**7 OTHER CONSIDERATIONS** 169

Understanding Focus,
Clarity, and Sharpness **169**

Focus in Low-Light Environments **172**

Depth of Field and Sharpness **175**

Depth of Field and Hyperfocal
Distance **179**

Focus Stacking **180**

User-Defined Menus for Different
Scenarios **182**

Techniques to Improve Sharpness
While Handholding **183**

Lens Quality and Impact
on Sharpness **185**

How to Check Your DSLR
for AF Accuracy **185**

How to Fine-Tune AF **187**

Using Third-Party Lenses on
Nikon Cameras **190**

Glossary **191**

Index **194**

# Foreword

It is with great pleasure that we present this book, another publication in the Nikonians Press series. These volumes are easy-to-read reference books aimed to reinforce what the Nikonians Academy teaches throughout North America and the world.

The Nikonians Academy—powered by Nikonians.org, the worldwide home for Nikon photographers of all skill levels—was created to extend to a small group setting an even more intense and intimate sharing, learning, and inspiring experience than is found in the Nikonians community forums. Since its inception, the Nikonians Academy has given such experiences to over 15,000 attendees.

In early 2005, author Mike Hagen was appointed Director of the Nikonians Academy. He has led many successful workshops, and has also acquired other great instructors who share and live the same values for academic excellence, and who are at ease with both the craft and the art of photography.

Whether taking a class with Mike or with another instructor, Nikonians Academy attendees continually rave about their experiences. Mike is well known for his intensity, energy, and enthusiasm. If you have the opportunity to participate in a workshop with him, you will be pleasantly surprised by his patience and generosity, and by his infectious enthusiasm for imparting his knowledge to all participants. These virtues, along with his thorough knowledge of the subject matter, are obvious in the pages of this volume.

Mike combines his passion for the outdoors with excellence in photography. He is a skilled photography

instructor, location photographer, workshop leader, and editorial writer. He started Visual Adventures in 1998 (originally named Out There Images) as a way to share his passion for photography with others.

For many years, we have taken the Nikon Autofocus System for granted, but Nikon engineers continually surprise us by adding ever more capabilities. As the System becomes further enhanced with added modes and features, we begin to wonder what each of them does and when they should be used. In this book, Mike Hagen teaches how the system works and how to best to use it for specific shooting conditions and subjects; all made easy by Mike's clear, concise, and friendly writing style.

Nikonians, through the NikoniansPress, is proud of our joint publishing venture with Rocky Nook as we continue to present new volumes to the world of Nikon users who are hungry for yet more knowledge of Nikon photographic systems.

We hope you will enjoy this book!

Bo Stahlbrandt and J. Ramón Palacios
Founders and Administrators
www.nikonians.org

# Introduction

Nikon has always prided itself on its autofocus system. While it is very good and very accurate, it requires quite a bit of knowledge to use it effectively. This book is dedicated to helping Nikon DSLR shooters become experts with their autofocus systems.

The term *autofocus* implies *automatic*, as in, "the camera does the work for you." As you probably know, trying to get excellent result with autofocus can be difficult and can lead to frustration. Whether you use an entry-level Nikon D3300, a midrange Nikon D750, or a top-of-the-line Nikon D4S, this book provides solid strategies that will help you avoid those frustrations and will help you excel where you might otherwise have failed.

Make mistakes while you photograph your dog so you can correct them before you head off to Tanzania to photograph lions

The best way to master the autofocus system is through practice and iteration. The learning process should go like this:

1. Shoot with an objective
2. Take hundreds of pictures
3. Review them on your computer
4. Identify your mistakes
5. Repeat daily

My motto as a photographer is ABS: Always Be Shooting. The only way to improve is to continually pursue knowledge and skills. For example, before leaving on a big international photo trip, many of my professional photographer colleagues dedicate a day to photographing seagulls at the seashore, or photographing their pets in their back yards. They do this to hone their skills in a low-risk situation so when they get to their real destination in Africa or the Galápagos Islands, they don't mess up. I want you to do the same thing.

Throughout this book I'll show examples of good and poor autofocus technique. I'll show my winning shots, like this lion, and a few I could have done better, like this dog. Experience is the best teacher, and I want you to regularly practice the techniques found in the pages of this book.

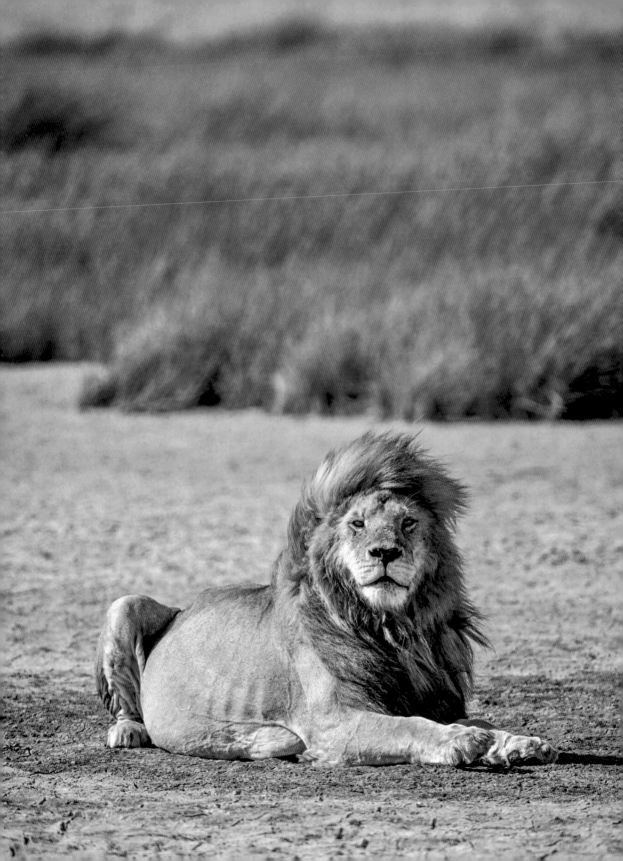

# Autofocus Defined

One of the most frequent comments I hear from new photographers is that their images look too soft. They mistakenly place blame on the camera's autofocus (AF) system or on a lens. They sometimes claim they received a defective model from the factory. The truth is that in almost every case the problem is the photographer, not the equipment.

Like most things in life, creating great photographs requires a fair amount of knowledge and a lot of practice. This chapter will help you understand how AF works. When you know what AF is capable of, you will also know its limitations. Let's dive in.

## How AF Works

Modern Nikon digital single-lens reflex (DSLR) cameras use AF modules made with charge coupled device (CCD) imaging sensors. These AF sensors are located inside the camera body toward the bottom, underneath the mirror. Light passes through the main reflex mirror and hits another mirror that directs the light down to the AF module (figure 1-1).

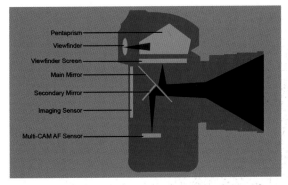

Figure 1-1: The AF CCD sensor module on Nikon DSLR cameras is mounted inside the body near the base of the camera. After light passes through the lens, it is split into two paths via the main mirror. One path travels to the viewfinder, and the other path travels down to the Multi-CAM AF sensor system.

Three significant factors—light level, subject contrast, and distinct lines—influence AF sensor performance, including the ability to acquire and track focus (figure 1-2).

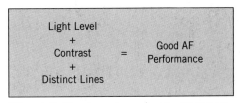

Figure 1-2: The elements required for AF sensors to work properly

Many other elements need to be considered to create a sharp photograph, such as the following:

- Subject movement
- Camera shake and vibration
- Shutter speed
- Lens quality
- Sensor quality and resolution
- AF sensor calibration
- High ISO noise
- Long exposure noise

In addition to the Multi-CAM sensor system, the AF system on your Nikon DSLR uses a combination of servo modes and focus area patterns. A servo mode determines how the lens motor is driven, and most cameras have two to four servo modes. Continuous servo, for example, moves the AF elements of the lens so it can track a moving object. Focus area patterns determine how many focus points are being used at one time. You can configure the camera to use one point or multiple points.

You have to figure out the best combination of servo mode, focus pattern, light level, subject contrast, and shutter speed to capture a sharp image.

---

**The Focus Patterns**

- Auto-area
- 51-point 3D
- Dynamic 51-point (d-51)
- Dynamic 39-point (d-39)
- Dynamic 21-point (d-21)
- Dynamic 9-point (d-9)
- Single-point
- Group-area AF

---

Mastering the AF system on a modern DSLR is complicated, but after you learn how to set the camera to meet your needs, you'll quickly rise above the smartphone crowd with amazing shots that are impossible to capture with basic camera systems. The key is learning to master all the settings and combining the right settings for a specific subject. In chapter 4 I will discuss more than 20 scenarios and include the AF settings I recommend for common photographic scenarios.

## Servos

The word *servo* means motor. In technical circles, it is often called a *servomotor* or a *servomechanism*. Servos are used in all kinds of industrial applications such as to control robots, steer radio-controlled cars, rotate tables, pump hydraulic fluid, and apply brakes. In reference to AF, the term *servo* relates to the motor

---

**The Servo Modes**

- AF-S
- AF-C
- AF-A
- AF-F

that drives the AF optical elements in a lens.

There are three servo modes for still photography plus one for video on current Nikon DSLR cameras:

- Single-servo AF (AF-S)
- Continuous-servo AF (AF-C)
- Automatic-servo AF (AF-A)
- Full-time-servo AF (AF-F) is used on some cameras in video mode

Figure 1-4: AF-S is the perfect focus mode for portraits because the subject is stationary

### AF-S (Single-Servo AF)

AF-S is available on all Nikon DSLRs (figure 1-3). After the camera focuses on an object, it locks the focus. It will remain locked as long as you press the shutter-release button halfway or as long as you press the rear AF-ON button. The instant you remove your finger, focus is unlocked and you can refocus on another subject.

AF-S is typically used for stationary subjects, such as for portraits (figure 1-4), macro images, landscapes,

architecture, and studio or flash photography. Newer Nikon cameras allow you to use single-point AF, group-area AF, or auto-area AF. While in AF-S mode, you cannot use the dynamic AF modes—d-9, d-21, d-39, or d-51—because they require continuous servo operation (i.e., AF-C mode).

### AF-C (Continuous-Servo AF)

AF-C is provided on all Nikon DSLR cameras (figure 1-5). In this servo mode, the camera continues to focus as long

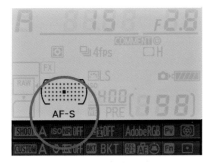

Figure 1-3: AF-S stands for single-servo AF and is shown here on the camera info screen

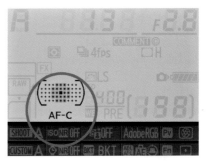

Figure 1-5: AF-C mode as shown on the camera info screen

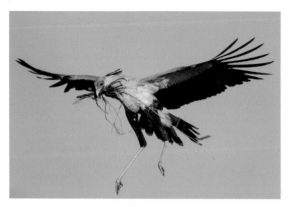

Figure 1-6: AF-C is perfectly suited for taking pictures of birds in flight

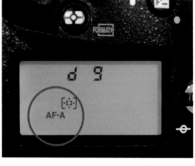

Figure 1-7: AF-A mode on the D600 LCD screen

as you press either the shutter-release button or the AF-ON button. AF-C continuously looks for movement as the subject advances toward or recedes from the camera. As long as you can keep a focus point on the subject, the camera can track the movement.

AF-C is used when the subject is in motion, such as for sports, birds in flight (figure 1-6), auto racing, and active toddlers.

In AF-C mode, current Nikon cameras allow you to use single-point, d-9, d-21, d-39, d-51, 3D, group-area, and auto-area sensor patterns.

### AF-A (Automatic-Servo AF)

AF-A (figure 1-7) is available on mid-range and entry-level cameras, such as the D5300, D3300, D600, and D90. It is not available on higher-end cameras, such as the D7200, D750, D810, or D4S.

In AF-A mode, the camera tries to figure out which servo mode to use on its own. If the camera detects

movement in the scene, it will automatically select AF-C. If it thinks the scene is stationary, it will automatically select AF-S.

The problem with using AF-A is that it's impossible for the camera to know what your photographic intentions are. Let's say you are photographing a foot-race like the 100-meter dash. Before the race starts, all the runners are in their positions on the starting blocks. The camera senses that all the runners are stationary, so it automatically chooses AF-S. When the runners jump off the line and sprint down the track, the camera will be stuck in AF-S mode when it should be in AF-C mode. You'll get one sharp photograph of the beginning of the race, and the rest of the photos will be out of focus because the AF system didn't track the runners in motion.

If the camera starts out in AF-S mode and you need it to use AF-C mode, you have to lift your finger off the shutter-release button after the athletes start

moving, then quickly press the shutter-release button again to resume AF. This will cause you to miss some shots while the camera adjusts to the change.

### AF-F (Full-Time-Servo AF)

AF-F is available only when you shoot video in Live View mode on a Nikon camera, like the D5300, D750, or D810. Cameras without video capability, like the D300, D60, and Df, don't have AF-F servo mode.

AF-F works almost the same as AF-C in that it causes the camera to continuously focus on the subject as it moves throughout the scene. The difference is you don't need to keep your finger on the shutter-release button or the AF-ON button for focusing to continue. Because you are shooting video, the camera automatically keeps the focus motor activated. I will cover AF-F in more detail in chapter 5.

## Multi-CAM Sensor System

As mentioned earlier, the Nikon AF system uses CCD sensors to focus. The CCD sensors interface with the entire AF system to determine focus. Nikon calls this sensor the Multi-CAM. The Multi-CAM uses multiple AF sensors in the AF module.

The Multi-CAM AF system uses phase detection. Basically, the camera divides the incoming light into image pairs then compares them in its software. The pairs are projected on CCD imaging elements that are very similar to CCDs used for capturing photographs. The difference is that these CCD elements register only gray tones and are used solely to determine phase alignment.

Traditionally, Nikon named each camera's Multi-CAM system according to how many imaging elements were in the CCD. For example, the Multi-CAM 530 used 530 CCD elements. This has been changed, and now Nikon uses different conventions to name the Multi-CAM AF modules, such as Multi-CAM 3500 and Multi-CAM 4800.

The camera uses the CCD elements in conjunction with AF sensor positions to determine if the subject is in focus. Modern Nikon cameras have 11, 39, or 51 sensor positions. Older Nikon cameras have 1, 3, 5, or 11 sensor positions. The sensor positions represent the physical locations in the viewfinder where the camera will acquire and track focus.

The AF computer measures the distance to the subject by using a beam splitter and a small mirror that redirects part of the incoming light toward the AF sensor. The sensor is located at the bottom of camera and is separate from the camera's light metering system. In effect, this beam splitter creates a simple rangefinder, similar to split-screen systems on older film cameras.

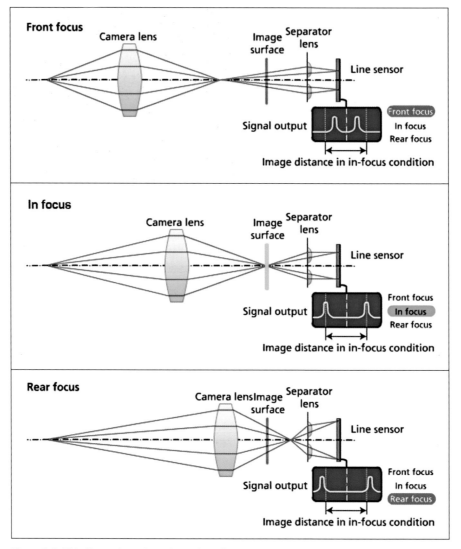

Figure 1-8: This figure shows how phase detection works. In the top image, the images are out of phase in front of the focus plane. In the middle image, the images are in phase on the focal plane. In the bottom image, the images are out of phase behind the focus plane.

After the beam is split, the two images are analyzed and compared to find similar light intensity patterns. After the camera detects the differences in phase, it generates instructions to tell the lens to focus forward or backward (figure 1-8). The camera computer performs these calculations thousands

of times per second until it achieves correct focus.

The AF process works like this:

1. The Multi-CAM computer (processor) makes a small change in the focusing distance by rotating the focus servo
2. The computer then reads the AF sensor to determine if the focus has improved
3. Using that information, the computer sets the lens to a new focusing distance
4. This process is repeated until the computer achieves the highest contrast (phase alignment) in the scene

When the camera is set to AF-S, this process stops as soon as the camera achieves the highest contrast or phase alignment. When the camera is set to AF-C, the process continues only as long as you half-press the shutter-release button or fully press the AF-ON button. If the camera is unable to achieve focus (phase alignment), it will continue to hunt for focus, continuously moving the focus servo in a back-and-forth motion.

Beginning with the venerable Nikon D1, the Multi-CAM AF sensor module (figure 1-9) has been around for many years and has been used in both film cameras (F5, F6, N70) and digital cameras. The AF modules have various names ranging from Multi-CAM 530 to Multi-CAM 4800FX. In general, the

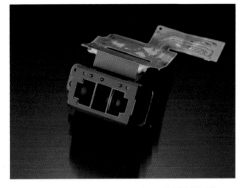

Figure 1-9: The Nikon Multi-CAM 3500FX AF module

higher the number, the more advanced the AF system. Cameras like the D4S have a very fast, high-performance AF system, and cameras like the D3300 use a slower but still very accurate AF system.

In the new Nikon FX DSLRs, such as the D750, D810, and D4S, the AF module is called the Multi-CAM 3500FX. For the higher-end DX DSLRs, such as the D7100 and D7200, it is called the Multi-CAM 3500DX.

The 51-point AF system found in higher-end Nikon cameras was introduced in 2007 with the Nikon D3 and D300. It has evolved from the Multi-CAM 3500 to the current Multi-CAM 3500FXII, which is the current top-of-the-line AF system, in the new D750 and D810 cameras. Even though the Multi-CAM 4800 has a higher model number, it has only 39 AF points and is used in lower-end full-frame cameras like the D610 and Df. I'm not sure why Nikon changed their numbering convention

to use a higher numbered name for a lower performance camera, but I guess that's their prerogative.

The main difference between the 51-point and 39-point systems is AF speed. The computer processors on 51-point cameras allow for faster focus acquisition, faster tracking, better overall performance, and more customization. This matters for sports and action photographers, but if your primary subjects are landscapes, travel, or portraits, the differences may not be as important. The operation of the systems is almost the same; both produce sharp photographs, and they have similar menu options.

On entry-level cameras, such as the D40/D60 and D3000-series bodies (D3000, D3100, D3200, D3300), Nikon has upgraded from a 3-point AF system on the D40 to an 11-point system on the D3300. Again, the AF systems on these bodies are accurate, but they aren't as fast as the 39-point or 51-point systems.

## Description of Nikon AF Modules

Nikon has done an incredible job with the development of their Multi-CAM AF modules since the era of their very early digital cameras, such as the D1, D100, and D70. We now enjoy incredibly capable and somewhat complex AF modules to help us achieve sharp focus in just about any situation. The current state of the art in Nikon cameras is the Multi-CAM 3500FXII, which is found on cameras like the Nikon D750.

Most AF modules use a mix of cross-type sensors and single-direction sensors. Let's talk about each in more detail.

### Cross-Type Sensors

Cross-type sensors can detect contrast in vertical, horizontal, and diagonal lines (figure 1-10). These sensors are the most useful because they focus on just about any type of subject. The upside is that they work really well, but the downside is that only a few are included in the Multi-CAM focus module.

Nikon cameras have anywhere from 1 cross-type sensor (on cameras like the D3300, D60, and D90) to 15 cross-type sensors (on cameras like the D3, D4, and D810) (figure 1-11).

### Single-Direction Sensors

Single-direction sensors detect contrast in either vertical or horizontal lines, but not both. In Nikon's literature, they are sometimes called linear sensors or horizontal sensors.

In the newer Nikon cameras—like the D3000 series, D5000 series, D7000 series, D300 series, D700, D750, D600 series, D800 series, and all

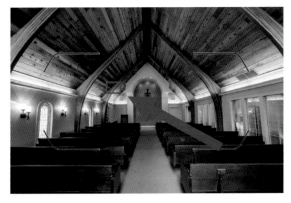

Figure 1-10: A cross-type sensor allows you to focus on most lines of contrast, regardless of their direction

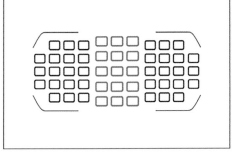

Figure 1-11: The red sensors are cross-type sensors, and the black sensors are single-direction sensors

professional-style bodies—these sensors are oriented with the long axis of the viewfinder. In other words, if you are holding your camera in the horizontal orientation, the sensors will focus only on horizontal lines of contrast (figure 1-12).

This behavior is important to understand, especially for sports and action photography. Make sure the AF

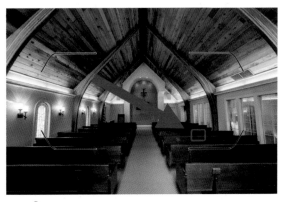

Figure 1-12: A single-direction sensor will focus only on horizontal lines of contrast, like the backs of these church pews. Or, if the camera is oriented vertically (portrait), it will focus only on vertical lines of contrast.

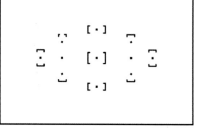

Figure 1-13: An 11-point sensor system from the Nikon D3300

sensor is positioned over something on the subject's jersey that has a contrasty horizontal line—perhaps the base of the player's number, the name on the back, or a horizontal stripe. If you try to focus on vertical lines with the horizontal sensor, you'll be out of luck and the camera will continue unsuccessfully to hunt for focus.

### 3-Point, 5-Point, 11-Point Sensors

Cameras such as the D70 and D3000 series came with an 11-point AF array in the Multi-CAM 1000 (figure 1-13 and table 1-1). Other cameras such as the D40 were shipped with a 3-point AF array (figure 1-14).

## AF Tracking

Any time you want to photograph a moving object, you'll need to use AF-C mode. It allows the camera to track the subject as it moves throughout the viewfinder of the camera. In a perfect

| AF Module | No. Sensors | No. Cross-Pattern Sensors | Cameras |
|---|---|---|---|
| Multi-CAM 530 | 3 | 1 | D40, D40X, D60 |
| Multi-CAM 900 | 5 | 1 | D50, D70, D70s, D100 |
| Multi-CAM 1000 | 11 | 1 | D3000, D3100, D3200, D3300, D5000, D5100, D80, D90, D200 |
| Multi-CAM 1300 | 5 | 1 | D1 series |
| Multi-CAM 2000 | 11 | 9 | D2 series |
| Multi-CAM 3500DX | 51 | 15 | D300, D300S, D7100 |
| Multi-CAM 3500FX | 51 | 15 | D700, D3 series |
| Multi-CAM 3500FX | 51 | 15 | D800, D810, D4, D4S |
| Multi-CAM 3500FXII | 51 | 15 | D750 |
| Multi-CAM 3500DXII | 51 | 15 | D7200 |
| Multi-CAM 4800DX | 39 | 9 | D7000, D5200, D5300, D5500 |
| Multi-CAM 4800FX | 39 | 9 | D600, D610, Df |

Table 1-1: Multi-CAM AF module name, the number of sensors in the module, the number of cross-pattern sensors, and which camera bodies use the module

Figure 1-14: A 3-point sensor system from the Nikon D40 and D60

world, you would be able to keep the camera's AF sensor positioned on the subject at all times, but since we are human, most of us struggle with this. To help solve this problem, Nikon provides dynamic tracking modes that incorporate multiple sensors that work together.

The dynamic AF system starts tracking the subject with the priority sensor. Then, if necessary, it hands off the tracking responsibility to other sensors in the group or pattern. For example, if you are using a single AF sensor and don't keep it over the subject, the camera loses track of the subject and it goes out of focus. If you use a dynamic pattern, such as d-9, d-21, d-39, d-51, 3D, or Auto-area, the camera hands off the subject from the priority sensor to other sensors in the group as the subject moves.

The most important thing to learn about the Nikon AF system is how the priority sensor influences the overall AF performance. In the dynamic-area AF modes (d-9, d-21, d-39, d-39, d-51, 3D

tracking) the AF system always keys off the priority sensor. Your job is to keep the priority sensor on the subject. If you fail, the dynamic tracking system hands off AF to other sensors in the group that you chose (e.g., 21-point group).

This additional help from the group lasts anywhere from a half second to two seconds. During that time, your goal is to try to reposition the priority sensor back onto the subject. If you don't, and the priority sensor remains off the subject for a period of time (anywhere from an instant to about 1.5 seconds), the camera assumes you want it to refocus wherever the priority sensor is located, then it will refocus on the new subject.

In auto-area AF or group-area AF, the camera doesn't use a priority sensor. In auto-area AF, the camera decides which sensors it will use to acquire and track the subject. In group-area AF, the camera uses closest subject priority within the group of five sensors. I'll cover each of these sensor patterns later in this chapter.

### Scene Recognition System

Let's say you are photographing a bird in flight. You'll probably set your AF servo to AF-C and start taking photos by pressing either the shutter-release button halfway or the AF-ON button to track the bird as it flies. It is very difficult to keep the priority AF sensor perfectly aligned on a bird's eye while

it's in flight, so for situations like this Nikon developed its scene recognition system (SRS) to help you retain focus. It is a dynamic sensor technology that works like this:

- The camera recognizes the subject and scene in the viewfinder by identifying colors and shapes
- The camera determines what you are focusing on based on the priority sensor (i.e., the bird)
- Now that the camera recognizes the scene and the subject, it can better track the subject's movement throughout the frame

If the bird abruptly moves away from a focus point, the SRS will hand off focus responsibility to an adjacent sensor. By using the camera's customization tools from either the AF menus or the AF mode button, you can determine how many sensors are available for assuming focus responsibility.

Let's say you are using the d-9 dynamic-area AF mode. In this case, the camera has up to nine sensors to choose from. If the bird moves away from all nine AF sensors, the camera will lose focus. But as long as you keep the bird within the group of nine sensors, the camera will maintain focus.

The SRS calculates the exposure, determines the auto white balance values, and influences AF. For example, if a soccer player wearing a green jersey traverses the frame from left to right, the SRS adds this information to the focus sensor data to help it more accurately track focus.

The SRS employs Nikon's famous red, green, blue (RGB) light meter called the 3D Color Matrix Metering system. The light meter compares what it sees to an internal database of 30,000 photographs to calculate metering and AF settings for each scene. The meter (and therefore the AF system) is biased toward human subjects and will follow the subject within the frame. Beginning with the Nikon D90, the SRS incorporated face recognition.

### AF-Area Modes

Depending on the model, your Nikon DSLR has from three to seven AF-area modes (table 1-2). These AF-area modes are groups of AF sensors that work together to help you achieve focus on a subject.

In its most basic configuration, the AF system can have only one active sensor while shooting. At its most complex configuration, all 51 sensors can be active while shooting. The process of setting up your camera for different AF-area modes depends on the camera model and therefore requires the use of different buttons and menu items. Each camera generation uses a different process; the following sections summarize

| Camera | Single point | Dynamic area | d-9 | d-21 | d-39 | d-51 | 3D tracking | Group area | Auto area |
|---|---|---|---|---|---|---|---|---|---|
| D40, D40X, D60, D80 | X | X | | | | | | | X |
| D90 | X | X | | | | | X | | X |
| D300, D300S, D700, D3, D3S, D3X | X | | X | X | | X | X | | X |
| D7000, D600, D610, Df, D5200, D5300, D5500 | X | | X | X | X | | X | | X |
| D7100, D7200, D800, D4 | X | | X | X | | X | X | | X |
| D810, D750, D4S | X | | X | X | | X | X | X | X |
| D3000, D3100, D3200, D3300, D5000, D5100 | X | X | | | | | X | | X |

Table 1-2: The AF-area modes for most modern Nikon DSLR cameras

the instructions for the indicated models.

**D7000, D7100, D7200, D600, D610, D750, D800, D810, D810A, Df, D4, D4S**
Press the focus mode selector button while rotating the sub-selector (figure 1-15). Look for the readout on either the top LCD panel or the rear monitor.

**D3000, D3100, D3200, D3300, D5000, D5100, D5200, D5300, D5500**
Press the i (info) button (figure 1-16), then highlight the current AF-area mode on the screen with the multi-selector. Press the OK button.

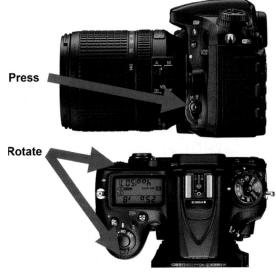

Figure 1-15: Selecting the AF-area mode on newer Nikon cameras involves pressing the focus mode selector button, rotating the sub-selector, and viewing the results on the LCD panel

Figure 1-17: The AF-area mode switch is located on the back of the camera body, as shown here on a Nikon D300S

Figure 1-16: On a Nikon D5300, press the i button, then navigate to the AF-area mode with the multi-selector

### D300, D300S, D700, D2H, D2Hs, D2X, D3, D3X, D3S

There is a physical switch on the backs of these cameras that you use to select an AF-area mode (figure 1-17). Rotate the switch to the area mode setting of your choice. If you choose dynamic-area AF, you'll need to access the custom setting menu and choose the pattern or AF area (figure 1-18).

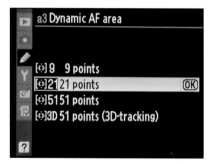

Figure 1-18: The custom setting menu on a Nikon D700, where you choose the dynamic AF area

### D40, D40X, D50, D60, D70, D70s, D80, D90

From the camera's menu system, choose AF-area mode (figure 1-19), then choose single point, dynamic area, auto area, or 3D tracking.

Note that not all AF-area modes are available for each servo mode. For example, you can't choose dynamic-area AF or 3D tracking when you use

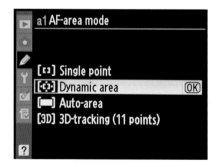

Figure 1-19: The AF-area mode menu on a D90

Figure 1-20: The viewfinder in single-point AF mode

Figure 1-21: Dynamic-21 sensor pattern. The middle sensor is the priority sensor, and the outer 20 sensors help the priority sensor when the subject leaves the priority sensor location.

AF-S (single servo) mode because the camera won't continuously track the subject.

### Single Point AF

In single-point AF (figure 1-20), there is only one active sensor; all the other AF sensors are inactive. You can place that single sensor in any of the available positions.

Single-point AF mode is best when the subject isn't moving and you want to critically focus on something very specific, such as the stamen of a flower or the subject's eye in a portrait. Single-point AF is one of the best options for macro, landscape, portrait, and architectural photography.

In general, it makes sense to use AF-S (single servo) with single-point AF. It is very difficult to use single-point AF for moving subjects, so it is rarely used with AF-C (continuous servo) mode.

### Dynamic-Area AF

Dynamic-area AF helps you maintain focus on moving subjects. In general,

it can be difficult for photographers to keep AF points positioned over the subject as it moves around the scene. Dynamic-area AF hands off focus responsibility to other sensors in the group as the subject moves within that group. Dynamic-area AF works only in AF-C (continuous servo) mode.

Depending on your camera model, there are one to three dynamic-area AF modes to choose from. Cameras with 3, 5, or 11 focus points allow you to choose only dynamic focus. Cameras with 39 or 51 focus points allow you to choose from dynamic-9, dynamic-21, dynamic-39, or dynamic-51. These options are displayed on the camera LCD or monitor as d-9, d-21, d-39, or d-51. The pattern group in the viewfinder is shown in figure 1-21.

After you select a dynamic focus mode, you will see only one sensor in the viewfinder; you can't see the other sensors in the group. This confuses

Figure 1-22: When you move the priority sensor to a different position in the viewfinder, the group of sensors travels along with it. If you position the priority sensor near an edge, you won't have all sensors available for use because there are no more sensors outside the sensor field. In this figure, the priority sensor is black.

some people because they expect to see the same number of sensors as in the dynamic group they chose. You have to trust that they are there and they are working in the background to help you maintain focus. High-end cameras, like the D4S and D810, allow you make the sensor group visible in the viewfinder by using custom settings (chapter 2).

As with single-area AF, you can move the priority sensor, and therefore the entire group of sensors, to any available focus point (figure 1-22). If you have a 51-point AF system, the priority sensor can be located at any one of those 51 points. The sensors that form the dynamic group (e.g., 21 sensors in the d-21 setting) will surround the priority sensor.

The sensor you see in the viewfinder is the priority sensor, and this is what starts the AF process. There's one priority sensor, and it is always located at the middle of the dynamic-area AF sensor pattern. This priority sensor starts the focus tracking, but it doesn't necessarily remain the focus point throughout your shooting sequence.

To understand how dynamic-area AF works, imagine you are photographing a bird in flight. As you start focusing by pressing the AF-ON button or pressing the shutter-release button halfway, the camera first acquires focus from the priority sensor. Then, as the bird moves throughout the frame, or as you shake the camera a bit, the bird leaves the priority sensor. This is where the dynamic setting begins to work. The camera tracks the bird as it moves throughout the sensor pattern by handing off responsibility to other sensors as necessary.

If you are using the single-point area mode and the bird leaves the sensor, the camera will change the focus to the clouds in the background. The dynamic-area sensor pattern serves as a kind of safety net by allowing the subject to move around within the frame.

There are a couple of detailed points I want to make about the priority sensor as it pertains to dynamic-area AF. If the bird leaves the priority sensor

for a significant length of time, but it stays within the group, the camera will eventually refocus on whatever the priority sensor is positioned over. Let's say the bird is on the right side of the 21-point AF pattern, and the priority sensor is positioned over a tree in the background. Given enough time, usually three to five seconds, the camera will assume that you no longer want to focus on the bird and want to focus on the tree instead.

This demonstrates how important it is for you to pay attention to the placement of the priority sensor. Even though you have the safety net of sensors in dynamic-area AF mode, you still need to realize that the camera wants you to lead the dynamic sensor pattern with the priority sensor. If you accidentally move the priority sensor off the flying bird for a moment, the camera will help you for those few seconds until you can reposition the priority sensor back on the bird. If you leave the priority sensor off the bird for a longer period of time, the camera assumes you want to focus on the subject at the location of the priority sensor.

The other point pertains to what happens when the bird leaves the dynamic group entirely. Fundamentally, the same thing happens as explained in the previous two paragraphs. The difference is that the camera uses the settings you entered into the custom setting menu titled Focus tracking with lock-on. If you have this menu item set to Off, the camera will refocus almost instantly as soon as the bird leaves the focus pattern. If you have the menu item set to Long, the camera will wait to refocus for approximately 1.5 seconds. I will talk more about this menu item in chapter 2.

Because you are using the priority sensor to acquire the initial focus, the focus is as precise as if you were using AF-C. In other words, if you are using continuous servo, the initial focus acquisition is the same whether you use single-point AF or dynamic-area AF. Therefore, it is OK to use a dynamic setting (d-9, d-21, d-39, d-51) for landscape, macro, portrait, and architectural shots.

Some Nikon cameras, like the D3000 series, D90, and D60, have an option only for dynamic-area AF. Other models, like the D4S, D300S, and D610, allow you choose the size of the dynamic area.

### d-9

I recommend using 9-point dynamic-area AF when the movement of the subject is fairly predictable. Baseball is a great place to use d-9 because the players' movements are often consistent. You know that after the batter hits the ball, he's going to run to first base along an obvious path. Because the runner generally doesn't dart from side to side,

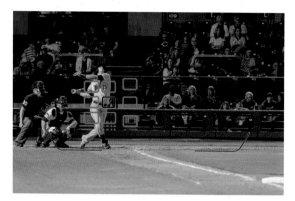

Figure 1-23: Baseball is a perfect application for dynamic-area 9-point AF

Figure 1-24: The dynamic-area 21-point pattern is perfect for all kinds of action photography. Here, I used it to photograph this red-footed booby hunting for fish in the Galapagos Islands. The priority sensor is in the middle of the 21-point pattern.

you can keep the tight 9-point pattern over his body (figure 1-23).

### d-21

I recommend 21-point dynamic-area AF (figure 1-24) for most moving subjects (even baseball players, if I'm being honest). This is my favorite dynamic-AF area mode. I've been using it as my main AF sensor pattern since the Nikon D3 and D300 cameras were released in 2008. The 21-point coverage seems to be large enough for most sports images, wildlife photography, and action shots. At the same time, it doesn't suffer as much from the problems that the 51-point and 3D area modes have (see the next sections).

I use d-21 for football, tennis, soccer, track and field, cross country, birds in flight, wildlife in Africa, airplanes, and just about everything else that moves.

Most photographers would be fine if they set their cameras to d-21 and left them there.

### d-39 and d-51

If you choose d-39 or d-51, all the sensors in the AF array will be active during your photo sequence. If the subject moves away from the priority sensor,

any of the other sensors will continue to track the subject. The d-39 and d-51 settings are like a big AF safety net. This sounds great, but it can be problematic.

One of the problems with having multiple active sensors in the AF area is that the camera is always trying to assess what it should or should not focus on. Sometimes it picks up on something in the focusing pattern that is similar to the subject you are trying to track, and it switches the focus to that (figure 1-25).

The problem with having a lot of active sensors occurs when you're photographing a scene with a busy background or lots of similar subjects, like in team sports. Suppose you're photographing a football game, and there are 22 players on the field. You want to photograph only your son, not the other players. You start out by focusing on your son, and then another kid with the same color jersey enters the 51-point AF area. The camera cannot understand which kid you want to photograph, and it sometimes switches the focus to the other kid.

It gets really complicated when there are five or six kids in the frame and the dynamic AF sensor system starts jumping among all of them. Ultimately, you'll wish you had used a smaller sensor pattern, such as d-21 or d-9.

Ideally, the camera will effectively incorporate the SRS and the 3D Color

Figure 1-25: It is difficult to use d-51 for soccer because the AF system gets confused by all the players

Matrix Metering system to help track the subject you want to photograph. The 39-point and 51-point modes work well in scenes with simple backgrounds. For example, if you are photographing an airplane against the clear blue sky, the camera will do a very good job of focus tracking with d-39 or d-51 because there isn't anything else in the sky to compete with the plane.

Anytime the scene or background is complicated, the 39-point and 51-point pattern groups start to become ineffective. Things like bright shiny objects and reflections in mirrors or windows wreak havoc on how these groups operate. As always, your mileage may vary, so be sure to test the AF on your own camera before trusting my recommendations.

**Group-Area AF**
Group-area AF is the newest pattern group in the Nikon system (figure 1-26). At the time of this writing, the only

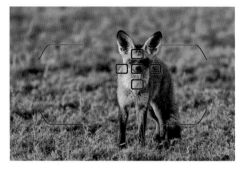

Figure 1-26: Group-area AF works well for situations when you'll photograph a single moving subject, like this bat-eared fox in Tanzania

cameras with group-area AF are the D750, D810, D810A, and D4S.

Group-area AF uses a group of five sensors that work as a dense cluster of AF points. The camera uses closest-subject priority within these five sensors to figure out which sensor it will use to acquire focus.

To understand how this pattern works, imagine you are taking a picture of someone's face. You position the five-sensor group over the person's face and notice that the top sensor is over the forehead, the right and left sensors are over the eyes, the middle sensor is over the bridge of the nose, and the bottom sensor is over the tip of the nose. In this case, the closest object within the group of five sensors is the tip of the nose (figure 1-27). Therefore, the camera will use the bottom sensor and focus on the tip of the nose.

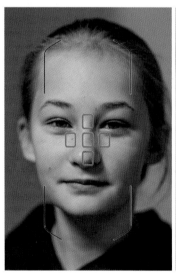

Figure 1-27: Here, I used group-area AF on a Nikon D750 to focus on the subject's face. You can see how the tip of the nose is in focus, but the eyes are out of focus. This is because the camera focuses with the sensor that detects the closest object.

If you shoot portraits, you know that you should always focus on the eyes. Therefore, group-area AF should not be used for portraits or for any subject where you need precise AF. Rather, group-area AF should be used for fast action sports like motorcycle racing or basketball.

The main difference between group-area AF and something like 21-point dynamic-area AF is that group-area AF has *five* priority sensors, and d-21 has *one* priority sensor. In group-area AF, you need only one of the five AF points to acquire focus, but d-21 (or d-9 or d-51) requires the priority sensor to acquire focus before the dynamic system begins to work.

This distinction makes group-area AF better for fast action sports when you don't have much time to aim and compose your pictures. If any of the five sensors acquire focus, your task is to keep the five sensors located on the subject as it moves.

### 3D, 39-Point 3D, and 51-Point 3D

The 3D, 39-point 3D, and 51-point 3D AF area modes are also *dynamic*-area AF modes. Cameras that have 3-, 5-, or 11-point AF systems, like the D3300 and D5300, have only 3D tracking. These cameras don't have a sensor number associated with 3D tracking; for example, a Nikon D750 has 51-point 3D tracking.

The 3D tracking system works similarly to d-9, d-21, d-39, and d-51

modes in that AF begins with the priority sensor. In 3D mode, you can position the priority sensor anywhere in the field of available sensors, such as on your son who is playing soccer.

When the camera begins focusing in AF-C mode, the system takes over to track the subject within the entire array of AF points (e.g., all 51 points). After the subject begins moving, the priority sensor begins to move along with the subject. If you pay close attention while shooting, you'll see the black AF sensor move throughout the scene and track directly with the subject.

In 3D tracking mode, the camera's EXPEED processor is incorporated into the AF system and uses data from the RGB matrix metering light meter. With this additional data, the camera is supposed to be better at selecting and tracking the subject, even when the subject leaves the initial point where focus began.

In other words, with the matrix light meter, the camera determines the shape, color, and location of the subject. Then it incorporates that knowledge into the AF sensors to better track the moving subject. Conceptually, it should be able to track a black swan flying through a flock of white geese while the camera remains stationary.

This system works best when you focus on a subject that contrasts well against the background (figure 1-28), such as a bird against a cloudless blue

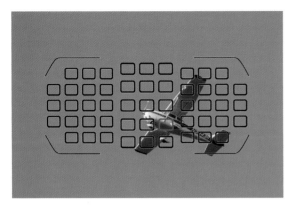

Figure 1-28: In this photo, 3D tracking works fine because the airplane contrasts nicely with the sky

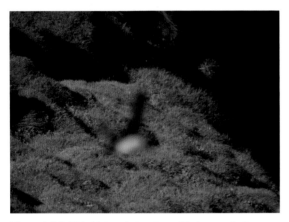

Figure 1-29: This blurry photo of a puffin is a perfect example of the camera having difficulty tracking a subject against a busy background. That white blob in the middle is supposed to be my prize-winning photograph of a puffin in flight.

sky or a dog running in a field of grass. The 3D system doesn't work very well when the subject doesn't contrast with the background or when the background is cluttered (figure 1-29).

One of the problems I have with 3D AF is that you lose the ability to bias the AF like you can with the priority sensor in d-21 or in group-area AF. After the camera assumes control of the AF sensor, you lose control. No matter where you point the camera, it takes over the focus, and you can't bias it back to the subject.

In 3D-area mode, if the camera sends the AF sensor to the left side of the frame, but the subject is on the right side of the frame, it can be almost impossible to get the focus back onto the subject. The only recourse is to lift your finger from the shutter-release button or the AF-ON button and restart the focus. When you lift your finger from the button, the AF sensor returns to your starting position, and you can start over again.

**Auto-Area AF**

With auto-area AF, the camera makes all the decisions about what to initially focus on and what to track. This mode works in AF-S and AF-C servo modes.

Your job is to compose the picture, and the camera's job is to figure out what to focus on. In fact, you don't have any control over where the camera chooses to focus. The camera doesn't use a priority sensor because all sensors are active (figure 1-30).

To make a focus decision, the camera utilizes the matrix meter, the SRS,

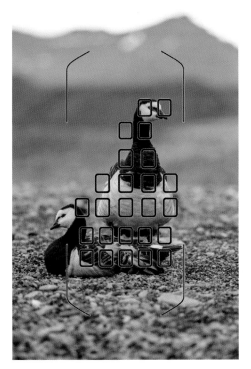

Figure 1-30: Auto-area AF is designed to automatically choose the appropriate focus points for the scene. Sometimes it does a good job, like in this photo of Icelandic geese.

as a point-and-shoot. I suggest using auto-area AF when you are on vacation or when you hand your camera to a friend to take your photograph so you don't have to think about focus points and subject tracking. Let the camera try to do the job for you, and you can go back to enjoying your mojito.

In AF-S mode, the camera will show you the sensors it is using to acquire focus (figure 1-30). Sometimes the camera will choose something to focus on that you don't want to be in focus. Your only recourse is to lift your finger from the shutter-release button or AF-ON button and try again. Hopefully the camera will get it right the second or third time. If it doesn't focus on the correct subject, use any other mode that lets you choose the focus point.

Overall, I don't recommend auto-area AF mode because you give up too much control.

and the EXPEED processor to determine the most likely subject for the image. If a person is in the scene, the camera will generally prioritize the person's face. If there is a brightly colored flower, the camera will generally pick that. But the truth is that you are never really sure what the camera will focus on, so beware and be careful.

Auto-area AF mode is best suited to scenarios in which you use the camera

## Three Elements Required for AF

As I mentioned earlier in this chapter, three elements are required for the AF system to work properly: light, contrast, and distinct lines. If any one of these elements is not present on the subject, the AF system will struggle to acquire focus. Let's go through each of these three aspects in more detail.

### Light

The AF sensors require the subject to be illuminated with a minimum amount of light for the system to focus properly. Depending on the camera, the AF system will operate from -2 exposure values (EV) to +19 EV. In the real world, this translates to a brightness range from a very dim lightbulb to a bright sunny day on a white sandy beach. Another way to think about this brightness range is roughly the range of brightness in which you can read a book.

If the scene is too dark, the AF system won't acquire focus and will hunt until it gives up. Higher-performance cameras, such as the Nikon D810 and D4S, perform better in low light situations than entry-level cameras, such as the D3300. The D4S works in a brightness range from -2 EV to +19 EV, and the D3300 works from -1 EV to +19 EV. That's not a lot of difference, but 1 stop of light is fairly significant when it comes to shooting outdoors at twilight or indoors at your daughter's Christmas play.

The lens aperture also plays a big role in how much light gets to the AF sensors. You will find that lenses with an aperture of f/1.4 or f/2.8 focus much faster than lenses with a maximum aperture of f/5.6 or f/6.3. I'll talk more about lens apertures later in this chapter.

### Contrast

The next thing the AF sensors require for accurate focus is contrast on the surface of the subject. Stated another way, if the subject has no contrast, the camera will not be capable of acquiring initial focus or tracking focus as the subject moves.

Let's say you are photographing a wall in your house to show your Facebook friends your new paint color. If the wall has no texture or contrast, your camera will not be able to focus. The AF system will hunt until it ultimately gives up. To solve the problem, place the AF sensor on the intersection between the ceiling and the wall because that line probably has enough contrast for the AF sensor to work.

In another example, when you photograph the ocean from the shore, it is common for the sky to be hazy. Atmospheric haze can reduce the contrast in the scene enough to make it impossible for the camera to acquire focus. I know a lot of photographers who've gone out to photograph the beautiful sunset only to be frustrated when their cameras would not focus on the horizon line. The solution is to either focus on the crashing waves (which might limit the depth of field) or to switch your camera to manual focus and focus the old-fashioned way by manually rotating the focus ring on your lens.

### Distinct Lines

The third requirement for the AF sensors is distinct lines. The AF sensors operate by detecting vertical or horizontal lines. As you learned earlier in this chapter, there are two types of AF sensors: cross type and single direction.

On the 51-point AF systems, the middle 15 sensors are cross-type sensors that will focus on vertical, horizontal, or diagonal lines. The outer sensors—the 18 on the left and the 18 on the right—will focus only on lines that are aligned with the long axis of the camera frame. For example, if the camera is positioned horizontally, the outer sensors will focus only on horizontal lines. If the camera is positioned vertically, the outer sensors will focus only on vertical lines.

With older Nikon cameras, such as the D40, D70, and D3000, only the middle sensor is a cross-type sensor.

## Lens Aperture and Effective Aperture

Earlier I talked about how the AF modules, like the Multi-CAM 3500, work from -2 EV to +19 EV. That's a big brightness range, but this is only half the story. Nikon AF works only if enough light passes through the lens. Even if it is bright enough outside, the lens might reduce the light enough to render the AF system inoperable.

A number of variables impact how much light passes through the lens, including aperture, filters, teleconverters, and extension tubes. Let's look at this more closely so you can better understand why your Tamron 150–600mm f/4.5–f/6.3 might not focus in low light.

### How Aperture Impacts AF Performance

Assuming you are using a lens without a filter or a teleconverter, the aperture the camera sees is equal to the maximum aperture of the lens. Let's say you have a Nikon 70–300mm zoom lens (figure 1-31). This lens has a variable aperture that ranges from f/4.5 to f/5.6 depending on the focal length. At 70mm the lens operates at f/4.5, and at 300mm the lens operates at f/5.6.

Most lenses that are available today have maximum apertures ranging from

Figure 1-31: Nikon 70–300mm f/4–f/5.6 lens

f/1.4 to f/6.3. Prime lenses, such as the Nikon 24mm, 50mm, or 85mm lenses, typically come in apertures of either f/1.4 or f/1.8. Professional zoom lenses, such as the 14–24mm, 24–70mm, and 70–200mm, are constant-aperture lenses at f/2.8. The longer telephoto lenses, such as the 200mm, 300mm, 400mm, 500mm, 600mm, and 800mm lenses, have maximum apertures of f/2, f/2.8, f/4, and f/5.6. Most kit lenses from Nikon and third-party manufacturers are variable-aperture zooms from f/3.5–f/5.6.

### Center AF Points Work at f/8, Outer AF Points Work at f/5.6

The AF systems of all Nikon DSLR cameras effectively operate with lenses that have apertures of f/5.6 or greater. Most modern lenses stay at their maximum aperture when they aren't taking a picture. Let's say you set your 70–300mm lens to f/16. When you are looking through the viewfinder,

the camera keeps the aperture open to the maximum aperture of the lens. Then, when you take a photograph, the camera stops the lens aperture down to f/16. Immediately after the exposure is finished, the camera opens the lens back up to the maximum aperture. Because the autofocus system operates only when the mirror is down, the camera "sees" f/5.6. When the mirror flips up and the camera takes the picture, the autofocus system is temporarily inactive.

Each Nikon AF module has different sensor positions that work at different aperture brightness levels. For example, cameras like the D810 and D4Ss have 11 sensors positions that will operate at f/8, 15 sensors that will operate between f/5.6 and f/8, and 51 sensors that will operate at f/5.6 (figure 1-32).

As you can see, all Nikon lenses work with the Nikon AF system because the maximum aperture of all Nikon lenses is f/5.6 or greater. There are a

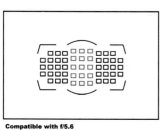 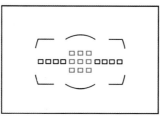 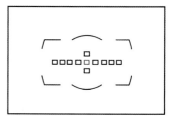

Compatible with f/5.6
☐ Perform as cross sensors
☐ Perform as line sensors

Compatible with aperture slower than f/5.6 and faster than f/8

Compatible with f/8

Figure 1-32: This diagram shows which sensors work with what apertures on a Nikon D4S

few third-party lenses from Tamron, Sigma, and Tokina that have maximum apertures of f/6.3 when they are zoomed to their longest focal lengths. In these cases, f/6.3 is right on the edge of AF capability for the outer sensors on Nikon cameras. If it is really bright outside, you will probably be able to focus with these lenses. However, toward dusk and into twilight, you won't be able to use AF with these lenses at f/6.3 in conjunction with the outer sensors in your Nikon camera body.

On a Nikon camera with the Multi-CAM 3500 system, you can use 15 sensors to focus with an f/6.3 lens. These sensors work with lenses that have effective apertures between f/5.6 and f/6.3. My suggestion is to keep the AF points toward the middle to take advantage of sensors that will operate down to f/8.

Other cameras, like the D5500, will operate only with lenses that have a maximum aperture of f/5.6. The Df supports f/8 lenses on seven focus points and f/7.1 lenses on the center 33 focus points.

### Teleconverters, Polarizers, Neutral Density Filters, and Extension Tubes

Anything you do to your lens that reduces the amount of light coming into your camera will degrade the AF performance. This includes using a teleconverter, a polarizer, a neutral

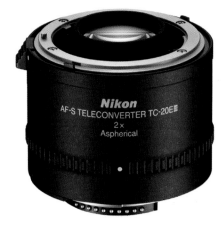

Figure 1-33: The Nikon AF-S Teleconverter TC-20E III doubles the focal length of compatible lenses while reducing by half the amount of light entering the camera. This means that a lens with a maximum aperture of f/4 will allow the equivalent amount of light as an f/8 lens.

density (ND) filter, or an extension tube. The more light entering the camera, the more information the AF system has to work with, and the faster the AF system will work regardless of the camera. This holds true for the D3300 and the D4S.

Let's start by discussing teleconverters. Nikon has three teleconverters in its product line: a 1.4×, a 1.7×, and a 2.0× (figure 1-33). By their very nature, teleconverters reduce the amount of light entering the camera. For example, a 1.4× teleconverter will reduce the light by 1 stop, so an f/2.8 lens will transmit the equivalent amount of light as an f/4 lens. A 1.7× teleconverter reduces the amount of light by 1.5 stops, and a 2.0× teleconverter reduces the amount of light by 2 stops.

Practically speaking, this means that if you are using a lens with a maximum aperture of f/5.6, adding a 1.4× teleconverter automatically brings you to the minimum brightness for the AF system to operate at f/8. Say, for example, you are using a Nikon 70–200mm f/4 lens and want to also use a 2.0× teleconverter. This puts you at f/8 and will limit the number AF sensors the camera can use.

The same holds true for polarizers and ND filters (figures 1-34 and 1-35). A polarizing filter typically reduces the amount of light entering the camera by 1 to 2 stops. Therefore, if you use a lens with a maximum aperture of f/5.6, rotating the polarizer to the maximum effect will cause the amount of light coming into the camera to drop by 2 stops, which is equivalent to f/11. This means your camera will not be able to use AF.

ND filters (figure 1-35) are used to reduce the amount of light coming into the camera so you can create long

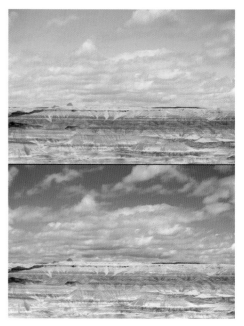

Figure 1-34: The top photo was taken without a polarizing filter, and the bottom photo was taken with a polarizing filter. A polarizing filter helps darken the sky and adds definition to the clouds. It also reduces the amount of light entering the camera through the lens.

exposures in bright light. This effect is commonly seen in waterfall photos taken with 5 to 10 second exposures so the water looks silky smooth.

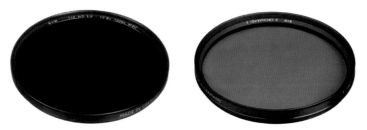

Figure 1-35: A B+W ND filter (*left*) and a B+W polarizing filter (*right*)

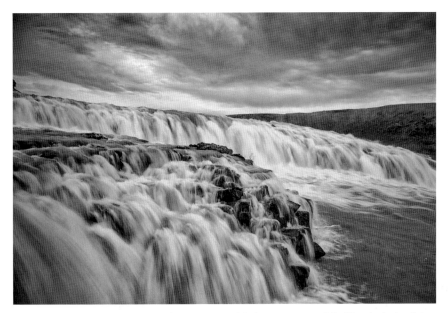

Figure 1-36: I used a 10-stop ND filter to create this long exposure of Gullfoss in Iceland. I focused the lens before I mounted the ND filter.

Obviously, if you use an ND filter, your camera will not be able to use AF. The best approach to focusing is to first use AF on the scene, then mount the ND filter, then meter and take the photograph (figure 1-36).

Extension tubes do not contain optical elements, and they are used to decrease the minimum focus distance of a lens (figure 1-37). You mount them between the lens and the camera. They simply move the camera farther away from the focusing plane (imaging sensor).

Extension tubes also reduce the amount of light that comes into the camera. They come in various

Figure 1-37: An extension tube mounts between the camera and the lens. A 36mm extension tube reduces the amount of light entering the camera by approximately 2 stops.

| Camera | Compatible with Standard Focus Lens? (Body Motor) | Compatible with AF-S Lens? (Lens Motor) |
|---|---|---|
| D40, D40X, D60 | N | Y |
| D3000 series, D5000 series | N | Y |
| D70, D80, D90 | Y | Y |
| D7000 series, D600, D610 | Y | Y |
| D750, D800, D810, Df, D300, D300S | Y | Y |
| D2 series, D3 series, D4 series | Y | Y |

Table 1-3: Nikon DSLR models and supported AF systems

thicknesses, such as 12mm, 25mm, and 36mm, and can be stacked. Extension tubes typically reduce the amount of light from 1 to 5 stops, depending on how many you use in series.

## AF Drive Systems

Nikon AF cameras employ two types of AF motors. One lives in the camera body and drives a gear that connects the body to the lens. The other is called a silent wave motor (SWM) and resides in the lens itself.

### SWM versus Body Motor

SWMs are typically much faster at focusing than the older style body-driven focus motor. Most new Nikon lenses are SWM lenses, but Nikon has quite a few standard AF lenses in their lineup that require the body motor.

Not all Nikon cameras can focus with the older gear-driven AF lenses. Generally speaking, the more expensive the camera body, the higher the probability that it has a built-in body motor. For example, the Nikon D3300 and D5500 cameras do not have a built-in body motor and therefore can accept only AF-S lenses. On the other hand, cameras such as the D7200, D750, D810, and D4S have built-in body motors and can operate older AF lenses and the newer AF-S lenses (table 1-3).

SWM lenses use a technology called ultrasonic motors. Most third-party lens manufacturers have both SWM lenses and standard-focus lenses that are compatible with the Nikon system:

- Sigma: Hyper Sonic Motor (HSM)
- Tamron: Ultra Silent Drive (USD)
- Tokina: Silent DC Motor

### Impact on Focus Speed

Generally speaking, the older the lens and the lower the cost, the slower it focuses. Traditional gear-drive lenses are much slower to focus than the newer style AF-S lenses. For example, the Nikon 80–400mm f/4.5–5.6D ED takes multiple seconds to rack focus from infinity to the minimum focus distance. The new AF-S 80–400mm f/4.5–5.6G VR II takes less than a second to do the same thing.

Similarly, some lower-cost kit lenses are AF-S lenses, such as the 18–55mm, 18–105mm, and 18–140mm lenses.

However, because of their low cost, they focus rather slowly, so you might be frustrated if you try to use them for sports, action, or moving wildlife. These lenses work best in bright situations and with subjects that have a lot of contrast.

The fastest focusing lenses in Nikon's lineup are the AF-S 400mm f/2.8, AF-S 300mm f/2.8, and similar telephotos. They are designed to be the ultimate in performance. Any of the current Nikon pro lenses should have no problem keeping up with action, whether professional football or your hyperactive grandson.

# Camera and Menu Settings

With the more complicated AF systems in today's modern DSLRs, the options for customizing your camera can be overwhelming. Just trying to understand what each menu does and how each camera setting and switch impacts AF is daunting. Fortunately, you don't need to be a rocket scientist to figure all this out—you have this book. Let's talk about all the settings, buttons, and menus that influence the Nikon AF system.

## External Switches and Buttons

I'll start with the switches and buttons on the outside of Nikon DSLR cameras. Over the past few years since video has become a significant part of DSLRs, Nikon has both eliminated and moved a number of external controls to make room for video settings. Let's go through the buttons and switches as they pertain to AF.

### AF Mode Selector

This switch allows you to set your camera's AF mode and turn AF on or off. The operation of the switch depends on which camera you own.

**D7200, D7100, D7000, D600, D610, D750, D800, D810, D4, D4S, Df**

The AF mode selector on newer Nikon DSLRs (figure 2-1) performs two functions. The first is to help you choose between AF and manual focus. These options are indicated by the AF and M labels on the body.

You access the second function from the button inside the switch. This button allows you to select an AF area mode by pressing it while simultaneously

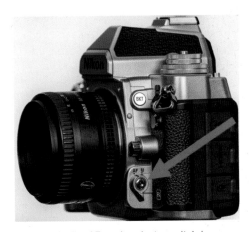

Figure 2-1: The AF mode selector switch is located on the front of the camera, as shown here on a Nikon Df. Notice the two positions (AF and M) and the button inside.

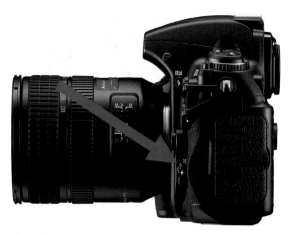

Figure 2-2: The AF mode selector switch is located on the front of the camera, as shown here on a Nikon D700. Notice that there are three positions: C, S, and M.

Figure 2-3: On the Nikon D700, change the position of this switch to choose dynamic-area, single-point, or auto-area AF mode. In this figure, the switch is set to single-point mode.

rotating the command dial and subcommand dial. The command dial controls the focus servo modes—AF-C, AF-S, and AF-A (note that AF-A is not available on the D800, D810, Df, D4, or D4S). The subcommand dial controls the area mode and allows you to choose from settings like dynamic-area, automatic-area, and single-point AF.

### D2X, D2Xs, D300, D300S, D700, D3, D3S

With these cameras, the switch (figure 2-2) has three positions: C, S, and M. The C setting stands for continuous-servo AF, S stands for single-servo AF, and M stands for manual focus. These servo modes are covered in detail in chapter 1.

To change the AF-area mode, rotate the AF-area mode selector on the back of the camera (figure 2-3). The D300

series, D700, and D3 series cameras have three positions, including single point, dynamic area, and auto area. The D200 and D2 series cameras have those same settings and an additional setting called group-dynamic AF. Sensor group area modes are covered in detail in chapter 1.

### D5500, D5300, D5200, D5100, D5000, D3300, D3200, D3100, D3000, D60, D50, D40

Press the i button to access the information display menu shown in figure 2-4. Use the multi-selector to navigate to the focus mode options. Press OK. Choose the AF-A, AF-S, AF-C, or manual focus (MF) focus mode.

To change the AF-area mode, press the i button to access the information display menu. Use the multi-selector to

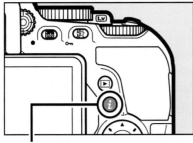

*i* button

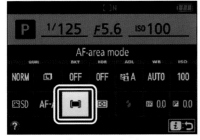

Information display

Figure 2-4: To access the focus mode options on the D5500 camera, press the i button, then navigate to the AF-area mode icon on the bottom menu bar

Figure 2-5: Press the AF button with your index finger, then rotate the main command dial with your thumb to change the AF servo mode to AF-A, AF-S, or AF-C

navigate to the AF-area mode options. Press OK. Choose either single-point AF, dynamic-area AF (e.g., 9, 11, 21, or 39—the number of available points depends on which camera you have), 3D tracking, or auto-area AF.

### D90, D80, D70

The AF selector switch on these cameras has two positions: AF and M. To change the servo mode on the D90 and D80 (figure 2-5), press the AF button on the top of the camera while rotating the main command dial, and choose AF-A,

AF-S, or AF-C. On the D70, press the menu button and navigate to Custom Settings Menu (CSM) 02 to choose AF-C or AF-S.

To change the area mode on the D90 and D80, press the menu button and navigate to CSM a1 (on the D90) or CSM 02 (on the D80) to choose single-point, dynamic-area, auto-area, or 3D tracking.

### Multi-Selector and Focus Selector Lock

Pressing the multi-selector allows you to move the position of the priority AF point throughout the AF field when the camera is in shooting mode (figure 2-6). If the menu is turned on, the multi-selector will allow you to select menu items.

If you choose single-point AF, you'll move only one focus point when you press the multi-selector. If you choose dynamic-area or group-area AF, you

Figure 2-6: Use the multi-selector to move the AF point to different positions in the viewfinder. On the D4S, the focus selector lock is located below the multi-selector. On other Nikon cameras, the switch is sometimes located around the circumference of the multi-selector.

move the group of sensors. Remember that when you select auto-area AF, you cannot change the position of the priority sensor because the camera chooses the AF point for you.

All Nikon DSLR cameras have a lock/dot switch on the back of the camera called the focus selector lock. This switch either locks the AF sensor position or allows you to move it with the multi-selector. Sometimes you want to lock the AF point and prevent it from accidentally being moved. For example, you may be shooting a landscape photo and want the AF sensor to stay on a specific flower. After you set the AF point, rotate the switch to the L (lock) position to lock out future adjustments of the AF position.

Of course, you will oftentimes want to move the AF point. Typical situations are sports and wildlife photography where you need to move the sensor to the right when the subject is running in one direction, then to the left when the subject is running in the opposite direction.

In general, I suggest leaving the switch set to the unlocked position (dot) so you have complete control and flexibility. One caveat is if you are a left-eyed shooter; that is, if you look through the viewfinder with your left eye when you take pictures. A left-eyed shooter's nose typically presses against the multi-selector (figure 2-7) and can easily move the focus point by accident, especially if the nose is prominent.

Don't laugh! This is a real problem that has caused lots of photographers to miss shots because they have accidentally moved the focus point position. If this describes you, rotate the switch to the L (lock) position.

### Sub-Selector (Nikon D4 and D4S)

The sub-selectors (figure 2-8) on a Nikon D4 or D4S can be programmed to perform a number of functions. One function is to move the AF points around the viewfinder, just like the multi-selector does.

To program the sub-selector to move the focus points, access CSM f5. More information on this menu item is provided on page 66.

Figure 2-7: Left-eyed shooters often have a problem with their noses pressing the multi-selector and thereby accidentally moving the focus point. You can solve this problem by locking the focus selector.

Figure 2-8: The sub-selectors on the Nikon D4S are programmable

### AF-ON Button

The AF-ON button (figure 2-9) is provided only on higher-end professional and semiprofessional Nikon cameras, such as the Df, D810, and D4S. The primary purpose of this button is to activate focus when you press it. At the most basic level, you can focus by pressing the shutter-release button halfway or by pressing the AF-ON button. The difference is that the shutter-release button can be used to focus and take a photograph, and the AF-ON button can be used only to focus.

All DSLR cameras in the Nikon lineup that do not have an AF-ON button can be configured so the AE-L/AF-L button will function as the AF-ON button. There's quite a bit to know about using the AF-ON button effectively, so be sure to read the section titled "AF Shooting Styles and Back-Button AF" on page 69.

Figure 2-9: AF-ON button on a Nikon D810

## CSM a1–a12

There are a lot of cameras in the Nikon lineup, and the company has done a pretty good job of keeping menu item names consistent across models. That said, there are also quite a few differences. For example, the D4S has 12 menu items under the AF settings, and the D3300 has four menu items.

In this section, menu names are shown as subheadings, and menu numbers are in parentheses for different cameras. Your camera may or may not have all these menu items. Some older cameras, like the D70 and D80, have a completely different numbering system, so if you have one of those cameras, pay attention to the name of the menu item rather than the menu number.

### AF-C Priority Selection
### (a1 on Most Cameras)

In AF-C mode, this menu item (figure 2-10) controls if pictures can be taken as soon as the shutter-release button is fully pressed (release priority) or only when the image is in focus (focus priority). The only time this menu function is active is when you are using AF-C mode. It doesn't apply in AF-S, AF-A, or manual focus modes.

Remember that the main reason to use AF-C is when you are photographing moving subjects like sports or wildlife. This menu item lets you tell the camera whether or not to take a photograph if

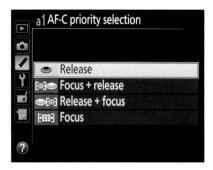

Figure 2-10: AF-C priority selection menu on the D4S. I generally set mine for release priority.

it does not detect that the subject is in focus.

At first blush, you might be tempted to prevent the camera from taking photographs if they are not in focus. It makes sense, right? The whole point of this book is how to take photos that are in focus. However, there are lots of times in sports and action photography when it is OK to have a photo that isn't perfectly sharp.

Also, there are many times when the focus sensor is positioned over an area on the subject that does not have adequate contrast for the camera to focus. In these cases, the camera assumes the subject is out of focus. By looking through the viewfinder, you might be able to see that the subject is in focus, but the camera assumes it is out of focus because it doesn't detect contrast. If this menu item is set for focus priority, the camera won't allow you to take the shot.

Focus priority in AF-C mode gets really frustrating when you are

photographing your daughter's soccer game and she's kicking the winning goal. You see that she's in focus, and you want the camera to take the photograph, but it just won't do it because it can't acquire focus, and you miss the shot. The solution is to set the menu to release priority, and it will take the picture the instant you press the shutter-release button, whether or not it is in focus. Setting your camera for release priority is living dangerously, so be extra diligent to make sure you use the focus system well.

On the other hand, you might be the type of photographer who doesn't want even one photograph on your memory card unless it is tack sharp. In that case, choose focus priority and be prepared for the camera to hesitate from time to time while it is trying to acquire focus.

Depending on your camera, you have two, three, or four options on the AF-C priority menu.

### Release

The camera will take the photograph as soon as the shutter-release button is fully depressed. I recommend this setting for most sports and action photographers. Use this setting any time you use the back-button focus method (page 69).

### Focus + Release

In this situation, the camera won't take the first photograph unless it detects that the subject is in focus. Then it reverts to release priority and will shoot the remaining frames at the maximum frame rate as long as the shutter-release button is fully pressed down (until the buffer or memory card is full).

### Release + Focus

The camera begins taking photographs immediately when you press the shutter-release button, whether or not the subject is initially in focus. Then it prioritizes in-focus shots by slowing down the frame rate to ensure a higher percentage of in-focus images. For example, if your camera shoots at a maximum frame rate of 6 frames per second (fps), using release + focus might drop the frame rate to 3 fps or 4 fps until it can completely track the moving subject.

### Focus

This is the most restrictive of the settings because the camera won't take any photographs it deems out of focus. Fundamentally, this means you might not get any images of the subject if the camera is unable to achieve focus. I recommend this setting for photographers who are sticklers about AF perfection, but know that you'll need to be patient and diligent with your AF technique. Make sure that the focus point is always over something on the subject that has contrast.

## AF-S Priority Selection (a2 on Most Cameras)

AF-S priority determines when the camera will take a photo in AF-S servo mode, depending on whether or not the subject is in focus. As you already know, you typically use AF-S servo when you photograph still subjects such as portraits, landscapes, macro images, and architecture. In these situations, it makes the most sense for the camera to ensure the subject is in complete focus before the shutter is released. Therefore, my suggestion is to use focus priority rather than release priority (figure 2-11). There are only two choices in this menu: release and focus.

### Release

Release will allow the camera to take the photo the moment you press the shutter-release button. This is a dangerous setting to use in AF-S mode because typically your priority is absolute clarity when you use AF-S.

### Focus

Focus priority means the camera will not take the photograph until the subject is in focus. Most photographers should set their cameras to focus priority. Keep in mind that if you use focus priority and the camera cannot achieve focus, it will hesitate or may not allow you to take the shot.

There will be lots of situations when you are photographing and the camera won't allow you to take the

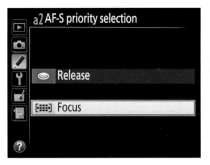

Figure 2-11: AF-S priority selection menu. I recommend focus priority for most scenarios.

picture—examples include photographing a hazy landscape or a subject that doesn't have contrast, like a wedding dress or a wall. In these situations, the camera will hesitate to take the picture.

Other situations in which it is common for the camera to not acquire AF are in astrophotography or when you shoot night scenes. The quickest way to take the photograph is to switch the AF setting to manual or switch the lens to manual focus. Then the camera will allow you to photograph the scene at any time.

The interesting thing is that oftentimes when it is too dark for the AF sensors to focus the lens, the focus indicator/rangefinder at the lower left of the viewfinder (page 174) still works and can help you during manual focus. If that does not work, you will have to focus the old-fashioned way: by sight.

### Center AF Area (a2 on D90 and D80)

The Nikon D80 and D90 cameras have an option to change the size of the center focus point from normal zone to

Figure 2-12: Center AF area menu item on a D80

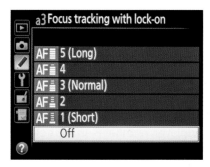

Figure 2-13: Focus tracking with lock-on menu options range from Off to Long

wide zone (figure 2-12). Use normal zone when you need to precisely focus on stationary objects like flowers, portraits, and bugs. Use wide zone when you photograph sports and wildlife. I recommend using wide zone in conjunction with dynamic-area AF for the best results.

### Focus Tracking with Lock-On (a3 or a4 on Most Higher-End Cameras)

The purpose of this menu item is to help you photograph subjects that are moving through a busy or cluttered environment. It lets you adjust the amount of time the camera waits to refocus on a new subject that passes between the subject and your camera (figure 2-13). This menu item is available only on higher-end Nikon cameras like the D600, Df, and D4S; it isn't available on entry-level Nikon cameras like the D3300 or D5500.

Let's say you are photographing a team sport, and your intention is to photograph a specific player (figure 2-14). You'll set your camera to AF-C servo so you can track movement.

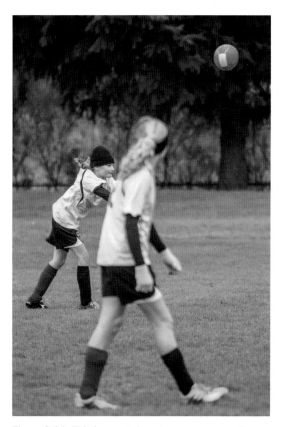

Figure 2-14: This image, taken at a soccer game, shows how one player was allowed to pass while the camera maintained focus on the player who threw the ball. The menu was set to Long delay.

Now suppose your player, number 12, is running on the field and you are doing your best to track her as she moves. At some point during the game, another player, number 5, is bound to run between the camera and player 12. This presents a dilemma for your camera's AF system. Should it immediately jump to player 5, or should it let player 5 pass while maintaining focus on player 12?

In this example, because you are specifically trying to photograph player 12, you want the camera to let player 5 pass while maintaining focus on player 12. To accomplish this, set the menu item to Long delay, which allows temporary obstructions to pass while keeping focus on the original subject.

With the Long setting, the AF system waits approximately 1.5 seconds. If player 5 stands between you and player 12 for less than 1.5 seconds, the AF system will remain on player 12. If player 5 stands between you and player 12 for more than 1.5 seconds, the AF system will refocus on player 5.

Another example of when to use this setting is when you photograph a lion on the Serengeti Plain of Tanzania. Suppose you are tracking the lion as it walks through tall grass. You are doing your best to keep the AF point on the lion's eye when it saunters behind a tuft of grass. In this situation, you don't want the AF system to jump to the tuft

of grass; you want it to stay focused on the lion. Again, set the menu to Long delay to tell the camera to ignore the grass as it passes by the AF sensors while you track the lion.

Most higher-end Nikon cameras have up to six settings for this menu item. In my experience, most photographers either want to set this menu to Long delay or they want it Off. The typical settings are as follows:

- **5 (Long):** About a 1.5-second delay
- **4**
- **3 (Normal):** About a 1-second delay
- **2**
- **1 (Short):** About a 0.5-second delay
- **Off:** No delay; the camera refocuses instantly if another subject comes between you and the main subject

There are situations in which you'll want to set the delay to Off, which means there is no hesitation in the AF system, and the camera will refocus the instant something comes between the subject and the camera. Examples of when you may want the camera to behave this way are as follows:

- Photographing a flock of birds and you want the camera to focus on any bird
- Photographing a sporting event and you want to capture the action that is closest to the camera

- Photographing any landscape, macro, or portrait shot (because nothing will pass between the subject and the camera)

### Rangefinder (a4 on D5000 Series, Setup Menu on D3000 Series)

This menu item is available only on cameras like the Nikon D5000 series and D3000 series. It is not available on more expensive cameras like the D810, D750, or D7200. When you turn this feature on, it activates a linear graph (similar to a number line) at the bottom of the viewfinder and helps you manually focus. When it is turned on, the linear graph replaces the exposure indicator (figure 2-15).

If the linear graph displays bars to the right, the subject is beyond (behind) the current focus point. Turn the focus barrel toward infinity. If the graph displays a value to the left, the subject is between the current focus point and the camera. Turn the focus barrel toward the camera (minimum focus distance of the lens). As you get closer to achieving an accurate focus, the graph will trend toward zero.

I suggest using this graph in conjunction with the focus indicator dot in the lower left of the viewfinder (see page 174). As a side note, this rangefinder function requires a lens with a maximum aperture greater than f/5.6. If you use a teleconverter or polarizer on your

| Indicator | Description |
|---|---|
| 0 | Subject in focus. |
| 0 | Focus point is slightly in front of subject. |
| 0 | Focus point is well in front of subject. |
| 0 | Focus point is slightly behind subject. |
| 0 | Focus point is well behind subject. |
| | Camera can not determine correct focus. |

Figure 2-15: The rangefinder is visible at the lower left of the viewfinder in this Nikon D5500. This figure shows what the indicators mean.

lens, you might reduce the maximum effective aperture to below f/5.6, even though the lens itself may be faster than f/5.6.

### AF Activation (a4 or a5 on Most Higher-End Cameras)

This menu item is used to configure which buttons activate AF on your DSLR. If your camera has an AF-ON button (like the D700, D810, Df, and D4S), you can choose from two options:

- **Shutter/AF-ON:** This setting allows focus activation for both the shutter-release button and the AF-ON button
- **AF-ON only:** This setting allows focus activation only for the AF-ON button. The shutter-release button will not activate focus.

Figure 2-16: AF activation menu

Figure 2-17: Focus point illumination menu on a Nikon Df

The readout in the menu is confusing after you make a selection. It says Off when AF-ON only is activated, and it says On when Shutter/AF-ON (default) is activated (figure 2-16).

The idea is that the setting allows you to change the AF method from the traditional front-button focus to back-button focus. I think back-button focus is more efficient, and most people should use this method. For a full description of back-button AF, see page 69.

If your camera does not have an AF-ON button, you can still configure the camera for back-button focus, but you'll use a different CSM group (Controls or Setup). The name of the menu item is usually Assign AE-L/AF-L button. See page 66 for more on this menu option.

### AF Point Illumination
### (a4 or a5 on Most Cameras)

This menu item is shown as AF point illumination on some DSLR cameras and Focus point illumination on the D4/D4S and Df (figure 2-17). The newest higher-end cameras, like the D750, have one menu titled Focus Point Illumination (a4) and another titled AF Point Illumination (a5).

These menus let you choose how the camera displays the AF sensors in the viewfinder while you shoot. When you look through the viewfinder, you'll see that the priority sensor is black (or very dark gray). When you press the shutter-release button halfway or press the AF-ON button, the camera turns the focus sensor red for a second and then it returns to black.

The red is helpful because it indicates the position of the priority sensor. Many times people mistakenly have the sensor in the wrong position, so this quick red blink alerts you to that fact. You can then change the position, if necessary, by pressing the multi-selector.

On some cameras, like the D3000 series and D5000 series, you don't have these options. Most higher-end DSLRs, like the D750, D800, and D700, give you

On, Off, and Auto options. Professional cameras like the D4S offer a full menu of choices. Let's go through the options.

Menu options on most cameras (D610, D750, D810, etc.):

- **Auto:** The camera automatically illuminates the focus points when the ambient light is low and when you activate AF with the shutter-release button or AF-ON button
- **On:** The camera illuminates the focus points any time the shutter-release button or AF-ON button is pressed. I recommend this setting.
- **Off:** The camera does not ever illuminate the focus points

Menu options on the D4, D4S, D750, D800, D810, and so forth (figure 2-18; note that these options are not available on all cameras):

- **Manual focus mode:** I suggest setting this option to off. When the camera is in manual focus mode, I don't like the AF sensors to illuminate. When the sensors don't light up, it tells me that I have my camera set to manual focus. Years ago I was shooting a wedding with my Nikon D70 and had set the focus switch to manual for a few images. I forgot to turn it back to AF and resumed shooting the wedding. That camera always illuminated the AF points whenever I pressed the

Figure 2-18: The Focus point illumination menu options on the D4S

shutter-release button, even if I was using manual focus mode. I continued shooting and watching the AF points blink, thinking the camera was focusing. I didn't realize my mistake for a couple hours and missed a bunch of shots that day. Don't repeat my mistake. Turn Manual focus mode illumination off.

- **Continuous mode:** When you turn this setting on, the AF points will stay illuminated while the camera takes pictures in CL or CH mode. CL stands for continuous low frame rate and CH stands for continuous high frame rate. If you turn it off, the AF points will illuminate for a moment when you start shooting, then they will turn off for the duration of the shooting sequence in CL or CH mode.
- **Focus point brightness:** This setting provides four brightness levels for the focus points in the viewfinder: low, normal, high, and extra high. For most shooting scenarios I recommend using normal, but here are a few

situations when it makes sense to use other settings:

- **Low:** Astrophotography, night photography
- **High or extra high:** Bright days, sandy beaches, snow and glaciers

- **Dynamic-area AF display:** Use this menu item to display the entire dynamic AF pattern in the viewfinder (figure 2-19). When you turn it off, you'll see only the center focus point (priority sensor) and have to guess the size of the pattern area. With this feature turned on, you'll easily see the pattern area and will be able to judge how far the subject can move before it leaves the dynamic AF area. This is especially helpful in sports and wildlife photography when there is quick action. I suggest turning this feature on.
- **Group-area AF illumination:** This setting changes the icons that display the group area pattern in the viewfinder from dots to boxes. I like having the boxes because it's easier to understand what's going on.

### Focus Point Wrap-Around (a6 or a7 on Most Cameras)

This menu item (figure 2-20) allows you to move the AF point at a faster pace around the field of available sensors. If you have an older Nikon camera with three or five focus points, moving the AF

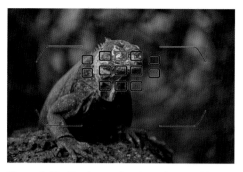

Figure 2-19: Turning on the dynamic-area AF display will show all the active dynamic AF points in the viewfinder. It allows you to see the sensor overlay in settings like d-21.

sensor around the field isn't that big of a deal. When you need to recompose, it doesn't take too long to move the sensor from the left side of the frame to the right side. However, if you have a camera with 51 AF points, like the D810 or D300, it can take 10 presses of the multi-selector to move the sensor from the left side of the frame to the right side.

If you are a sports shooter, the amount of time this takes can seem like an eternity, and you might miss the shot while you frantically press the multi-selector. For landscape and portrait photographers, speed isn't an issue, so you don't need to worry as much about these settings.

The wrap function allows you to move the sensor from one side of the AF field to the other by continuing in the same direction. If the sensor is positioned on the left side of the frame and you want to move it to the right side, turn on wrap, then you can press the

Figure 2-20: Focus point wrap-around menu on a D800

Figure 2-21: Number of focus points menu

multi-selector once to the left. The AF point will wrap around the back and appear on the right side of the frame. This also works when you move the sensor from the bottom to the top or vice versa. Using the wrap function is much more efficient than pressing the multi-selector repeatedly, and I generally recommend turning this function on for most scenarios.

The two choices for this menu item are as follows:

- **Wrap:** This setting allows you to keep moving the AF sensor when you come to the edge of the AF field. For example, if you are moving the sensor to the right and come to the right edge of the field, pressing the multi-selector once more to the right will wrap the sensor around to the left side of the field.
- **No wrap:** The movement of the AF sensor will stop at the edge of the focus point field

### Number of Focus Points (a7 or a8 on Most Cameras)

Newer Nikon cameras have a menu titled Number of focus points (figure 2-21), and older Nikon cameras have a menu titled AF point selection. The factory default for this setting is AF51 or AF39, depending on the camera. This means you can position the priority AF sensor in any of the camera's 51 or 39 available spots. You change the position of the AF sensor by pressing the multi-selector while looking through the viewfinder. (Note that you can't position the AF sensor in auto-area AF.)

Sports and wildlife photographers often need to move the AF sensor very quickly in response to a moving subject. For example, in basketball, team A might have the ball, then team B steals the ball and starts running the opposite direction. In response, the photographer needs to move the AF point to the other side of the frame for a better composition.

Figure 2-22: Built-in AF-assist illuminator menu

With 51 or 39 points, it takes a lot of multi-selector clicks to move the AF point. To speed up the process, you can reduce the number of AF home positions from 51 or 39 points to 11 points. It is much quicker to move the sensor around the AF field with fewer points.

If you choose AF11 from the menu, you will be able to position the priority sensor only at those 11 home spots. Note that the group of sensors in dynamic-area or group-area AF still travels with the priority sensor. For example, if you use d-21 as the sensor pattern, the entire group is still arranged around any of those 11 home positions.

There are two options for this menu:

- **AF51 (or AF39):** You can position the priority sensor at any of the camera's 51 or 39 sensor locations. Landscape, travel, and portrait photographers should use AF51 as the default setting so they have full control over the position of the AF sensor.
- **AF11:** This setting limits the number of sensor positions to 11. Sports, action, and wildlife photographers should use AF11 so they can rapidly move the sensor around the viewfinder.

### Built-In AF-Assist Illuminator (a8 or a9 on Most Cameras)

This menu item (figure 2-22) is not available on professional Nikon cameras, like the D3 series or D4 series. It is available on all entry-level and semi-pro Nikon DSLR cameras, such as the D3000 series, D5000 series, D610, D810, and so forth.

As I mentioned in chapter 1, the Nikon AF system requires three main elements to effectively operate: light, contrast, and distinct lines. The built-in AF-assist illuminator is a small LED on the front of the camera that casts light onto the scene (figure 2-23).

The LED lamp shines light onto the scene only if the camera determines it is too dark for normal AF operation. These situations typically occur for event photographers who shoot in dark reception halls or for landscape photographers who shoot after sunset or before sunrise.

One thing to note is that the lamp is frequently obscured by lenses with large lens hoods. If you decide to use the AF-assist lamp, I suggest using smaller prime lenses to prevent the lamp from being blocked.

The AF-assist lamp works only in AF-S or AF-A mode; it doesn't work in AF-C mode. The assist light turns on for

Figure 2-23: The AF-assist illuminator is located on the front of most entry-level and semi-pro Nikon DSLR cameras

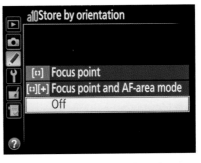

Figure 2-24: The Store by orientation menu on a Nikon D4S

a moment while the camera focuses, and then it immediately turns off.

The light can be annoying for people on the receiving end, so I suggest using it only when you absolutely must. If you are a wedding photographer, I definitely suggest that you do not use it! You'll annoy the guests, the bride and groom, *and* the mother of the bride. The best option for wedding photographers is to use an accessory flash, like the SB-700 or SB-910, because it has a built-in AF-assist pattern that emits a red grid rather than a bright beam of white light. If you use a flash that has an AF-assist beam, like the SB-700 or SB-910, the AF-assist LED on the camera body will automatically turn off when the accessory flash is powered on. See chapter 7 for more information on how to use the AF-assist beam of an accessory flash.

The menu options are as follows:

- **On:** Turns on the AF-assist illuminator function

- **Off:** Turns off the AF-assist illuminator function

### Store by Orientation (a8, a9, or a10 on Newer High-End Cameras)

This function allows the camera to remember the AF sensor position by camera orientation (figure 2-24). When the function is turned on, the camera remembers the last position of the AF point when the camera was in a vertical orientation, then it reverts to the last position of the AF point when it was in a horizontal orientation (figure 2-25).

The camera will remember the sensor positions for three camera

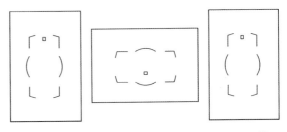

Figure 2-25: When this option is enabled, the camera will remember the last position of the AF sensor when it is in vertical or horizontal orientation

orientations: vertical with handgrip down, horizontal, and vertical with handgrip up. The camera won't remember an upside-down position; it reverts to the horizontal orientation.

When I photograph any given scene, I take both vertical and horizontal images. I do this for a couple of reasons: I don't always know which composition will look better as a print on the wall, and I don't know if a client will request a horizontal or vertical image for a project. I often position the AF point differently for my vertical and horizontal shots. The camera will remember these positions and automatically return the sensor to the previous location when I reorient the camera.

When I photograph wildlife, my practice is to compose the photo vertically and then move the AF sensor to the animal's eye. I often wait patiently for some type of interesting behavior, then I immediately rotate the camera to a horizontal position, compose the image, and move the AF sensor to the eye again. I switch between vertical and horizontal orientations quite frequently, so having the camera automatically reposition the AF sensor for me is helpful.

The menu options for some cameras, like the D800, are as follows:

- **Yes:** This option turns the function on. The camera will remember the different focus point locations depending on the orientation of the camera.

- **No:** This option does not store the focus point position by orientation. When you rotate the camera vertically or horizontally, the AF point stays in the same position.

The menu options for other cameras, like the D4S, are as follows (figure 2-24):

- **Focus point:** The camera remembers the different focus point locations depending on the orientation of the camera
- **Focus point and AF-area mode:** The camera remembers the different focus point locations and the AF-area mode depending on the orientation of the camera. This is useful if you want to use single-point AF in vertical orientation and dynamic-area AF in horizontal orientation.
- **Off:** The camera does not store the focus point position by orientation. When you rotate the camera vertically or horizontally, the AF point stays in the same position.

There are downsides to turning on the Store by orientation feature. For example, I don't recommend this setting when you shoot handheld, like when you are travelling or shooting your family reunion. In these situations, you often cannot repeat your shots. You rarely have a chance to take the same shot over and over again, like with landscapes or wildlife. Each composition is usually unique, so it's frustrating when

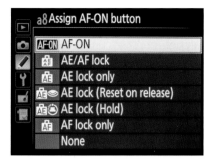

Figure 2-26: There are numerous choices in the Assign AF-ON button menu. I recommend leaving it set to AF-ON.

Figure 2-27: The menu choices for Assign AF-ON button (vert.)

the camera automatically returns the sensor to a specific position for vertical and horizontal shots. You'll find that you always move the sensor to a new position instead of using the position the camera has remembered.

### Assign AF-ON Button (a8 or a9 on D3/D4 Series Cameras)

This menu item (figure 2-26) allows you to define the purpose for the AF-ON button and is available only on the Nikon D3 series and D4 series cameras. My recommendation is to program this button so it performs the AF-ON function, but there are other options, such as AE-L (Hold), AE-L/AF-L, AE-L (Reset on release), AF-L only, and others. It makes sense to leave this button set to operate as the AF-ON button, especially if you use the back-button focusing technique I will explain later in this chapter.

### Assign AF-On Button (Vert.) (a8, a9, or a10 on D2/D3/D4 Series Cameras)

For the most part, the choices in this menu are the same as those in the

previously discussed menu. The difference is that you can choose AF-ON or Same as AF-ON button (figure 2-27). These choices can be confusing because they seem to say the same thing. If you choose Same as AF-ON button, the vertical grip AF-ON button will mirror the function of the normal AF-ON button. For example, if you set the AF-ON button to AF-ON, the vertical grip AF-ON button will also have the AF-ON functionality. If you set the AF-ON button to AE-L (Hold), the vertical grip AF-ON button will also be AE-L (Hold).

### AF-ON for MB-D10 or MB-D80 (a10 on D700/D300/D300S, a6 on D90)

Many Nikon DSLR cameras can accept an accessory battery grip that adds further functionality to the camera (figure 2-28). There are three benefits to using a battery grip on your camera:

- It provides extra battery life to the camera

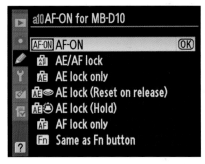

Figure 2-29: The menu choices for assigning the behavior of the AF-ON button on the accessory battery grip

Figure 2-28: A vertical grip adds extra capabilities to your Nikon camera, including shutter and AF-ON access for photography in the vertical orientation. The vertical grip also provides extra support for your wrist when you use big lenses and flash units.

- It improves the overall ergonomics of the camera, especially when you use a large f/2.8 lens
- It allows vertical orientation shutter release and AF-ON/AE-L control

The cameras that accept a vertical grip have a menu item (figure 2-29) that defines what the AF-ON button does. In general, these options include settings like AE/AF lock, AE lock only, AE lock (Hold), FV (flash value) lock, and AF-ON. If you use the back-button focusing technique I describe on page 69, I

suggest setting the button to AF-ON. If you don't use this technique, I suggest setting the button to AE lock (Hold).

Beginning with the D7000, Nikon changed the menu location for this option from the CSM a group (AF) to the CSM f group (Controls). Cameras like the D600 series, D7000 series, D800 series, D750, and Df use CSM f9, f10, and f14. Nikon also slightly changed the menu name to Assign MB-DXX (where XX is the model number) AF-ON button. I will discuss the vertical grip options for these cameras later in the chapter.

### Limit AF-Area Mode Selection (a11 on D810 and D4S)

There are so many AF choices available to D810 and D4S users that even Nikon realizes you might not need to choose from every potential option when shooting. This menu option (figure 2-30) allows you to hide certain AF options from the LCD control panels when you press the AF mode selector button.

For example, if you never use Auto-area AF or 3D-tracking, you can deselect

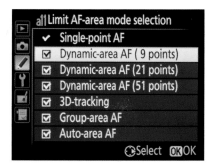

Figure 2-30: Limit AF-area mode selection allows you to reduce the number of available options for AF areas

Figure 2-31: Autofocus mode restrictions on a Nikon D4S

them from this menu. Then, when you choose an AF-area mode by pressing the AF mode button and rotating the command dials, these two options won't appear as choices on your camera's LCD panel. The goal is to simplify the camera and reduce the number of options so that when you are in the field you don't have to scroll through so many choices. It also helps prevent you from making an incorrect choice in the heat of the moment.

Here's a tip: Use menu groups A, B, C, and D to set up different AF modes for specific shooting scenarios. If you use menu group A for landscapes, turn off everything except single-point AF. If you use menu group B for bird-in-flight photography, turn off single-point AF and d-9.

## Autofocus Mode Restrictions (a12 on D4S)

The options for this menu (figure 2-31) are AF-S, AF-C, or No restrictions. If you uncheck items on the menu, you can limit the number of AF servo options

that are available when you press the AF mode button and rotate the command dials.

For example, if you use AF-C mode only because you use the back-button focus technique, you can eliminate the AF-S option from your available choices. Alternatively, if you are solely a landscape photographer who uses the shutter-release button to focus, there's no reason to have AF-C as an option.

## Beep (d1 on Most Cameras)

Menu d1 turns the camera beep on or off. The beep makes a sound in AF-S mode only when the camera confirms AF. It doesn't make a sound in AF-C mode. In general, I don't recommend using the beep because it can be distracting in real-world shooting scenarios, such as wedding and wildlife photography. The only time I recommend using the beep is if you have limited eyesight. In that case, the beep confirms focus and is a valuable tool.

Most lower-end DSLRs let you choose only on or off. Higher-end

cameras allow you to also choose the pitch and volume of the beep.

## Menus f1–f12

The CSM f (Controls) group generally pertains to how the buttons are configured and what they control. Many buttons on Nikon cameras are programmable and are designed to perform multiple functions. Nikon does this for a variety of reasons; one of the main reasons is ergonomics. People who have smaller hands may find it difficult to reach the AF-ON button with their thumb, and others might simply prefer to press the AE-L/AF-L button. The neat thing is that most buttons are programmable, and you need to understand how the choices impact AF.

I won't talk about all the menu items in the f group, only the ones that impact the AF system.

### Switch (f1 on Higher-End Cameras Like D700, D810)

This menu item (figure 2-32) doesn't have anything directly to do with AF, but it can help you in low light. Normally, when you rotate the power switch to the right, it will illuminate the LCD panels on the camera for easier reading at night. If you choose Backlight and information display on menu f1, the power switch will also activate the information panel on the back of the

Figure 2-32: The Switch menu allows you to control how the power switch operates in the illumination position

camera. This is in addition to pressing the info button or i button on other cameras.

Sometimes I like to adjust my camera's AF settings by looking at the information screen (figure 2-33) because the readout is so much larger than the LCD panel on top of the camera. Using the power switch to activate the information screen saves time in the field.

### OK Button (f1 or f2 on D750, D600, Df, D5300, and Others)

On the midrange Nikon DSLR cameras from the D3000 series to the D750 series, the OK button is positioned in the middle of the multi-selector. If you program it correctly, the OK button can replicate the functionality of the standard multi-selector center button found on higher-end cameras like the D810 and D4S.

Most of the time the OK button (figure 2-34) is used to confirm menu choices, but it also has some very useful applications for AF. Depending on

Figure 2-33: It's easy to see camera settings on the information screen on the back of most newer Nikon DSLRs. The info button is circled, and the arrow points to the information screen.

Figure 2-34: The OK button menu on a Nikon D750

your camera, there may be one to three submenus that you can use to customize this button.

The most important setting is Shooting mode. When your camera is in Shooting mode, you can program the OK button to either center the AF point or highlight the active focus point. By far the most useful setting is to center the focus point.

I use this capability regularly in just about every shooting scenario because it is much faster to center the AF point by pressing the OK button than by moving it manually with the multi-selector. If the AF point is in the upper-left corner of the viewfinder and you want to quickly move it back to center, a single press of the OK button will instantly move it.

Some cameras, like the D750, have other options in the OK button submenu called Playback mode and Live view. In Playback mode, you can program the OK button to quickly zoom in to the photo to check the focus accuracy. Configure the OK button in Playback mode to Zoom on/off, then go to the next submenu and choose 1:1 (100%). Then, after you take a photo, view the image on the rear monitor. You can press the OK button to quickly zoom in to the photo at 100% to check the focus. I use this function all the time. On other cameras, such as the D700/D800/D3/D4 series models, you can program the multi-selector center button to do the same things.

The last option in the OK button submenu is Live view. Here you need to decide which option is best for your shooting style: RESET or Zoom on/off. RESET will center the focus point in live view mode, and Zoom on/off will zoom in to the scene to help you obtain accurate focus in live view. I find myself going back and forth between these

Figure 2-35: Program the user menus (U1 and U2) to assign different functions to the OK button, depending on the subjects you shoot

Figure 2-36: The location of the function button varies depending on the camera model

settings. When I shoot video of moving subjects, I find it more helpful to use RESET. This allows me to quickly reposition the AF point rather than moving it around the scene with the multi-selector. On the other hand, when I shoot video of still images like landscapes and closeups, I program the OK button to zoom in to the scene at 100% so I can get accurate focus.

I suggest that you program the user menus (U1 and U2) to include different options for the OK button (figure 2-35). For example, you could designate menu U1 for landscapes and program the OK button Live view setting to Zoom on/off; you could use menu U2 for portraits or sports and choose RESET.

### Assign Fn Button (f2, f3, f5 Depending on Your Camera)

Depending on the camera model, either one or two submenus are used to configure the function button (figure 2-36). One of the menus is titled Press, and the

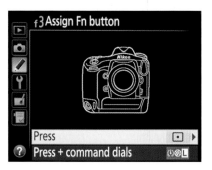

Figure 2-37: The Assign Fn button menu on a D4S

other is titled Press + command dials (figure 2-37).

#### Press
Most people use the function button to quickly activate the spot meter or for FV lock. For the purposes of AF and sharpness, there are multiple options to consider. Let's go through the items that pertain to AF:

- **AE/AF lock:** This locks both autoexposure and autofocus while you press the function button. In my opinion, this is not a useful choice because it locks both autoexposure and autofocus simultaneously. You rarely want to meter and focus on the same spot in a composition. For example, in a landscape, you might meter on clouds so you don't blow out the highlights in the image. Then you focus on the subject at the hyperfocal distance (see chapter 7). Locking the exposure and the focus together doesn't make sense.
- **AF lock only:** This will lock the AF when you press and hold the function button. The key is that you have to keep pressing the function button to continue locking the focus. Your camera probably has a dedicated AE-L/AF-L button, so use it instead for focus lock. Remember that if you are using AF-S mode (single-servo AF), any time you hold down the shutter-release button halfway the focus is locked, thereby duplicating this option. Use the function button to lock focus only if you are using AF-C mode and you use the AE-L/AF-L button for another purpose, like exposure lock.
- **AF-ON:** Setting your function button to serve as an AF-ON button is an interesting idea because your camera might already have an AF-ON button.

My suggestion is to program the function button as an AF-ON button only if needed for ergonomic reasons.
- **Viewfinder grid display:** This option doesn't necessarily impact AF; it has more to do with composition and potentially depth of field. Normally, you can permanently activate the viewfinder grid from the CSM d group. However, if you want the grid to be off during normal shooting and on at specific times, you can program the function button to activate it when you press the function button. With respect to hyperfocal distance, you can use the gridlines to help estimate where in the frame you should focus. See chapter 7 for more about hyperfocal distance.
- **Access top item in MY MENU:** MY MENU is a programmable menu group that allows you to add only the menu items you most frequently use (figure 2-38). If you regularly change settings like white balance, color space, flash parameters, or AF configuration, you can add a few of them to MY MENU. It's easier to access settings from MY MENU than to hunt for them in the larger menu system.
- If there is something in the AF menu group (f1–f12) that you want to access quickly, add it to MY MENU and place it on the top line of MY MENU. Then, when you press the function button, it will open the top item in MY MENU

Figure 2-38: MY MENU is a programmable menu that lets you put your most-often used menu items in a dedicated list. Here, I've programmed mine for quick access to Focus tracking, Flash control, and ISO sensitivity settings.

Figure 2-39: The Press + command dials submenu

so you can quickly make a change. My suggestion is to use the function button to access a3 Focus tracking with lock-on. I regularly change this setting, depending on the subject I'm photographing.

- **AF-area mode:** This function is available on entry-level Nikon cameras, like the D5500. These cameras don't have an AF mode button. Generally, you choose an AF mode from the information screen on the back monitor. If you program the function button to access AF-area mode, you can simply press the function button while you rotate the command dial to change the area mode to single-point, dynamic-area, and auto-area AF.

### Press + Command Dials

The second way to use the function button is to press it with one finger while you rotate the main command dial and subcommand dial. This allows you to turn different functions on or off. As you can see in figure 2-39, there are numerous options available in this menu. For general shooting, I typically program Press + command dials to choose a non-CPU lens number or to choose an image area.

With respect to focus and image sharpness, the only option on the menu that makes sense to use is Exposure delay mode. After you assign it to the function button, you press the function button and rotate the main command dial to activate Exposure delay mode. Then, while you press the function button, rotate the subcommand dial to set the delay (in seconds).

Exposure delay mode works as a pseudo mirror lock-up mode. This isn't an AF tool per se, but it can help you take sharper photographs by reducing vibrations when your camera is mounted on a tripod.

Note that you can also activate Exposure delay mode from the CSM d group, usually d4, d9, or d10, depending on your camera.

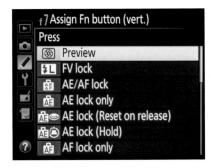

Figure 2-40: Menu f7 on the Nikon D4/
D4S controls the vertical function button

Figure 2-41: The vertical function button on the D4/
D4S is located next to the shutter-release button on
the vertical grip

### Assign Fn Button (Vert.) (f7 on D4/D4S)

This menu (figure 2-40) allows you to
choose the role of the vertical function
button on the Nikon D4/D4S. This is a
second function button that is located
beside the shutter-release button on the
vertical grip (figure 2-41). The options
are the same as those for the regular
function button, described previously.
There are not many settings that
affect AF.

On a D4S, I use the vertical function
button to activate spot metering in most
shooting scenarios.

### Multi-Selector Center Button (f1 or f2 on Semi-Pro and Pro Cameras)

Like the OK button on cameras such as
the D7200 and D610, the multi-selector
center button (figure 2-42) can be used
to select menu items or assist with a
few things that impact AF. The most
beneficial use of the multi-selector
center button is that when the camera
is in shooting mode, it can quickly move
the AF point back to the center position.
The alternative is to manually move

the AF point by using the multi-selector
and clicking it once for each movement.
In the heat of the moment, it seems
to take an eternity to move the sensor
back to the middle, so I like being able

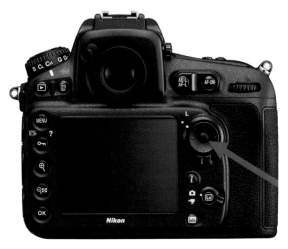

Figure 2-42: The multi-selector center button on a
Nikon D810

to press the multi-selector center button to move the AF point to the middle.

The options for this button are listed in the following sections.

### Shooting Mode

- **Reset:** This allows you to instantly move the AF point back to the center position when you press the multi-selector center button. I suggest that you use this option.
- **Highlight active focus point:** This turns the active focus point red for a moment when you press the multi-selector center button. I don't think this is a useful choice.
- **Not used:** This means that, in shooting mode, nothing will happen when you press the multi-selector center button.

### Playback Mode

- **Thumbnail on/off:** This setting allows you to quickly activate thumbnail views of the images on your memory card
- **View histograms:** This setting activates the histogram function for the photo you are currently viewing on the monitor
- **Zoom on/off:** This choice allows you to quickly zoom in to a photo at high magnification without having to press the zoom buttons on the camera. My suggestion is to choose this option so you can quickly assess AF accuracy when you review your photos during

playback. Depending on your camera model, be sure to choose medium magnification or 1:1 for the best results.

- **Choose slot and folder:** This option allows you to choose the slot and folder that will be used to store your photographs. I don't think this option is useful for most photographers.

### Live View

- **RESET:** This allows you to instantly move the AF point to the center position when you press the multi-selector center button
- **Zoom on/off:** This choice allows you to quickly zoom in to a photo at high magnification without having to press the zoom buttons on the camera. My suggestion is to choose this option so you can quickly assess AF accuracy when you review your photos during playback. Be sure to choose medium magnification or 1:1 for the best results.
- **Not used:** This means that, in shooting mode, nothing will happen when you press the center of the multi-selector button.

With Live View, you have an interesting quandary about how to most effectively use the multi-selector center button. Do you want to quickly zoom in to check critical focus, or do you want to reset the AF point to the middle position? I've used both settings, and quite

often when I have chosen one option, I wish I had chosen the other. In general, I think it is more useful to zoom to medium magnification (1:1) to check critical focus. In Live view you get a very accurate representation of focus because you see the image as it is actually rendered on the sensor.

### Multi-Selector (f3 on High-End Cameras Like the D810, D4S, and Df)

This menu item has no impact on AF. I mention it here because sometimes it is good to know what you don't have to know.

### Assign Preview Button (f3, f5 on Most Cameras)

Everything I said in the previous sections about the options available for the Assign Fn button pertain to the Assign preview button menu (figure 2-43). Typically, the preview button is used as a depth-of-field (DOF) preview button. In the film days, photographers regularly stopped down their lenses to get a better understanding what was, and was not, in focus because every frame of film had a monetary cost. With digital photography, we don't worry about the cost of individual pictures. After all, we can review photos on the back of the camera to check the DOF. That said, I still use my DOF preview button out of habit and because I find it helpful to understand what's in focus and what's out of focus when I compose my images.

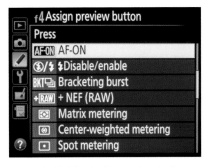

Figure 2-43: The Assign preview button menu

Here's how DOF preview works: Normally, what you see through the viewfinder is what the world looks like when the aperture of the lens is wide open. If you are using an f/2.8 lens, you see everything through the viewfinder with a very narrow DOF at f/2.8. If your intent is to take the photo at f/8, the aperture will stop down when you trip the shutter. If you press the DOF preview button, the camera stops the lens down to f/8 so you can see the DOF in the viewfinder before you take the photograph. Keep in mind that when you press the DOF preview button, the viewfinder gets darker, so it might take a little time for your eyes to adjust.

Read chapter 7 for more information on DOF and hyperfocal distance.

Like the function button, there are two ways to add functionality to the preview button on most higher-end Nikon cameras. The first way is with Press, and the second way is with Press + command dials. As I mentioned in the first paragraph of this section, all the other settings—such as AE-lock, AF-lock,

and other options—are the same as those for the preview button.

### Assign AE-L/AF-L Button (Menu Number Varies Depending on Your Camera)

Everything I said about Assign Fn button and Assign preview button holds true for the AE-L/AF-L button. As before, there are two ways to use the button: one as Press and the other as Press + command dials. Most Nikon cameras have an AE-L/AF-L button (figure 2-44), but only the higher-end cameras have both this button and an AF-ON button.

If your camera has only an AE-L/AF-L button (D3300, D5500, D750, etc.) and you want to use the back-button focusing technique (page 69), you will need to program the AE-L/AF-L button to work as an AF-ON button. With these cameras, I program my Fn (function) button to lock exposure and use the AE-L/AF-L button to operate as an AF-ON button.

On the other hand, if your camera has both an AF-ON button and an AE-L/AF-L button, my recommendation is to program the AE-L/AF-L button to operate as AE-L (Hold).

### Assign Sub-Selector (f5 on D4/D4S)

The sub-selector is a little peg button above the multi-selector and is available only on the Nikon D4 and D4S (figure 2-45). It can be toggled left, right, up, or down just like the multi-selector. You

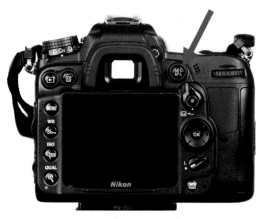

Figure 2-44: The AE-L/AF-L button on a Nikon D7000

can also program the middle of the sub-selector so that when you push it, one of the functions available on the menu is activated (figure 2-46). These functions can be programmed under menu f6 and are shown in the next section.

There are two choices for the left, right, up, and down movements of the sub-selector. The first is Same as multi-selector, and the second is Focus point selection. If you choose Focus point selection, the position of the focus points will change when you move the sub-selector. If you choose Same as multi-selector, you can use the sub-selector to navigate through the menus and to change the AF position. My general recommendation is to choose Same as multi-selector. This option gives you the most functionality.

Note: If the AF lock switch is set to L, you won't be able to move the AF position with either the multi-selector or the sub-selector.

Figure 2-45: The sub-selector on a Nikon D4S. There's also a vertical sub-selector (not circled).

Figure 2-46: Assign sub-selector menu

Figure 2-47: Assign sub-selector center button menu

### Assign Sub-Selector Center (f6 on D4/D4S)

The D4 and D4S cameras do not have an AE-L/AF-L button. Instead, they have a programmable button called a sub-selector. This adds functionality because the sub-selector center button can be programmed for a wide variety of options (figure 2-47). One option is to use the sub-selector to lock exposure or focus, like the AE-L/AF-L button on other Nikon cameras.

Like the other programmable buttons, the sub-selector can be used in two ways: Press or Press + command dials. My recommendation for the sub-selector center button is to program it as an AE-L (hold) button. Another option is to program the center button as a RESET button. RESET allows you to move the AF sensor to the middle point.

This would probably duplicate the function of the multi-selector center button, but it is a viable option if you use a different setting for the multi-selector.

### Release Button to Use Dial (Menu Number Varies among Cameras)

This menu item (figure 2-48) allows you to press a button once, rotate the command dial to change the value, then press the button again to set the value. For example, you can press the AF mode button once, then change the area mode to d-21, and then press the AF mode button again to lock in the value. Most

Figure 2-48: Release button to use dial menu

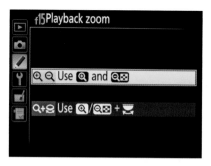

Figure 2-49: I recommend setting playback zoom on the D4/D4S to +/–

people simply press and hold the AF mode button while rotating the command dial to make a selection, but this feature is available for people who are not physically able to press the button and rotate the dial at the same time.

This feature works for just about any button on the camera, including white balance, ISO, bracketing, image quality, exposure mode, and exposure compensation.

### Assign Multi-Selector (Vert.) (f14 on D4/D4S)

The Nikon D4 and D4S have multi-selectors in both horizontal and vertical orientations. My general recommendation is to set the vertical multi-selector to operate the same way as the horizontal multi-selector. This includes selecting the AF point position, quickly zooming in and out of photographs with the center button, and scrolling through pictures during playback.

### Playback Zoom (f15 on D4/D4S)

It is common for a photographer to zoom in to a photograph after capture to check critical focus. On older Nikon professional cameras, like the D2 and D3 series, zooming in requires pressing the thumbnail button while rotating the main command dial. This is somewhat complicated, and Nikon addressed it on their lower-end cameras by adding +/– zoom buttons on the left side of the camera.

On the Nikon D4 series professional cameras, you can zoom in either by using the traditional method (old-style D2 or D3 method) or by pressing the +/– buttons on the left side of the camera. Unless you have both a D3 and a D4 and want them to operate the same way, I don't recommend using the older zooming method because it is much more cumbersome. Instead, choose the first option (plus and minus symbols) on this menu (figure 2-49).

### Assign MB-D12 AF-ON (Menu Item Varies from Camera to Camera)

The title of this menu is different depending on the camera you own. Nikon names their vertical grips with MB-DXX, where XX represents the

model number. The D750 uses the MB-D16, the D800 and D810 use the MB-D12, the D7000 uses the MB-D11, and the D700 and D300 use the MB-D10.

This menu allows you to assign the function of the AF-ON button on your accessory vertical grip. In general, I recommend assigning the AF-ON function to the AF-ON button on the vertical grip. However, if you don't use back-button focus, you might consider programming it to be an AE-L (hold) button.

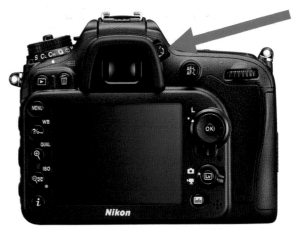

Figure 2-50: The diopter control allows you to adjust the viewfinder for your own vision requirements

## Diopter

The diopter control allows you to adjust the focus in the viewfinder according to your vision correction prescription. The best way to determine if the camera focuses accurately is to make sure that what you see in the viewfinder is clear. Nikon DSLR cameras allow you to adjust the diopter magnification of the viewfinder with a small dial on the side of the pentaprism (figure 2-50).

The best way to adjust the diopter is to take off your corrective lens and point the camera toward a bright light source. Then rotate the diopter dial while you pay attention to the numbers, gridlines, and symbols etched on the focusing screen of the viewfinder.

If you wear eyeglasses when you shoot, adjust the diopter while you're wearing them. If you shoot without eyeglasses, adjust the diopter without them. The total range of diopter adjustment is from $-2$ m$^{-1}$ to $+1$ m$^{-1}$. If your prescription is beyond this diopter range, you can buy screw-on or snap-on diopter eyepieces that range from $-5$ m$^{-1}$ to $+3$ m$^{-1}$ at any big photography retailer for $10 to $20 each.

## AF Shooting Styles and Back-Button AF

Most people begin working with the AF system by focusing with the shutter-release button. Almost all cameras engage the AF system when you press the shutter-release button halfway. This is a normal approach to AF, and it works well. Photographers have been using this feature since AF was first introduced in the 1980s.

There are some benefits of using a different AF method, commonly called back-button focus. I recommend that most people use back-button focus

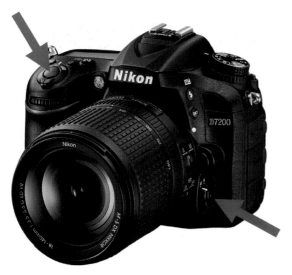

Figure 2-51: To use front-button focus, choose AF-C or AF-S on the AF mode selector switch, depending on the movement of the subject, and press the shutter-release button halfway

because it works for just about every photographic situation and is more efficient; you can focus more quickly in dynamic situations because the AF servo motor does not have to switch between AF-S mode and AF-C mode.

I'll start this discussion with a description of front-button focusing, also known as shutter-release button AF, then I will describe back-button focusing using either the AF-ON button or the AE-L/AF-L button.

### Shutter-Release AF

For years, front-button focusing has been the most common way for photographers to initiate AF (figure 2-51). With front-button focusing, you press the shutter-release button halfway to

activate AF. The AF system remains engaged as long as you halfway press or fully press the shutter-release button in AF-C mode. With the camera in AF-S mode, as soon as focus is acquired, the focus system locks and the AF servo retains focus on the subject. As long as you continue pressing halfway down on the shutter-release button, the focus remains locked.

In AF-C mode, the focus system activates as soon as you press the shutter-release button halfway or fully. In AF-C mode, the AF system continually searches for movement as long as the shutter-release button is pressed halfway or fully pressed.

Let's look at a few examples of how to front-button focus. My intent is to compare the steps needed for front-button focus with the steps needed for back-button focus, which I'll discuss in the next section.

Suppose you are shooting a portrait. It is common to focus on the person's eyes then recompose the frame so the subject is on the left or right of the composition. In AF-S mode this is fairly easy because as soon as you acquire focus on the subject, the camera stops the focus servo and locks focus. Front-button focusing works fine in this scenario.

Now let's look at two more examples: one with a flying bird that lands on a branch, and one with a runner in a race. In both examples, the subject will first be moving and then be stationary.

Figure 2-52: When the bird is flying, you need to use AF-C mode. When the bird lands on the branch, as shown here, you need to switch to AF-S so you can focus then recompose.

To effectively use the AF system with front-button AF, you need to use AF-C (continuous servo) mode as long as the subject is moving. While the bird is flying or while the runner is moving, your camera will need to be in AF-C mode. When the bird lands on a branch (figure 2-52) or when the runner stops running, you focus and recompose to place the subject on the left or right side of the picture.

The only way to recompose without the camera refocusing is to switch your camera to AF-S mode. AF-S allows you to focus and recompose when you press the shutter button halfway and hold it. When you're ready to take the picture, you press all the way down to release the shutter.

The requirement to switch between AF-C and AF-S mode is frustrating. You might be able to press the AF selector button while rotating the command dials without removing your eye from the viewfinder. This would allow you to keep tracking the subject in the viewfinder while you make changes to the AF settings. Most people can't do this, though. They have to remove the camera from their eye and change the setting while looking at the camera's LCD panels. Either way, it takes time to switch between AF-C and AF-S, and you might miss the shot.

For landscape photography, using the shutter-release button for focus is straightforward and follows a time-honored tradition of focusing and recomposing. Most people are familiar with focusing on an object in the foreground (or at the hyperfocal distance) then pressing and holding the shutter-release button halfway while recomposing the scene. This approach is the same for most architectural photography, macro photography, and portrait photography. In fact, for any scenario in which the subject is not moving, front-button focus is a good approach because it is simple and intuitive.

To be clear about the process and to illustrate it for comparison with back-button focus, here are the steps for front-button focus, both for stationary and moving subjects.

Front-button focus for a stationary subject:
1. Set the camera to AF-S mode.
2. Position the AF sensor over the subject.
3. Half-press the shutter-release button.
4. Keep holding the shutter-release button halfway to lock focus (or press the AF-Lock button).
5. Recompose the image.
6. Fully press the shutter-release button to take the picture.

Front-button focus for a moving subject:
1. Set the camera to AF-C mode.

2. Position the AF sensor over the subject.
3. Half-press the shutter-release button.
4. While the subject is moving, continue to press the shutter-release button halfway so the camera will track the subject. Fully depress the shutter-release button to take the photo.
5. The camera continues to track the subject as long as you press the shutter-release button halfway or fully.

### AF-A Mode—*Supposedly* Automatic

Some cameras in the Nikon lineup have AF-A mode, which is supposed to automatically choose either AF-S or AF-C, depending on subject movement. Sometimes it guesses accurately and sometimes it doesn't. If you choose AF-A mode, then as long as you press the shutter-release button halfway, the camera will choose to either lock focus or track the subject. In the case of a flying bird, the camera should automatically choose AF-C when the bird is flying toward you. If the bird is stationary on a branch, the camera should automatically choose AF-S.

AF-A mode was created for new photographers who have not learned the intricacies of the AF system because, but in my experience, it doesn't work as advertised.

Figure 2-53: In back-button focus with the AF-ON or AE-L/AF-L button, you use your thumb to activate focus while the camera is in AF-C servo mode

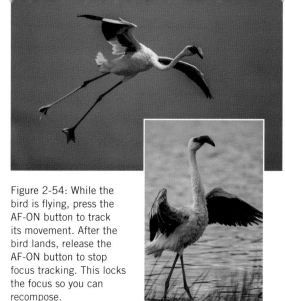

Figure 2-54: While the bird is flying, press the AF-ON button to track its movement. After the bird lands, release the AF-ON button to stop focus tracking. This locks the focus so you can recompose.

## Back-Button AF

For many photographers, back-button AF with the AF-ON button (figure 2-53) is a paradigm shift in the way they approach their AF technique. I can unequivocally state that if you adopt the back-button focus technique and spend time to learn it, you'll never go back to front-button focusing. Back-button AF with the AF-ON button or the AE-L/AF-L button is much more efficient and requires less physical interaction with the camera than traditional front-button focusing with the shutter-release button.

To effectively use back-button focus, access the menu system and set up either the AF-ON button or the AE-L/AF-L button to operate as an AF-ON button. Effectively, this deactivates AF control from the shutter-release button; the only button that initiates AF is the AF-ON button (or the AE-L/AF-L button

if you made that selection; throughout the rest of this discussion I'll use the nomenclature of AF-ON button for simplicity).

The next step, which is very important, is to set the focus servo to AF-C mode. As you'll see in a moment, AF-C is critical for back-button focus to work properly. Also make sure that AF-C priority (CSM a1) is set to release priority.

Using back-button AF is simple. Generally speaking, you press the AF-ON button any time you want to engage the AF servo, and you let go of the AF-ON button when you want AF to stop or lock. To further explain how this works, let's look again at an example of a flying bird that lands.

When the bird is flying (figure 2-54), you want the camera to continuously track its movement. Because the focus servo is set to AF-C, as long as you press and hold the AF-ON button, the camera

will track focus. When you want to take the photograph, you fully press the shutter-release button. If you keep pressing the AF-ON button with your thumb and remove your index finger from the shutter-release button, the camera keeps focusing.

Now, let's say the bird lands. If you remove your thumb from the AF-ON button, the AF system stops and keeps the focus at the current distance, where the bird landed. Now, with your thumb still removed, you can recompose the image and take the photograph; the camera does not refocus when you press the shutter-release button. As long as the bird stays the same distance from the camera, you do not have to refocus with the AF-ON button.

This technique has big ramifications for your photography because you no longer have to switch the camera from AF-C to AF-S mode. Simply press the AF-ON button to activate AF-C mode and release the button to lock focus. When you release the AF-ON button, the camera effectively operates like it is in AF-S mode.

Back-button AF can simply be described like this: While you are pressing the AF-ON button, the camera continuously focuses. When you let go of the AF-ON button, the focus stops, or locks.

Remember, for this technique to work properly, the camera needs to be in AF-C mode, and the AF-C priority menu needs to be set to release priority.

Photographing stationary subjects, like portraits, flowers, landscapes, and still lifes, with the AF-ON button works the same way. You focus once by pressing the AF-ON button, then let go of the AF-ON button when you take the photograph.

Now let's review the steps for comparison with front-button focus.

**Back-button focus for a stationary subject:**
1. Position the AF sensor over the subject you want to focus on
2. Press the AF-ON button with your thumb
3. Remove your thumb from the AF-ON button
4. Recompose the frame as desired
5. Take a picture by pressing the shutter-release button

**Back-button focus for a moving subject:**
1. Position the AF sensor over the subject you want to photograph.
2. Press and hold the AF-ON button with your thumb while the subject is moving.
3. Take a picture by pressing the shutter-release button.

You can see how simple this process is. Press the AF-ON button when the subject is moving, and release the AF-ON button when the subject is stationary. You no longer need to switch the camera from AF-C to AF-S. Back-button focusing takes care of the extra steps.

## How Shutter Speed Impacts Sharpness

More often than not, the biggest problem photographers have with achieving sharpness comes from long shutter speeds. Most people don't realize which shutter speeds are required to capture a crisp image. You might have focused well, but if the subject is moving or if you are shaking the camera even a little, you are most likely going to end up with a blurry photo (figure 2-55).

Lots of photographers own kit lenses and zoom lenses with relatively slow apertures from Nikon or third-party manufacturers. Some of the most popular lenses have focal lengths of 18–200mm, 18–140mm, and 55–300mm, with maximum apertures of f/5.6 when they are zoomed to their longest focal lengths. I know a lot of photographers who try to use these lenses to photograph sports in high school gyms or portraits in living rooms with the lens zoomed all the way out to the longest

Figure 2-55: This photo is blurry because of the long 1/3-second shutter speed. I was handholding a 24mm lens, which led to the slightly blurry background. The person was walking down the stairs, which led to a blurry subject. To get a sharp photo, I would have needed a shutter speed of at least 1/125 second to freeze the motion of the person on the stairs.

focal length. What they don't realize is that this requires shutter speeds around 1/10 second, and they are trying to handhold their cameras at 300mm. This is the perfect recipe for a blurry photograph!

To prevent motion blur from camera shake, I suggest using the old rule of 1/focal length for a lens without vibration reduction (VR). This rule was created in the mid-1900s and holds true to this day. Most relatively stable photographers can handhold their cameras at shutter speeds equal to 1/focal length. In other words, if you have a 30mm lens, you should be able to handhold your camera at 1/30 second and still capture a sharp photograph. This assumes the subject isn't moving, so it works for scenarios like landscapes, architecture, macros, and portraits.

If you are shooting with a 300mm lens, you need a shutter speed of at least 1/300 second to handhold your camera. If you are using camera with a DX sensor, like a D7200, the crop factor multiplies your focal length by 1.5. Therefore, a 300mm lens is equivalent to a 450mm lens, so the shutter speed really needs to be 1/450 second at a minimum.

Obviously, this rule can be relaxed a bit if you are using a VR lens, depending on how much the VR helps you. Some lenses offer 2 stops of improvement with VR, and others offer up to 4 stops of improvement.

Regardless of lens type (VR or non-VR) and focal length (15mm or 600mm),

the other thing you need to consider is subject movement. You may have your camera on a tripod to avoid movement, but if the subject moves during the exposure, you'll still get motion blur in the image. Here are some rules of thumb for shutter speeds to help freeze motion in your photographs:

- 1/1000 second for birds in flight to get sharp wing tips
- 1/500 to 1/1000 second for soccer and football
- 1/125 to 1/250 second for someone walking

### Using Auto ISO to Set Shutter Speed

Because shutter speed plays such a critical role in image sharpness, you should do everything you can to ensure you use the necessary shutter speed for the subject. One way to do this is by manually adjusting the ISO to help set the shutter speed, but this can slow you down and draw your attention away from the action. I suggest using auto ISO to automatically adjust the ISO based on the shutter speed you need.

There are two types of auto ISO: the first sets the ISO based on the shutter speed you choose, and the second sets the shutter speed based on the focal length of the lens you are using.

Most photographers choose auto ISO based on the shutter speed when they shoot sports. Figure 2-56 shows the menu you use to set the parameter for

Figure 2-56: Use auto ISO to set a minimum shutter speed. For example, use 1/1000 second for sports to get sharper pictures.

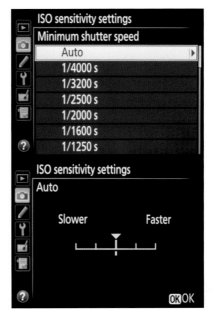

Figure 2-57: Auto ISO Auto sets the ISO so the shutter speed is based on the focal length of the lens

auto ISO. First choose the base ISO, from the top line of the menu. Then choose the maximum ISO (e.g., 6400). Finally, choose the slowest shutter speed you want to allow while shooting (e.g., 1/1000 second).

Now the camera will automatically set the ISO between 100 and 6400 while maintaining a minimum shutter speed of 1/1000 second. If the scene is too dark to use a shutter speed of 1/1000 second at ISO 6400, then the camera will reduce the shutter speed to get a good exposure.

Most newer Nikon DSLR cameras with the auto ISO feature have a very cool option that sets the ISO based on the focal length of the lens. This option is called Auto ISO Auto (figure 2-57). Use Auto ISO Auto when you are handholding your camera and the only motion you are worried about is camera shake.

I previously mentioned that for handholding your camera, the shutter speed should equal 1/focal length to prevent motion blur. The Auto ISO

Auto (figure 2-57) function allows you to set the shutter speed based on 1/(focal length), 1/(focal length x 2), or 1/(focal length x 4). For example, if you are using a 50mm lens, the settings will give you 1/50 second, 1/100 second, and 1/200 second, respectively.

## How ISO Noise and Long Exposure Noise Impact Sharpness

As cool as it is to use auto ISO to help with shutter speeds, you don't get something for nothing. Higher ISOs reduce image quality due to noise. As a photographer, you always balance sharpness

loss from motion blur with quality loss from higher ISOs. There isn't an easy answer to this dilemma. You can use a sharp photo with noise, but you can't use a blurry photo without noise, so use as a high an ISO value as needed to freeze motion blur.

There are two types of noise in digital photography: color noise (chroma) and luminance noise. Color noise is generally considered bad, and luminance noise is considered artistic. Color noise manifests as brown and orange splotches in the darker areas of a photograph. Luminance noise is somewhat analogous to grain in film. A little bit of luminance noise isn't a bad thing, and I don't generally worry too much about it in my images.

Two ways to deal with noise are in-camera or during post-processing. Dealing with noise in-camera requires that you turn on High ISO NR (noise reduction) in the shooting menu (figure 2-58). The camera then implements a noise reduction algorithm at high ISO values. The threshold for high noise depends on which camera you are using. For example, the Nikon D300 starts kicking in noise reduction after ISO 800, whereas other cameras initiate noise reduction at different ISO values.

There are generally four options:

- **High:** I find this setting to be overkill in most situations because it causes skin to look too smooth.

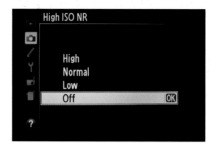

Figure 2-58: High ISO NR menu on a Nikon Df

- **Normal:** I recommend this setting only if you don't do noise reduction in post-processing.
- **Low:** Use low if you are nervous that you might lose too much sharpness but still want a bit of noise reduction.
- **Off:** Because I do most of my noise reduction in post-processing, I set my cameras to Off.

## P, S, A, M vs. Auto Exposure Modes and Impact on AF

Your Nikon DSLR has two groups of exposure modes that you can choose from (figure 2-59). The first group of modes includes P, S, A, and M, in which you are generally in control of the exposure variables and everything else on the camera, including AF. The second group of modes are automatic modes and include settings like portrait, sports, landscape, and closeup. In many of these modes, your camera assumes

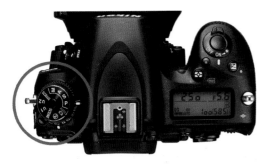

Figure 2-59: The mode dial on a Nikon D750 has the usual P, S, A, and M modes that are found on pro cameras, in addition to the auto, scene, and effects modes

control and automates things like exposure, white balance, and AF.

Nikon professional cameras, like the D810, D700, and D4, do not have automatic scene modes. Rather, they have only P, S, A, or M exposure modes. The big difference between the two groups of exposure modes is that the P, S, A, and M modes control only the exposure system, whereas the automatic modes also take control of the AF system.

With P, S, A, and M, you are responsible for setting up everything else in the camera menu system, including AF, picture control, color space, ISO, release modes, and so forth.

Nikon's entry-level and prosumer cameras, like the D3300, D5500, D610, and D750, have scene modes that take control of most settings, including AF, menus, white balance, and the exposure system. You have much less direct control over the way the camera operates when you use the scene modes.

If you set your Nikon D5500 to landscape mode, it will automatically choose AF-S because it assumes the subject is not moving. On the other hand, if you choose sports mode, the camera will choose AF-C because it assumes the subject is moving and needs to be tracked. These automated scene modes remove your own decision-making process from the equation.

Keep this in mind when you are shooting, and remember that the camera might lock you into a specific AF scenario that may be counter to what you are trying to accomplish. If you need full control over the AF system, use the P, S, A, and M modes, which leave all the AF settings available for you to optimize.

## How Frame Rate Impacts AF Performance

On entry-level and prosumer cameras, like the D3300, D5100, D610, and D750, the frame rate does not significantly impact AF performance because the frame rates on these cameras are relatively low, and the AF system is relatively fast. For example, the frame rate on the entry-level D3200 is 4 fps, while the frame rate on the professional D4S is 11 fps (figure 2-60).

Because of the way the AF system works—by sending light to the mirror then down to the AF system in the

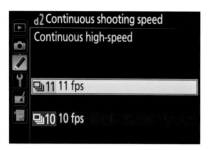

Figure 2-60: A Nikon D4S will shoot a maximum of 11 fps with full AF tracking

bottom of the camera—anytime the mirror is flipped up out of the way, the AF system is temporarily blocked and cannot track the subject.

On the fastest Nikon professional cameras, like the D3 and D4 series cameras, the continuous high frame rates of 9, 10, or 11 fps can sometimes impact AF performance. Each time the mirror flips up, the light path is blocked and the AF system cannot focus on the subject until the mirror flips back down to the home position.

The Nikon D4 lets you choose a frame rate of 10 fps or 11 fps (menu CSM d2). Most photographers choose 11 fps because it gives them the fastest available frame rate. The downside is that the Nikon D4 AF system cannot track subject motion at 11 fps. It begins tracking when you press the shutter-release button halfway or press the AF-ON button, then it immediately starts taking pictures at 11 fps, stops

focus tracking, and behaves as if it is in AF-S mode. When you lift your finger and press the shutter-release button again, the camera resumes tracking the subject, but only as long as you don't shoot at 11 fps. If you need focus tracking on a D4, you have to shoot at 10 fps or slower. This limitation does not exist on the newer Nikon D4S because Nikon improved the AF system. The D4S allows 11 fps and full AF tracking in AF-C mode.

The Nikon D3 and D3S cameras have the same limitation as the D4 at both 10 fps and 11 fps. If you want full AF tracking, you need to shoot at 9 fps or slower.

## DX versus FX and Sensor Coverage over the Frame

Many Nikon DSLR cameras have the same AF module. For example, the full-frame (FX) Nikon D610 and Nikon Df use the same AF module as the crop-sensor (DX) Nikon D7000. Similarly, the Nikon full-frame D3 and D700 have the same AF system as the crop-sensor Nikon D300 and D300S. The Nikon crop-sensor D7200 has the same AF sensor as the full-frame Nikon D4S and D810. In each of these cases, the AF modules occupy the same physical dimensions and AF sensor size, regardless of which camera they are mounted in.

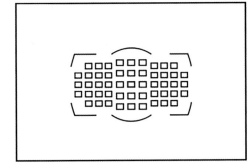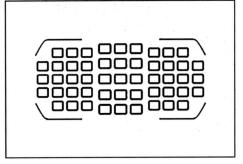

Figure 2-61: The Multi-CAM 3500 AF module covers a larger percentage of the viewfinder in a crop-sensor Nikon D7200 (*right*) than in a full-frame Nikon D4S (*left*)

What this means for you is that the AF sensor pattern area covers a larger percentage of the viewfinder in a DX camera and a smaller percentage of the viewfinder in an FX camera (figure 2-61). A DX camera might do a better job of tracking birds in flight as they move throughout the viewfinder, whereas with an FX camera you might have to work harder to keep the birds toward the middle of the frame to get the focus system to effectively track them.

# Lenses and Settings

In photography you'll find that mastering the lens is just as important as mastering the camera body. It's essential to understand what all the lens switches do and how they impact your photography. Also, it's important to understand AF performance as a function of how old the lens is or what type of AF drive motor it has because those factors play a big role in how quickly the lens acquires and tracks focus. It is worth your time to learn as much as you can about your lens because it is critical to achieving AF excellence.

Figure 3-1: Some Nikon lenses, like this 18–55mm kit lens, have only a switch with an A–M setting. When you set it to A, be careful that you don't rotate the focus ring and damage the internal gears.

## Lens Barrel Switches

Each year Nikon lenses seem to get more and more complex with extra features and switches. Let's go through the AF switches on most Nikon lens barrels so you will understand what they do.

### A–M

Some lenses with just an A–M setting (not M/A or A/M) have a switch that locks the front focus ring. When you turn this switch to A, the gear drive in the lens motor system is activated and prevents you from rotating the focus barrel manually. On some kit lenses that have an A–M switch, you have to be careful not to rotate the focus ring because you might damage the lens. You'll typically find this type of switch on kit lenses, such as the AF-S DX Nikkor 18–55mm f/3.5–5.6G VR ED II (figure 3-1).

On other lenses, like the 18–105mm lens, the A setting means the camera will always automatically focus, even if you rotate the focus ring. This lens has a hybrid version of the autofocus

silent wave motor (AF-S) system and is different than other AF-S lenses, like the 24–70mm f/2.8 or the 70–200mm f/2.8 lenses. The difference is that if you are pressing the shutter-release button halfway (or are pressing the AF-ON button) and the camera is autofocusing, then rotating the focus ring on the 18–105mm lens does not deactivate AF like it would in M/A mode, which is found on other AF-S lenses (discussed later).

In the case of the 18–105mm lens, the camera keeps autofocusing while you rotate the AF ring. In other words, you and the AF system fight each other for control of the lens. You normally wouldn't try to manually focus at the same time you press the shutter-release button or AF-ON button to initiate AF. If you wanted to manually focus, you would remove your finger from the AF button.

When you set the switch to the M position, the gear lock disengages and you can manually focus the lens. The following information is detailed, but it is important to understand. On most Nikon AF-S lenses, you can switch to manual focus by either switching the lens to M or moving the AF mode selector switch to M on the camera body. If you switch only the camera body to manual, you can keep the lens set to A and you'll be able to focus manually. This is not true for all lenses that mechanically lock out the focus ring,

like the 18–55mm lens. In this case, you have to set the lens switch to M so you can focus manually. This isn't an issue with other Nikon AF-S lenses that have M/A or A/M switches.

One more important note is that both the lens and the camera body have to be set to AF for AF to work. If either the lens or the camera body is not set to AF, the lens won't focus automatically.

### M/A - M

You'll find an M/A switch on lenses like the AF-S 24–70mm f/2.8G ED (figure 3-2), the AF-S 14–24mm f/2.8G ED, and many others in the Nikon lineup. These lenses use silent wave motors (SWMs) that are designed to provide the best of both worlds with respect to AF speed and manual focus flexibility.

The neat thing about working with AF-S lens is you don't need to physically switch the lens to manual focus mode to focus manually. You can use AF then immediately use manual focus by rotating the focus ring on the lens. This effectively overrides the AF system and puts the lens in manual focus mode. To resume AF, lift your finger from the shutter-release button (or AF-ON button) then press it again.

M/A indicates that you simply use the focus ring to start manual focus; no switch is required to make the transition. I use this technique when I'm photographing subjects like flowers or insects. First I use AF to rapidly acquire

Figure 3-2: The AF switches on an AF-S Nikon 24–70mm f/2.8G ED lens

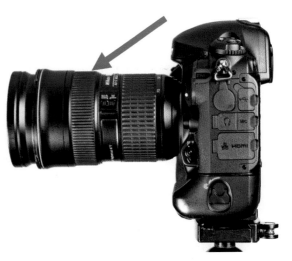

Figure 3-3: Be careful to not mistakenly rotate the focus ring on an AF-S lens and take it out of AF mode

initial focus, then I manually adjust it with the focus ring to fine-tune the focus in the middle or rear of the flower.

Because the M is listed first in M/A (as opposed to A/M, described in the next section), the camera puts priority on manual focus. In other words, M/A allows you to switch from AF to manual focus with virtually no lag time. You can even actively use AF on a moving subject, then as soon as you rotate the focus ring the camera will stop automatically focusing and immediately go into manual focus mode.

Be very careful not to unintentionally bump the focus ring on the lens. An example is when you use a long lens, like the 400mm f/2.8, on a beanbag. You have to be careful when you pan the lens from side to side so you don't mistakenly rotate the focus ring and take the lens out of AF mode (figure 3-3).

If your lens has an M setting, use it to enter manual focus mode. This does the same thing as setting the camera body to manual focus. If either the

camera body or the lens is set to M, the lens will be in manual focus mode.

### A/M

A/M is fundamentally the same as M/A; the difference is that it requires more rotation on the focus ring before the camera switches to manual focus mode. This setting is convenient when, for example, you are resting the lens on a beanbag or you are handholding it and small movements of the focus ring would initiate manual focus, such as in M/A mode. Setting the camera to A/M mode prevents small movements of the AF ring from deactivating AF and activating manual focus. It helps prevents accidental focus changes from small movements of the focus ring.

If you photograph sports or birds in flight, my suggestion is to use A/M mode if your lens has it. For landscapes,

Figure 3-4: The Nikon 400mm f/2.8 lens has M/A, A/M, and M focus modes

portraits, macro images, and general travel photography, I suggest M/A mode. As you can see in figure 3-4, only the more exotic Nikon lenses, like the 200mm f/2 and 400mm f/2.8, have an A/M setting. In fact, these lenses often have all three settings: M/A, A/M, and M. Most other Nikon AF-S lenses have only the M/A option.

### Focus Limit Switch

Sometimes when you try to focus on a subject and the lens cannot quickly acquire focus, the focus motor will rack back and forth between the minimum

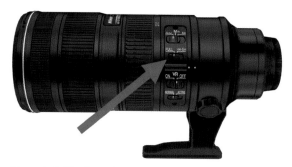

Figure 3-5: The focus limit switch on an AF-S Nikon 70–200mm f/2.8G ED VR II lens has two positions: Full and ∞–5m

focus distance and infinity while it searches. The time it takes for this hunting to occur can be frustrating, so many telephoto lenses have a switch that allows you to limit the focus distance from something like 2.5m to infinity or 5m to infinity (figure 3-5).

On most lenses, about half the focus motor rotation occurs from something like 2.5 meters to infinity, and the other half occurs from the minimum focus distance to 2.5 meters. By setting the focus limit switch, you effectively eliminate more than half the rotation distance, which significantly reduces how much time it takes for the lens to acquire focus.

Some Nikon lenses have a three-position focus limit switch that has setting positions like Full, ∞–2.5m, and 2.5m–min. This switch allows you to choose the range of focus for the lens. For example, if you do a lot of macro photography, you can limit the lens to the minimum focus distance range (2.5m–min). In general, I recommend leaving the lens set to Full until you need to limit the range.

Figure 3-6: The lens barrel buttons on high-end Nikon lenses are programmable

### AF-L, *Memory Recall, AF-ON*

This switch is provided on more expensive Nikon lenses, such as the 400mm f/2.8 (figure 3-6) and 600mm f/4 lenses. It lets you program how the lens barrel focus operation buttons work with respect to AF.

### AF-L

AF-L programs the buttons on the lens to lock AF. This works the same as the AE-L/AF-L button on the back of the camera. Sometimes it is easier to press the lens barrel button because your arm is frequently resting along the top of the lens while you hold the camera system steady.

### Memory Recall

Memory Recall allows you to set a specific focus distance in the lens memory then quickly return the focus to that distance in the future. This is convenient when you photograph sports, such as in baseball when you need to shoot the batter at home plate, then rapidly swing the camera to first base to capture the action.

The process works like this:

1. Set the selector switch to Memory Recall
2. Focus the lens on the subject distance you want the lens to remember (such as first base in the baseball example)
3. Press the lens barrel button to set the focus distance in memory
4. The lens will beep when the focus distance is correctly saved
5. During the game you can focus at different locations on the field, but when the batter hits the ball and starts sprinting toward first base, press the lens barrel button (Memory Recall) and the lens will automatically focus at the correct distance to first base
6. You will hear a double beep, which indicates the lens correctly returned to the distance stored in memory
7. Take the picture

### AF-ON

Setting the switch to AF-ON programs the lens barrel buttons to work exactly the same as the AF-ON button on the back of your camera. If you want to activate focus with the lens barrel button, set the switch to AF-ON and press the button on the side of the lens to activate focus.

### Beep On/Off Switch

This switch toggles the beep that sounds during memory set and recall. If you turn the beep on, it will make a sound when you set the memory distance and also when you recall the memory distance during shooting.

### VR Switches

These settings control the VR system, which is discussed later in this chapter.

## Lens AF Technologies

The Nikon AF system has continually improved over the years with new focus modules, new software, and new focus motor drives. In this section I explain AF terminology.

### AF-I

AF-I stands for auto focus internal. This older technology uses an electromagnetic motor inside the lens to focus and is available on super-telephoto lenses developed in the 1990s. AF-I lenses are no longer manufactured.

### AF-D

Older Nikon AF lenses utilize a mechanical coupling between the camera body AF motor and the lens. The camera body physically drives the AF system through a series of gears with a motor located on the lens mount (figure 3-7). The D designation in AF-D means the lens transfers focus distance information to the camera's exposure system. The camera uses this information from the Multi-CAM focus module to judge flash output, ambient exposure, and AF tracking.

All new lenses in the Nikon lineup communicate distance information to the camera, even though Nikon doesn't necessarily include D in the lens name. If the lens specifically states AF-D, it means the lens AF is driven by the camera body and the lens sends distance information to the camera. If the lens states AF-S, the lens AF is driven by an internal motor (discussed in the next section) and the lens sends distance information to the camera.

If you want to manually focus an AF-D lens, it is important to either set the lens switch to M or set the AF switch on the camera body to M to physically uncouple the lens gear system from the drive motor in the camera body. If you try to manually focus an AF-D lens with the gear still engaged, you'll rotate the motor inside the camera body on cameras like the D7200 and D4S. You could damage the motor, so turn the switch on your camera body to Manual so it retracts the focus motor gear drive.

Figure 3-7: Higher-end Nikon cameras still have an AF motor built in to the body to allow backwards compatibility with older Nikon AF-D lenses

Figure 3-8: The SWM on new Nikon lenses resides inside the lens rather than inside the camera body. Image courtesy Nikon Corporation.

### AF-S

The motor that drives the focus elements in an AF-S lens resides inside the lens itself (figure 3-8), rather than inside the camera body. AF-S technology uses linear motors that convert traveling ultrasonic waves into rotational motion to focus the optics.

Generally speaking, AF-S lenses focus faster than AF-D lenses. They are also much quieter because they aren't being driven by a physical motor and gear system.

There are two types of AF-S motors in Nikon lenses. One is a ring SWM system, as shown in figure 3-8, and the other is micro motor SWM. The ring SWM system uses metal rings around the perimeter of the lens that vibrate at ultrasonic frequencies. These vibrations, or waves, drive the focus elements quickly and quietly. Most high-end lenses from Nikon use a ring SWM system.

Micro motor SWM works more like a conventional electric motor. It uses a gear drive system to move the focus elements of the lens; therefore it is a bit slower and noisier than a ring SWM system. Micro motor SWM systems are used in kit lenses, like the 18–55mm and 18–105mm lenses.

How can you tell if your lens uses a ring SWM or a micro motor SWM? A lens with a ring SWM allows you to choose between M/A and M. A lens with a micro motor SWM allows you to choose between A and M.

## Using Manual Focus Lenses on New Bodies

Almost all manual focus Nikon lenses beginning in the 1960s can be used on newer Nikon DSLR cameras (figure 3-9).

This also holds true for newer manual focus lenses from Nikon, like the 24mm PC-E tilt-shift lens, and other third-party manufacturers, like Zeiss Otus lenses and Samyang lenses. Obviously, these lenses don't allow AF, but they function fine with the exposure system.

Even though these manual focus lenses do not work with AF, the camera's Multi-CAM AF sensors are still active and will give you feedback about focus. Use the AF indicator in the lower left of the viewfinder to determine when you achieve focus, or you can use Live View to get the most accurate focus.

Figure 3-9: This manual focus Nikon 50mm f/1.2 lens works fine on all Nikon cameras from the 1960s to the present. It works only with manual focus. On lower-end cameras, like the D3300 or D5500, the lens won't allow auto exposure modes, but it works in manual exposure mode.

## VR System and Sharpness

One of the biggest reasons photographers get inconsistent results with image sharpness does not have anything to do with focus accuracy, but rather with camera movement. As I mentioned in chapter 2, the shutter speed impacts sharpness to a great extent. The faster the shutter speed, the less subject movement or camera shake during the exposure. Photographers who are not steady when they handhold their cameras can rely on the image stabilization technology that is built in to many Nikon lenses. Nikon calls their image stabilization technology VR, for vibration reduction (figure 3-10).

Not all Nikon lenses have VR capability. Nikon keeps improving their VR technology and generally refers to different generations as VR and VR II. The newest lens in the Nikon lineup is the 300mm f/4E PF ED VR lens. Nikon says it offers 4.5 stops of vibration reduction, while earlier VR lenses offered 2 to 3 stops of vibration reduction.

A 4.5-stop vibration reduction implies that if you could normally handhold a 300mm lens without VR at a shutter speed of 1/300 second (1/focal length), then turning on the VR system should allow you to handhold the same lens at a 4.5-stop longer shutter speed while still getting a sharp photograph. That means you should be able to handhold the 300mm lens at 1/15 second rather than 1/300 second. That's very impressive, and it's very useful when you try to take photographs without a tripod.

Figure 3-10: The VR settings on a Nikon AF-S 70–200mm f/4G ED VR lens

The best practice dictates that you give the VR system about one second to stabilize before you start taking photos because internal lens elements move to counteract camera shake. When you first activate the VR system, those lens elements move quite rapidly, and if you take a photo during that time you might get a little blur because of the movement.

Activate VR by either pressing the shutter-release button halfway or pressing the AF-ON button on newer higher-end cameras, such as the D810 and D4S. Older Nikon cameras allow VR activation only when you press the shutter-release button halfway.

Using VR on a tripod is a bit tricky. My general recommendation is to turn off VR when you use a tripod. The gyros in the lens are always looking for movement. If they don't find movement in the system, the elements will slowly move and could cause blurriness in

longer exposures. In fact, if you look through your tripod-mounted camera with VR enabled, you'll see the image slowly moving around the viewfinder. Unless your lens has a tripod VR mode or an action VR mode, turn VR off when your camera is mounted on a tripod.

One of the neat features of VR is that it detects panning motion. Panning is when you follow the horizontal movement of a subject, such as a vehicle driving from left to right. The VR system detects the side-to-side movement of the camera and works to suppress blur in the vertical direction, rather than the horizontal direction. Panning detection is enabled regardless of the camera orientation (vertical or horizontal) or the direction of the pan.

Some people think that if VR is on, they will automatically get sharp photos. Let's say you are shooting at 125mm zoom and have VR turned on. Assume the lens gives you a 3-stop VR advantage, so you should be able to handhold that focal length at a shutter speed of 1/15 second. If you are photographing a tree at 1/15 second, you should be able to get a sharp photograph.

On the other hand, if you are photographing a moving subject, like a baseball player or a running puppy, the 1/15 second shutter speed will result in a blurry photograph. This has nothing to do with VR working properly, but everything to do with the long shutter speed. At 1/15 second, the subjects' arms and

legs will blur as they run, even if you pan with the movement.

VR is most useful when you photograph static scenes. It doesn't prevent moving subjects from blurring; only a fast shutter speed will do that.

Similarly, if you use a fast shutter speed, you don't need to use VR. Typically I turn off VR when I handhold my camera and shoot at shutter speeds more than twice the focal length of the lens. For example, if I'm shooting at 400mm, I turn off VR if the shutter speed is faster than 1/800 second. If the shutter speed is slower than 1/800 second (e.g., 1/500 second or 1/125 second), I use VR.

There are three reasons I turn off VR when I shoot with fast shutter speeds:

- The fast shutter speed freezes camera shake and the subject's movement.
- Turning off VR saves battery life.
- I don't have to wait for the VR system to settle down before I take photographs. I can quickly lift the camera and immediately shoot.

Here's a little-known fact about the VR system: it uses different algorithms, called a dual algorithm, when you press the shutter-release button halfway and when you take a photograph. The following is quoted directly from the Nikon literature:

*"If you look at a fully blur-corrected image through a viewfinder for a long period of time, you may start to feel discomfort as if you were suffering from car sickness. To prevent this, Nikon developed an algorithm exclusively used during half-pressing of the shutter-release button. The algorithm suppresses blur correction at a slightly weaker level than usual so that you can comfortably continue to view the subjects within the viewfinder. When the shutter-release button is fully pressed, a different algorithm is employed, so that the blur-correction effect is maximized during exposure, providing the clearest results.*

*Nikon's VR (Vibration Reduction) employs an exclusive dual-algorithm system—one to provide an easy-to-see viewfinder image during half-pressing of the shutter-release button, and the other to conduct accurate blur compensation during exposure.*

*The instant the shutter is released, the algorithms are switched. The VR lens group is reset to the center of the optical axis from any off-centered position resulting from VR operation. Although the shift range of the VR lens unit is limited, centering of the lens ensures uniform shift in all directions, maximizing the VR effect as well as optical performance."*

If VR is turned on, it is also active during movie recording. I often use VR

when I shoot video of wildlife with my long lenses because it does a great job of damping out wind and vehicle vibrations.

Now let's look at the settings on VR lenses and when to use them:

- **Off:** VR is turned off and the lens operates as if it were a non-VR lens. I generally recommend setting VR to Off when the lens is mounted on a sturdy tripod. If you detect some shaking in the viewfinder when your camera is mounted on a tripod, set the switch to Normal.
- **On:** VR is turned on. If the only VR switch options on your lens are On or Off, then turning VR on will behave exactly like Normal VR (discussed next). Your lens might have another VR switch that allows you to choose between Normal and Active.
- **Normal:** Use this setting when you are standing on a stable platform, such as the ground or a floor. This mode reduces camera movements from your shaky hands and allows panning.
- **Active:** Use this setting when the platform you are shooting from is moving; for example, a boat, a car, or when you are walking while shooting video. In addition to reducing movement from shaky hands, this mode reduces larger up-and-down and

side-to-side movements caused by the moving platform.
- **Tripod:** This mode is available on bigger super-telephoto lenses, such as the 400mm f/2.8, 500mm f/4, 600mm f/4, and 800mm f/5.6. This mode differentiates between the frequency of the vibration resulting from camera shake and the motion caused by tripod shake. This mode also allows you to pan with the movement of a runner or a bird in flight while you use the VR system.
- **Sport:** This is a new setting on the Nikon 400mm f/2.8E FL ED VR lens. Use this setting when you need to pan the camera while it is mounted on a monopod or tripod. It produces sharp images of the subject while allowing motion blur in the background.

## IF Lenses

Internal focusing (IF) lenses achieve focus by shifting the optics inside the lens. This means the overall length of the lens and the physical size of the lens doesn't change during focusing.

External focusing lenses, which change length when they are focused, can cause problems with compositions, especially if your camera is mounted on a tripod. If the lens changes length while

you focus, the tripod head can shift slightly, especially if you are not using a high-quality head. The shift sometimes throws the composition off, so you have to recompose after you focus.

IF lenses tend to eliminate a phenomenon called focus breathing, which is a change of magnification and angle of view that occurs with a traditional lens. Using a lens that eliminates focus breathing matters in focus stacking (chapter 7) and when you shoot video.

With a traditional lens, the composition can sometimes change significantly as you focus, which probably means you'll need to recompose. IF lenses maintain the overall length of the optical system, so the apparent magnification of the subject and the overall angle of view is maintained throughout the focal range.

IF lenses are much easier to use when you adjust polarizing filters and graduated ND filters because the front element doesn't rotate. It can be frustrating to set up a polarizing filter for a scene, then focus, which causes the front element to rotate, and you have to adjust the filter again.

The basic types of lens focusing methods are IF, rear focusing (RF), and extension system.

### IF

In an IF lens, one of the optical groups in the middle of the lens, in front of the diaphragm/iris, moves during focusing. The physical length of the lens doesn't change, and the front element doesn't rotate. There is some decrease in focal length toward closer focus distances.

### RF

In an RF lens, one or more lens groups behind the diaphragm/iris move during focusing. These lenses are generally small and lightweight, so AF is faster. Some RF lenses change in overall length and others don't. If the length of an RF lens does not change while it focuses, it is also an IF lens.

### Extension System

In an extension system, all the front-end optical groups are shifted during focusing. This shifting causes the overall length of the lens to change during focusing and zooming, often in combination with a rotating front element. Because so much mass is moving, these types of lenses tend to focus slower, and they are generally larger and heavier. They also tend to have a deeper minimum focusing distance than a similar IF lens.

## Parfocal Lenses

Some photographers use a special technique to obtain accurate focus. They zoom in tight on a subject, focus, and then zoom back out to take the photo. For a portrait, the approach is to zoom in and focus on the subject's eye, then zoom out and take the photo. The logic is that when you zoom in,

you'll get a more accurate focus on the eye.

This process works only with a very few lenses that are called parfocal lenses. Most zoom lenses change the focus distance as the focal length changes. For example, with the Nikon 24–120mm lens, if you zoom in to 120mm and focus on a flower, and then zoom back out to take the photo, the flower will be out of focus. This focus-shifting behavior is most evident when you attempt to focus a scene at infinity. This technique works fairly well when you try to focus on something close to the lens—maybe within three or four feet—but when you try to focus on a subject that is farther away, the image will be blurry.

The best technique for focus consistency is to focus the lens *after* you set the focal length. For example, if you intend to take a photo at 35mm, you should focus after you zoom the lens to 35mm.

True parfocal lenses are expensive to build and are found mostly in cinema. A few Nikon AF lenses are parfocal lenses: 17–35mm f/2.8, 24–70mm f/2.8 AF-S, 70–200mm f/2.8 VR I (figure 3-11).

Figure 3-11: The Nikon 70–200mm f/2.8 VR I (not VR II) is a parfocal lens

## Focus Speed

How fast your lens focuses plays a big part in determining what type of subject matter is best suited for it. Many of the early model AF lenses, such as the old 300mm f/4 AF-D lens and the 85mm f/1.4 AF-D lens, tended to focus very slowly. The main reason these older lenses are so slow to focus is their lens elements are driven by a mechanical motor based in the camera. The motor translates the rotational input through a series of gears inside the lens.

All these lenses are very sharp, but because they focus so slowly they are difficult to use for sports or wildlife photography. The newer professional AF-S lenses generally focus much faster. If you compare the focusing speed of the 300mm AF-S lens to the 300mm AF-D lens, the difference is night and day.

One of Nikon's iconic lenses was the first-generation 80–400mm f/4.5–5.6 AF-D. Photographers used this lens for years but became frustrated because of its slow focusing speed. I often had clients bring this lens on safaris in Africa only to discover they could not track birds in flight or sometimes even animals as slow as elephants. The new version of this lens, the 80–400mm f/4.5–5.6

AF-S VR II (figure 3-12), has a very fast focusing speed because of the SWM.

Just because a lens is an AF-S lens doesn't necessarily mean it will focus quickly. Many lower-end Nikon variable aperture zooms are AF-S lenses, but they focus very slowly. For example, kit lenses like the 18–55mm, 18–70mm, 18–105mm, and 18–140mm don't focus anywhere near as fast as the more expensive f/4 and f/2.8 lenses. The moral of the story is that if you need a lens that focuses fast, you need to spend a bit of money to buy expensive f/4, f/2.8, or faster AF-S lenses.

Figure 3-12: The new Nikon 80–400mm f/4.5–5.6 AF-S VR II lens (*left*) focuses two to three times faster than the older 80–400mm f/4.5–5.6 AF-S VR lens (*right*)

## Cable Releases and Remote Triggers

Cable releases (figure 3-13) are typically used for macro photography and long exposure photography when camera stability is of utmost importance. Rather than pressing the shutter-release button with your finger and causing the camera and tripod to move, it is better to use a cable release so your hand is not touching the camera while you take the photograph.

Lots of photographers who use a cable release for the first time are surprised that the camera automatically focuses when they press the cable release button. The cable release behaves like a shutter-release button, so it will not activate AF if you use the

Figure 3-13: The Nikon MC-30 is a simple and relatively inexpensive cable release for higher-end pro and semi-pro cameras

back-button focus technique I described in chapter 2.

If you use the shutter-release button to focus, the best practice is to turn the AF switch to manual before you use the cable release to take a photograph. This prevents you from refocusing the camera after you spend time and effort to obtain critical focus.

An alternate technique when you use a cable release is to AF while you look through the viewfinder, then use the AF-L button to lock the focus. Keep in mind that if you press the AF-L button to lock focus, it remembers the focus lock only as long as the camera light meter stays on, typically between six and eight seconds.

Nikon also sells a variety of remote releases, such as the ML-L3 infrared remote (figure 3-14) and the WR-T10 and WR-1 wireless remotes. The remotes have different functionalities, but they generally behave the same way with respect to AF. The best practice when you use a remote release is to turn the AF selector switches to manual so the remote release won't activate AF.

Figure 3-14: The Nikon ML-L3 infrared remote control works with consumer and prosumer Nikon DSLR cameras, like the D3300 and D750

# 4

# Field Techniques, Methods, and Tips

In this chapter I will go through a variety of common subjects and describe the best practices for techniques and the settings you should use. My goal is to give you solid AF setting recommendations for each type of photography you'll encounter. You can dial these settings into your camera system to help you capture sharp images.

# Outdoor Sports: Football

# Important Camera Settings

| Function | Setting |
|---|---|
| AF servo | AF-C |
| AF area | d-21 or group-area AF |
| Shooting mode | Continuous high |
| Exposure mode | Aperture priority or shutter priority |
| ISO | Auto ISO |
| Shutter speed range | 1/1000 second to 1/8000 second |
| Lens VR setting | Normal |
| Focus tracking with lock-on | Long |

## Comments

A focal length of 400mm is perfect for football photography. I suggest using the AF-S 80–400mm f/4.5–5.6, the 200–400mm f/4, or the 400mm f/2.8 lenses. Make sure you have a second body mounted with a 70–200mm f/2.8 lens to capture the closer action.

Use a shutter speed of 1/000 second or faster. Shoot in aperture priority mode with auto ISO turned on, or shoot in shutter priority mode at 1/1000 second.

Because you are shooting football players who are running, be sure to keep the focus servo set at AF-C in conjunction with a continuous high frame rate. As the play unfolds, track the subject with AF by pressing the AF-ON button (or press the shutter-release button halfway), then fully press the shutter-release button to take a burst of photographs at the peak of action. On newer cameras, I really like shooting group-area AF or d-21. On older cameras, I suggest d-21. If you use an entry-level camera, I suggest shooting in dynamic-area AF.

If you want to photograph a specific player, maybe the quarterback, set Focus tracking with lock-on to Long.

Use a monopod to help support heavier lenses and keep you from getting fatigued. A monopod is much easier to use than a tripod when you need to move around on the field or along the sidelines.

# Important Camera Settings

| Function | Setting |
|---|---|
| AF servo | AF-C |
| AF area | d-21 or group-area AF |
| Shooting mode | Continuous high |
| Exposure mode | Aperture priority or shutter priority |
| ISO | Auto ISO |
| Shutter speed range | 1/1000 second to 1/8000 second |
| Lens VR setting | Normal |
| Focus tracking with lock-on | Long |

## Comments

For running sports, keep your camera in AF-C servo. On newer cameras, I suggest group-area AF. On older cameras, I suggest d-21. If you are shooting with an entry-level camera, I suggest dynamic-area AF.

Use the continuous high frame rate so you'll have a better chance of capturing the peak action. Use shutter speeds of at least 1/1000 second for running, shot put, and discus.

If you can shoot on the field, you can get away with a 70–200mm or 70–300mm lens. If not, you'll need at least a 400mm lens.

I like using a monopod for track and field because it allows me to move quickly while I adjust my camera height from low to high.

For jumping events, if you can get down to the pit, try setting up your camera on a mini-pod low to the ground. Then prefocus your lens, set it to manual focus, and trigger the shutter with a remote or cable release.

One tip is to get a heat sheet that shows which events are happening at what time. This will help you get in the correct position before the event starts.

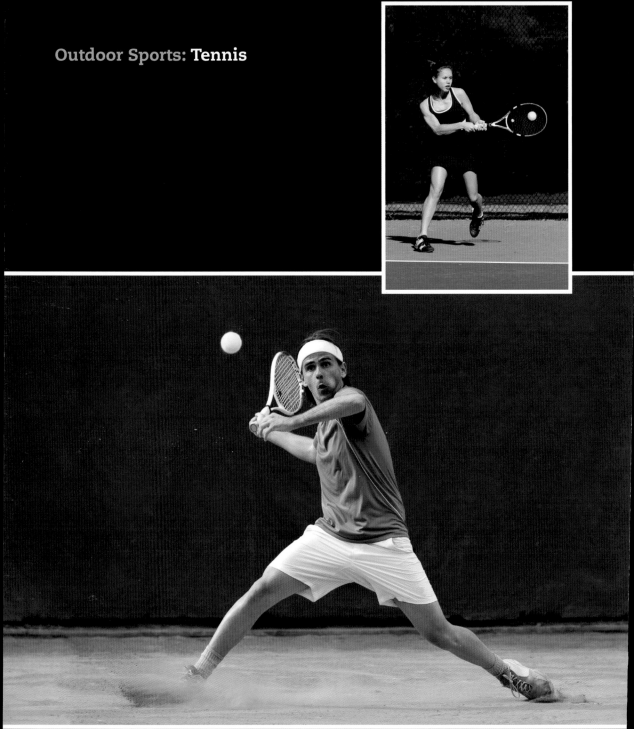

# Important Camera Settings

| Function | Setting |
|---|---|
| AF servo | AF-C |
| AF area | d-21, d-51, or group-area AF |
| Shooting mode | Continuous high |
| Exposure mode | Aperture priority or shutter priority |
| ISO | Auto ISO |
| Shutter speed range | 1/1000 second to 1/8000 second |
| Lens VR setting | Normal |
| Focus tracking with lock-on | Off |

## Comments

I recommend AF-C servo for most tennis photography. Switch to AF-S for photographs when a player is resting on a bench. If you use the back-button focus technique, leave the camera in AF-C mode all the time.

If you can shoot from a position where you don't have a lot of background interference, use a bigger dynamic-area AF field like d-21 or d-51. For example, if you are shooting from a higher position, such as in the stands, you could use d-51 because you'll be shooting down toward the court.

If you are shooting from a lower position at courtside, d-51 could get you into trouble when the sensor field crosses past one of the line judges or ball boys. I recommend d-21 or group-area AF when you shoot from a lower perspective.

Use fast shutter speeds of at least 1/1000 second, and try to time your shots so they include the ball in the frame.

The best overall focal length for tennis is about 300mm. I like shooting with the 80–400mm or 200–400mm lenses. The 70–200mm or 70–300mm lenses will also work.

# Important Camera Settings

| Function | Setting |
|---|---|
| AF servo | AF-C |
| AF area | Single or d-9 |
| Shooting mode | Continuous high |
| Exposure mode | Manual or shutter priority |
| ISO | Auto ISO (6400 or higher) |
| Shutter speed range | 1/1000 second |
| Lens VR setting | Normal |
| Focus tracking with lock-on | Long if tracking a single player |

## Comments

Basketball is one of the most difficult sports to photograph. Usually basketball gyms are dark, the lighting is terrible, and you can't use flash because the players are too far from where you're sitting. Getting shots like those in *Sports Illustrated* is nearly impossible for amateur photographers because professional photographers have worked with the arena before and have mounted their own strobes (flash units) in the rafters. The pros trigger their flashes with radio triggers. The fast pulses of the strobes freeze the motion of the players.

For the rest of us mere mortals, we have to work with high ISOs and slower shutter speeds. To get around these limitations, shoot with f/1.8 or f/1.4 prime lenses. If you can sit under one of the basketball hoops, you can use a 35mm f/1.4 lens on one camera body for close action and a longer lens, like a 200mm f/2 or 300mm f/2.8, for shots of players at the other end of the court.

Set the ISO to 6400 or higher, and shoot with a wide-open aperture. The goal is to get the fastest shutter speed possible, preferably 1/1000 second or faster. If this won't work, then 1/500 second will do, but your sharpest pictures will occur at the peak of action, like when a player is at the top of a jump.

Use AF-C servo. I also recommend single-area or d-9 because players are close together and the larger focus patterns might start tracking other players in the focus group. Use the Long setting for Focus tracking with lock-on if you are shooting a single player.

Shoot in a vertical orientation, and use the bottom focus points for high school and college players. You don't want them to jump out of the frame when you shoot from a low position or when you try to capture a dunk. Allow vertical space so the players' hands stay in the frame.

# Indoor Events: **Dance and Bands**

# Important Camera Settings

| Function | Setting |
|---|---|
| AF servo | AF-C |
| AF area | Group-area AF or d-21 |
| Shooting mode | Continuous high |
| Exposure mode | Aperture priority |
| ISO | Auto ISO (3200 or higher) |
| Shutter speed range | As fast as possible; 1/15 second to 1/30 second for deliberate motion blur |
| Lens VR setting | Normal |
| Focus tracking with lock-on | Off |

## Comments

In this type of situation, you're probably photographing in a studio or on a stage under spotlights or dramatic lighting with lots of different colors and brightness levels. The light is generally low, so your shutter speeds will often vary between 1/10 second and 1/250 second. You'll need to use every trick in your arsenal to keep your camera as steady as possible.

Shoot with your lens wide open to allow the most light into the camera. Try to time the release of the shutter so it coincides with the peak of action, such as the top of a jump when a dancer is still. This will help reduce motion blur from longer shutter speeds.

Pan with the motion whenever possible. Roll your finger over the shutter button; don't stab it, or you'll get motion blur from camera movement. Also, hold your breath while you shoot for maximum stability. Take a burst of shots, and one of them will probably be sharp.

I suggest group-area AF if your camera has it; otherwise use d-21. Use AF-C while a performer is moving, and lock focus when the performer pauses. If you use the AF-ON button (back-button focus), simply remove your thumb from the AF-ON button to lock focus when a dancer stops.

The dynamic range on a stage can vary as much as 10 to 15 stops, depending on the lighting and where the dancer is located on stage, so pay attention to areas in the scene that may result in blown-out highlights.

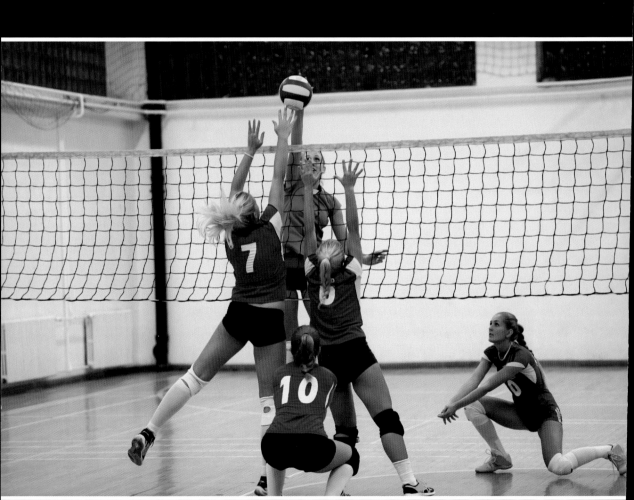

# Important Camera Settings

| Function | Setting |
|---|---|
| AF servo | AF-C |
| AF area | Single or group-area AF |
| Shooting mode | Continuous high |
| Exposure mode | Aperture priority |
| ISO | 3200 or higher |
| Shutter speed range | 1/500 second or faster |
| Lens VR setting | Normal |
| Focus tracking with lock-on | Long |

## Comments

Camera settings for indoor volleyball are very similar to basketball. The main issue is dim lighting, so use a very high ISO (3200 or higher) and a big aperture (f/1.4 or f/2.8).

I suggest using fast prime lenses, like the 50mm f/1.4 and 85mm f/1.4 lenses, for the best results. If you need the reach, use a 70–200mm f/2.8 lens, but know that you'll lose 2 stops of light at f/2.8 versus f/1.4.

Follow the ball and shoot in short bursts in continuous high frame rate. Use normal VR to help eliminate blur from camera shake, and time your shots to coincide with the peak of action, like when the athlete is at the top of a jump.

As with basketball, shoot in the vertical orientation and keep the focus points on the lower side of the frame when you shoot individual players. This allows players to jump without their hands leaving the frame. If you want to shoot three or four players, shoot in the horizontal orientation.

Use group-area AF or single-point AF for the best results. Volleyball is a very fast sport, and sometimes a larger focus pattern, like d-39 or d-51, can lead to poor AF performance because too many players are in the focus field. Keep the focus field smaller, and you'll capture better volleyball shots.

# Birds in Flight

# Important Camera Settings

| Function | Setting |
|---|---|
| AF servo | AF-C |
| AF area | d-21, d-9, or group-area AF |
| Shooting mode | Continuous high |
| Exposure mode | Aperture priority |
| ISO | 400 to 1600 |
| Shutter speed range | 1/1000 second to freeze motion; 1/60 second for panning blur |
| Lens VR setting | Tripod or off |
| Focus tracking with lock-on | Off |

## Comments

Use AF-C and group-area AF, d-21, or d-9, depending on the size of the bird and how fast it flies. Smaller birds are very difficult to focus on because of their erratic movements, so sometimes AF might not be possible. Photographing bigger birds like seagulls and eagles is much easier because of their slower movements and larger size.

Try to keep the AF point on the eye of the bird. The DOF is very shallow for long lenses, and if you don't focus on the eye, the entire shot will be ruined. To help deal with this, I suggest that you shoot with an aperture between f/8 and f/16 to get a bit more DOF.

Most bird photographers use 600mm or 800mm lenses, so fast shutter speeds and proper long lens technique are paramount. Long lens technique dictates that you lay your arm across the top of the lens to help dampen camera shake. For the best results, use a sturdy tripod with a gimbal head. A gimbal will help tremendously when you are panning. You can also use a ball head, but panning is more difficult because the camera and lens tend to flop over on their side.

If you handhold your camera, be sure to keep your elbows in tight against your body. Keep your knees slightly bent, and rotate your entire torso to track the bird. Track the focus (use AF-C mode) with the AF-ON button, then shoot a burst of images at the peak of the action.

If you use a teleconverter, remember that it will slow down your AF performance. I find that a 1.4x teleconverter slows the AF almost imperceptibly, and 1.7x and 2.0x teleconverters slow the AF enough to negatively impact AF performance in lower light.

# Landscapes

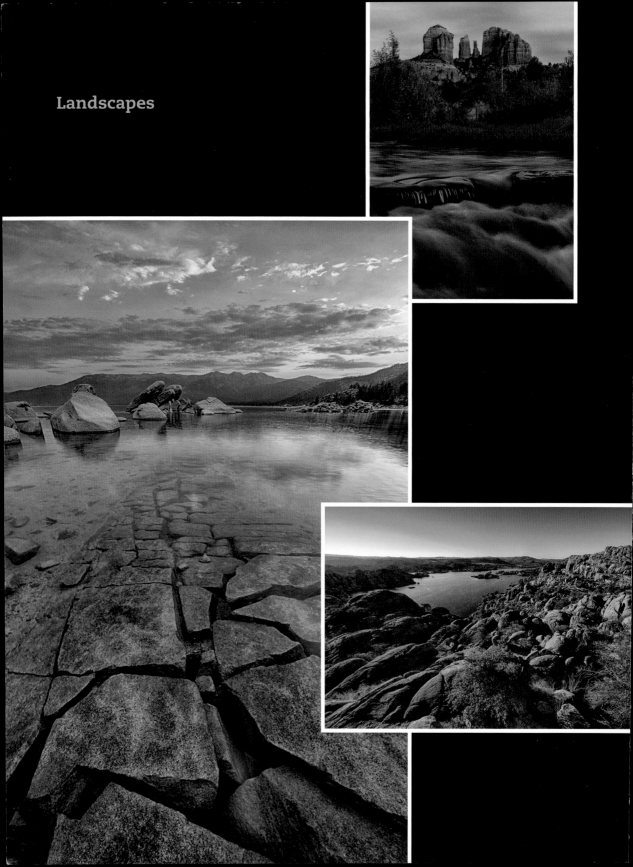

## Important Camera Settings

| Function | Setting |
|---|---|
| AF servo | AF-S |
| AF area | Single |
| Shooting mode | Single |
| Exposure mode | Manual or aperture priority |
| ISO | 100 |
| Shutter speed range | N/A |
| Lens VR setting | Off (assuming you are using a tripod) |
| Focus tracking with lock-on | N/A |

### Comments

Landscape photography is all about maximizing the DOF and maintaining sharpness from the front to the back of the frame.

AF-S mode works fine for landscapes if you are a front-button focuser. If you are a back-button focuser and use the AF-ON button, use AF-C, as described in chapter 2.

Single-point AF makes the most sense for landscapes because the scene doesn't move, so you can precisely choose a focus point to maximize the DOF. Focus at the hyperfocal distance (chapter 7), and use the hyperfocal distance markers on the lens to set the aperture.

Remember that very small apertures results in light diffraction, which leads to reduced image sharpness. You might be tempted to use f/22 or f/32, but past f/16 or so you lose sharpness that you might otherwise gain through additional DOF.

# Important Camera Settings

| Function | Setting |
| --- | --- |
| AF servo | AF-S |
| AF area | Single, d-9, or d-21 |
| Shooting mode | Single or continuous high |
| Exposure mode | Aperture priority |
| ISO | 100 to 400 |
| Shutter speed range | As conditions merit |
| Lens VR setting | Normal |
| Focus tracking with lock-on | Off |

## Comments

The most important thing to focus on when you shoot portraits is the subject's eye. If you shoot with a fast lens, like the 85mm f/1.4 lens, you need to be very careful about focusing critically so you don't accidentally focus on the nose or forehead.

When you shoot groups, use a smaller aperture like f/8 or f/11 to gain more DOF, and focus about one third of the way into the group to maximize the DOF. In group portraiture, you don't necessarily focus on anyone specifically; rather, you focus into the group to maximize the fact that one third of the DOF occurs in front of the focus point and two thirds of the DOF occurs behind the focus point.

For portrait photography, I generally like to use single-point AF or any of the dynamic AF modes, like d-9 or d-21, that use a priority focus point. Quite often you need to focus then recompose so the subject is on the left or right of the composition. Therefore, use AF-S mode if you are a front-button focuser, or AF-C mode if you are a back-button focuser.

When you shoot a wedding, there may be times when you need to shoot in continuous AF (AF-C). For example, when the bride is walking down the aisle or when people are dancing at the reception, you need to track their movement with AF-C. However, most of the time you'll use AF-S mode because a portrait subject will pose on a stool or in a standing position. Again, if you're a back-button focuser, you can leave the camera in AF-C mode to get the best of both worlds for moving and stationary portraits.

I keep my camera in continuous high frame rate so I can shoot bursts if necessary. If you use flash in your portraiture work, I suggest staying in single-shot mode; otherwise your flash units won't be able to recycle fast enough to keep up with a fast frame rate.

# Important Camera Settings

| Function | Setting |
|---|---|
| AF servo | Manual or AF-C |
| AF area | N/A or auto-area AF |
| Shooting mode | Continuous high |
| Exposure mode | Aperture priority |
| ISO | 800 to 3200 |
| Shutter speed range | 1/60 second to 1/500 second |
| Lens VR setting | Normal |
| Focus tracking with lock-on | Off |

## Comments

In street photography, you often have little time to compose and shoot. For this reason I suggest using a wide-angle prime lens with a focal length of 24mm or 35mm. The best street images are those in which you are very close to the subject. This requires an intimacy that you might be uncomfortable with, so you'll need to practice.

If you are walking through the city streets and are trying to get photographs of people in close proximity to you, it is common practice to prefocus your lens to a certain distance then lift the camera and shoot without looking through the viewfinder. This technique is called zone focusing. The idea is that you set your lens to f/5.6 or f/8 for a bit of DOF and prefocus your lens to four or five feet. Then, as you walk by someone on the street, you can quickly lift the camera and snap the photograph without waiting for AF to lock.

If you are not comfortable shooting people in such close proximity and want to use AF, I recommend setting the AF mode to group-area AF or auto-area AF. Both modes allow the camera to do a lot of work for you. The upside of auto-area AF is you don't have to aim the camera very accurately. The downside is that the camera might focus on something you don't want it to. Auto-area AF often focuses on background elements or bright shiny objects rather than the person you're trying to photograph.

One final recommendation is to stop walking when you take a photograph. This technique will help you keep the camera steady to prevent motion blur. You'll walk, briefly halt midstride to take a photo, and then resume walking.

# Important Camera Settings

| Function | Setting |
|---|---|
| AF servo | Manual |
| AF area | N/A or single |
| Shooting mode | Single |
| Exposure mode | Aperture priority |
| ISO | 100 |
| Shutter speed range | 1/125 second if handholding |
| Lens VR setting | Off or normal |
| Focus tracking with lock-on | Off |

## Comments

For macro photography, most accomplished photographers do not use AF. Rather, they use manual focus and move the camera back and forth to fine-tune the focus. Because the DOF of macro lenses is often shallow, it is sometimes nearly impossible for the AF system to accurately pinpoint the focus exactly where you need it.

For example, if you're photographing spiders, sometimes you want the AF to land on the front eyeball of the spider rather than the third eyeball back. Shoot at f/16 or f/22 to get the maximum DOF. To increase the DOF, you might consider using focus stacking (chapter 7).

If you are handholding a VR lens, I recommend setting it to normal VR mode. Rotate the lens focus barrel to the minimum focus distance, and move the camera back and forth until you are happy with the focus. If you are photographing a stationary subject, like a flower, you might consider mounting your camera on a focusing rail, which will allow you to accurately position the camera with gear-driven sliders.

Working in the field with plants and flowers presents special challenges because of environmental factors such as wind. I suggest using the fastest shutter speed possible to prevent motion blur.

Use a longer lens when you photograph skittish bugs like butterflies. For most macro work, a 90mm or 105mm macro lens is ideal. If you need a longer working space, use a 200mm macro lens.

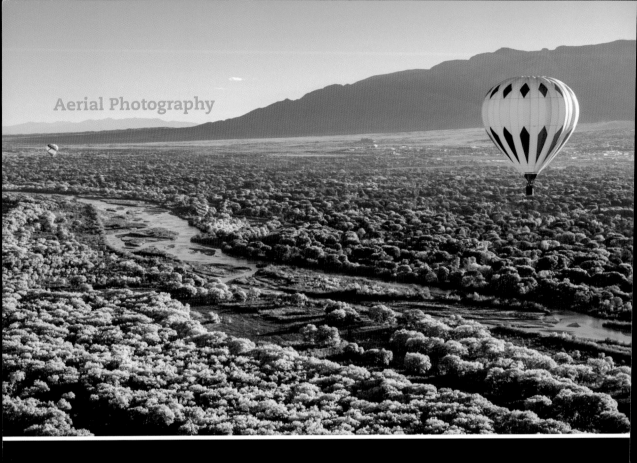

# Important Camera Settings

| Function | Setting |
|---|---|
| AF servo | Manual |
| AF area | N/A |
| Shooting mode | Continuous high |
| Exposure mode | Aperture priority |
| ISO | 100 to 3200 |
| Shutter speed range | 1/500 second to 1/8000 second |
| Lens VR setting | Active |
| Focus tracking with lock-on | Off |

## Comments

Aerial photography encompasses quite a few disciplines, including shooting from a moving airplane, helicopter, or hot air balloon. It also includes photographing the landscape from the air or photographing aircraft from inside another aircraft.

Creating sharp images from an airplane or helicopter requires you to reduce vibrations while focusing accurately on your subject.

The most common problem encountered when shooting from helicopters and small airplanes is not using a fast enough shutter speed to prevent motion blur from the vibration of the aircraft. The two most important tips are: Shoot at the fastest possible shutter speed and don't lean against the vibrating aircraft.

I suggest shooting at a minimum shutter speed of 1/500 s or faster. Speeds of 1/2000 s and faster will improve the sharpness of the image. Use a higher ISO setting if you need faster shutter speeds. Use active VR to further eliminate vibration.

When you're in an airplane, you're often at least 1,000 feet above the ground. At this height, the focus distance to the ground is effectively infinity. Set your camera at the infinity mark on your lens and leave it there for your entire photo shoot. Many photographers manually set their lenses to infinity and use gaffer's tape on the focus ring to prevent it from rotating.

Use AF as you get closer to the ground, especially with a longer lens, like the 70–200mm or 300mm f/2.8. If you end up photographing other airplanes while you're in the air, use AF to track the movements.

When shooting through a window, shoot at a wide aperture, like f/2.8 or f/4. It's common for the glass to have scratches and grime, so a wide aperture will limit the DOF to help ensure that the blemishes won't show in your final images. If you are lucky enough to shoot in an aircraft without a door or window, use apertures of f/5.6 to f/8 to maximize the sharpness of your lens.

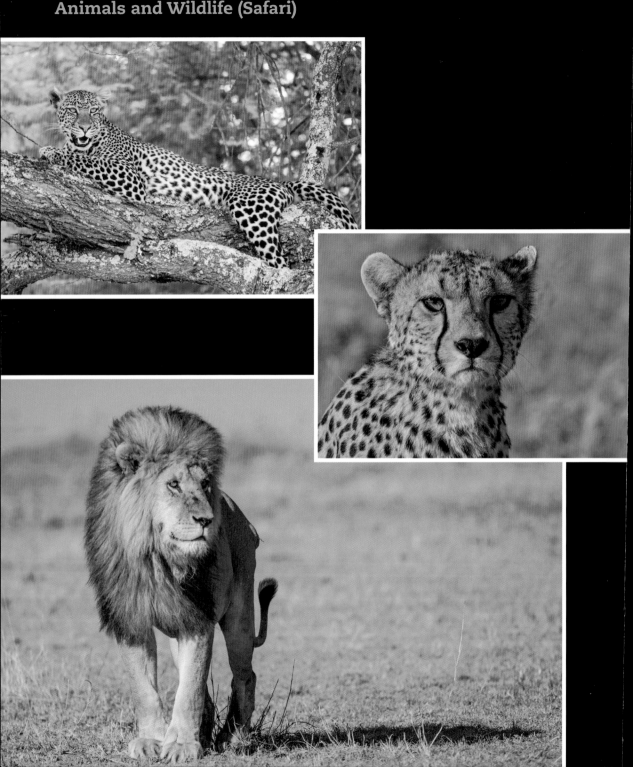

# Important Camera Settings

| Function | Setting |
| --- | --- |
| AF servo | AF-C |
| AF area | d-21 or group-area AF |
| Shooting mode | Continuous high |
| Exposure mode | Aperture priority |
| ISO | 100 to 3200 |
| Shutter speed range | 1/60 second to 1/2000 second |
| Lens VR setting | Normal or active |
| Focus tracking with lock-on | Off |

## Comments

Great wildlife photography often takes dedication, patience, and sometimes really long lenses. Most photographers underestimate the skill required to shoot with long lenses and obtain sharp images. The longer the lens, the more practice and skill is needed to capture crisp images because small movements at the camera translate to blur in the photo.

One of the most important requirements for sharp photographs is to use a very sturdy tripod with a top-of-the-line ball head. If you shoot wildlife from a vehicle, I highly recommend that you use a beanbag designed specifically for photography. In either case, you'll need to learn and practice proper long lens technique. This means you drape your arm over the top of the lens to add mass and therefore reduce vibrations while you take photographs. Simultaneously press your head against the back of the camera and hold your breath before you shoot to increase your chances of capturing a sharp image.

I recommend using d-21 or group-area AF for faster moving single animals. Usually d-21works well for most situations in wildlife photography, and it will help if the animal zigs while you zag. Shoot in AF-C mode so you can track the animal if it moves.

Use a high enough ISO so the shutter speed freezes the motion of the animal. For large mammals, you can often get away with 1/60 second. For smaller animals like foxes and squirrels, use a shutter speed of 1/250 second or 1/500 second.

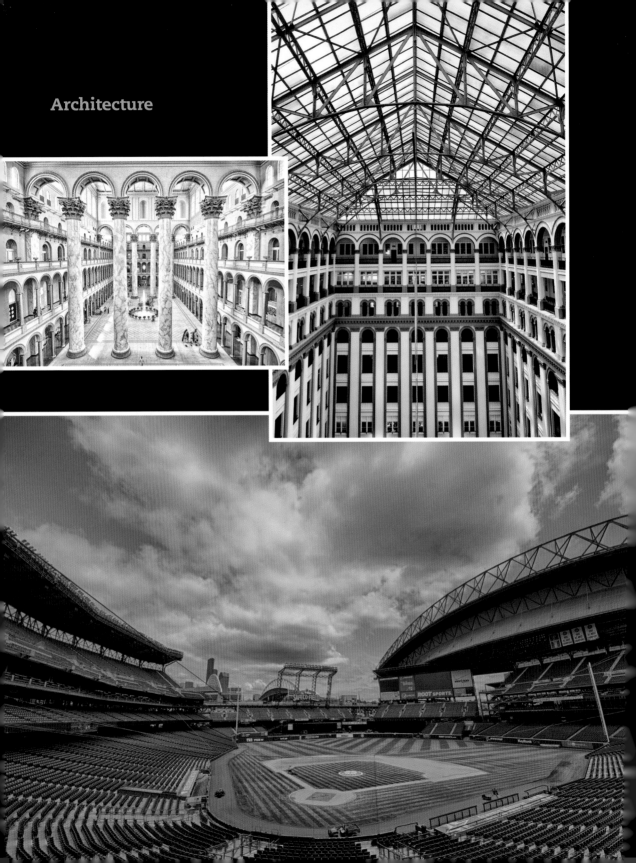

Architecture

# Important Camera Settings

| Function | Setting |
| --- | --- |
| AF servo | AF-S |
| AF area | Single (d-21 if you use AF-C and AF-ON) |
| Shooting mode | Single |
| Exposure mode | Aperture priority |
| ISO | 100 |
| Shutter speed range | 1 second to 1/250 second |
| Lens VR setting | Off |
| Focus tracking with lock-on | Off |

## Comments

Because architectural subjects don't move, AF is fairly simple. I recommend using single-point AF and AF-S servo. Use a low ISO and a small aperture, like f/16, to maximize the DOF. Learn how to use a DOF table to make sure the scene is in focus from front to rear.

If possible, use a sturdy tripod to keep the camera steady during long exposures.

## Important Camera Settings

| Function | Setting |
|---|---|
| AF servo | Manual |
| AF area | N/A |
| Shooting mode | Single |
| Exposure mode | Manual or aperture priority |
| ISO | 100 to 1600 |
| Shutter speed range | 30 seconds to 1/15 second |
| Lens VR setting | Off |
| Focus tracking with lock-on | Off |

### Comments

Photography at night presents a whole new set of challenges for AF. Remember from chapter 1 that the AF system requires three things: light, contrast, and distinct lines. At night the light is missing, so most night photography requires the camera to be in manual focus. Set either the lens or the camera to manual focus, and use the focus values on the focus ring to estimate distances.

If you want to use AF at night, bring a flashlight or headlamp and shine it on the subject while you use AF.

The shutter speeds will vary between 30 seconds and 1/15 second, so a sturdy tripod is essential. I recommend using a low ISO (100 or 200) to keep noise to a minimum. Use a higher ISO if you need to include stars in the scene.

When you compose a shot, be careful not to place large dark areas in the frame. They will show up as large swaths of black in your photo and will generally detract from the overall composition. Try to fill those areas with a building, a car, or a person. Another option is to "paint" the scene with a flashlight to fill in the shadows.

Underwater

# Important Camera Settings

| Function | Setting |
| --- | --- |
| AF servo | Manual or AF-C |
| AF area | Single |
| Shooting mode | Continuous high |
| Exposure mode | Aperture priority |
| ISO | 200 to 800 |
| Shutter speed range | 1/30 second to 1/125 second |
| Lens VR setting | N/A |
| Focus tracking with lock-on | Off |

## Comments

If you want to use your DSLR for underwater photography, you'll need to invest in a polycarbonate waterproof housing from a company like Aquatica, Sea & Sea, or AquaTech.

It is sometimes difficult to look through the viewfinder while you wear a mask and related gear, so many photographers prefocus the lens to a certain distance, like two feet, and use a smaller aperture like f/11 or f/22 to gain some DOF. When it is time to take the picture, they position the camera two feet from the subject and compose the photograph at arm's length. Wide-angle lenses from 10mm to 20mm work well with this technique.

If you want to do more macro and closeup photography, you'll need to shoot with 90mm to 105mm lenses. They can be difficult to use underwater because the DOF is very shallow. It makes sense to use AF with longer lenses, and I generally recommend single-point AF.

Remember that the water absorbs sunlight very quickly, so AF can be difficult at depth. One trick is to use a focus light (flashlight) to illuminate the subject while you engage the AF system. Because there is no significant ambient light, you frequently need to rely on strobes to light the subject.

# Adventure Sports: Point of View

# Important Camera Settings

| Function | Setting |
|---|---|
| AF servo | AF-S or AF-C |
| AF area | Auto-area AF or d-21 |
| Shooting mode | Continuous high |
| Exposure mode | Aperture priority |
| ISO | 100 to 3200 |
| Shutter speed range | 1/15 second to 1/8000 second |
| Lens VR setting | Active |
| Focus tracking with lock-on | Long |

## Comments

Shooting great images outdoors while surfing, climbing, hiking, or skiing can be very difficult. The late Galen Rowell was one of the first photographers to combine a love of outdoor sports with dramatic photography. He was a master at photographing rock climbing while he himself was rock climbing.

With the invention of tiny sports cameras like the GoPro, it is now easy to document your adventures. However, these small cameras have significant limitations, and if you want the most impressive adventure photographs you'll be better off using your DSLR.

Oftentimes when you are participating in a sport like kayaking, hiking, climbing, and hang gliding, your hands are busy doing important things—like keeping you alive. Since photography often has to take a backseat to the task at hand, I like to set up my camera to operate in a more automated fashion than I normally would use.

For these intense action sports, I suggest using auto-area AF or d-21. Some action sport photographers find that front-button focus is easier to use than back-button focus because it can be difficult to handhold a camera with one hand while pressing the AF-ON button.

Keep the shutter speed and ISO higher, use a bigger aperture than you normally would, and set the VR to active.

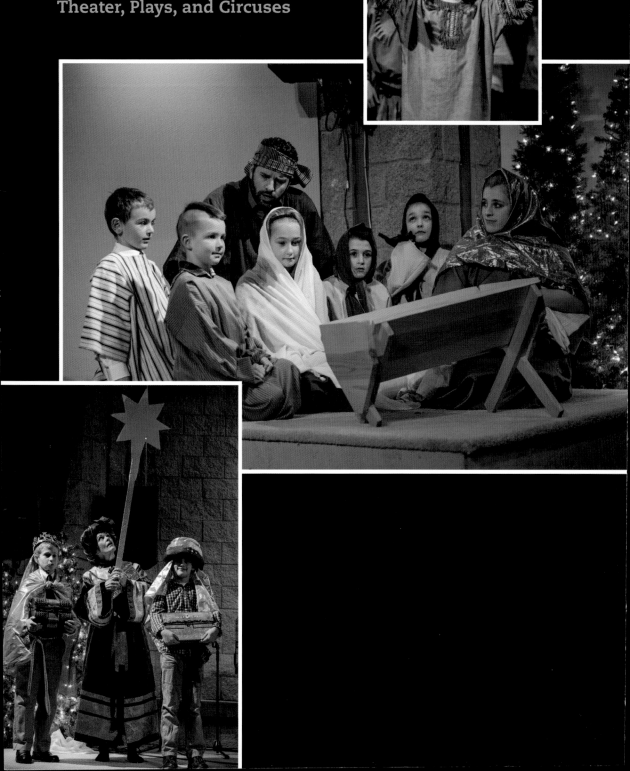

# Important Camera Settings

| Function | Setting |
|---|---|
| AF servo | AF-S |
| AF area | Single (d-9 if you use AF-C and AF-ON) |
| Shooting mode | Continuous high |
| Exposure mode | Aperture priority |
| ISO | 1600 to 6400 |
| Shutter speed range | 1/15 second to 1/125 second |
| Lens VR setting | Normal |
| Focus tracking with lock-on | Off |

## Comments

Stage productions typically have very low light levels, so it's challenging to use a long enough shutter speed. Speeds longer than 1/40 second will result in motion blur from the actors. You also need to pay close attention to motion blur from camera movement. To counter this, be sure to use a high ISO (1600 or higher), a large aperture (f/2.8), and set the VR to normal mode.

AF will respond slower in low light, but you'll get better AF performance when you use f/2.8 and faster lenses. Slower lenses, like variable aperture zooms, often hunt for focus due to the f/5.6 or f/6.3 maximum aperture at the long end of the zoom range.

I like to use d-9 or single-area AF when I photograph stage performances so I can focus on the faces of individual performers. Most stage events are fairly slow moving, so you don't need the d-51 or auto-area AF modes to track moving subjects. In fact, d-51 and auto-area AF can work against you because they don't know what specific thing you are trying to focus on.

If possible, I use a monopod when I shoot indoor performances. Tripods are generally not allowed, but monopods hardly ever get turned down at events, especially if they look like a walking stick. Use a monopod in conjunction with VR so you can take pictures down to a shutter speed of 1/15 second and still get reasonably sharp photos. Keep in mind that although you might be able to steady your camera at longer shutter speeds, an actor on stage might be blurry because of movement. Therefore, try to time your shots at the peak of action or during a pause in the acting.

Most of the time it's not practical to use a flash because you'll be in the audience at some distance from the stage. If the production is fairly small, it is probably OK to use flash. If you are at a big production, a flash will be annoying for everyone else in the theater. My recommendation is to use a high ISO and call it good.

# Important Camera Settings

| Function | Setting |
|---|---|
| AF servo | Manual |
| AF area | N/A |
| Shooting mode | Single |
| Exposure mode | Aperture priority |
| ISO | 100 to 1600 |
| Shutter speed range | 1/15 second to 1/8000 second |
| Lens VR setting | Off |
| Focus tracking with lock-on | N/A |

## Comments

Shooting panoramas in the era of digital photography requires you to take a series of photographs then merge them in software. For the software to work properly, it looks for similar pixels in different frames then overlaps them. If the pixels are focused the same, the software can easily align the images. If the same pixels in one photo are sharp, but they are blurry in the next photo, the software won't be able to align the images. Therefore, make sure the focus distance stays consistent from shot to shot.

To do this, I suggest shooting panoramas in manual focus mode. Make sure to focus at the hyperfocal distance (chapter 7) to maintain the appropriate DOF for the entire scene, and then switch to manual focus for each shot in the sequence.

Most photographers use a tripod for panoramas to maintain control over the overlapped portion of each frame. I think this is a good idea, but I frequently shoot panoramas handheld when I don't have my tripod with me. In these cases, I watch my shutter speed closely to make sure I can effectively handhold the camera without shaking it. I also overlap each photo a bit more than I would when I use a tripod.

My final tip for panoramas isn't related to AF or sharpness: make sure to lock the exposure and white balance. You want all shots in the sequence to have the same DOF (focus), the same exposure value, and the same color (white balance).

# HDR Images

## Important Camera Settings

| Function | Setting |
|---|---|
| AF servo | Manual |
| AF area | N/A |
| Shooting mode | Continuous high |
| Exposure mode | Aperture priority |
| ISO | 100 to 400 |
| Shutter speed range | 1 second to 1/8000 second |
| Lens VR setting | Off |
| Focus tracking with lock-on | Off |

### Comments

To create a high dynamic range (HDR) image, you take a series of photos at different exposure (brightness) levels then merge them in software. Similar to panoramas, make sure the overlapping pixels in the sequence of images have the same sharpness level.

To ensure consistency from shot to shot, take the sequence of photographs in manual focus mode. That will prevent the camera from shifting focus between shots. Also, set your camera's bracketing settings to change the shutter speed rather than the aperture from shot to shot. If the apertures in the shots are different, the DOF in each image will be different, and the software won't be able to align the photos.

Since you'll most likely use a tripod for the photo sequence, you won't need to worry too much about camera movement, but be aware that at long shutter speeds, elements in the scene like leaves or water might shift from shot to shot. This causes ghosting in the final image, but it can be corrected in most software.

Finally, be sure to turn off VR if your lens has it. If you keep VR turned on, each shot in the sequence will have a slightly different composition.

# Tripod Techniques

## Comments

The best advice I can give you about a tripod is to buy the strongest and sturdiest tripod you are willing to use. If you go to the trouble of using a tripod, make sure the tripod is a good one. Because I do a lot of landscape photography, I like using ball heads on my tripods. Ball heads are also very useful for macro, portrait, travel, and architectural photography. If you do a lot of action or bird-in-flight photography, you might also consider using a gimbal.

### Static Scenes with a Ball Head

There are basically two ways to compose and focus when you use a tripod. The first is to compose the scene then move the AF point to where you want to maximize the hyperfocal distance (chapter 7). The second method is to focus with the center point by aiming the camera at the hyperfocal distance, then recompose to frame the scene.

Both techniques are fine; pick a method based on your personal preference. Sometimes when I compose a scene with my camera on a tripod, it takes quite a while to get everything set up properly, such as the height, legs, angle, and camera orientation. After everything is set up, I realize I have to focus. If I point the camera to the subject I want to focus on, I have to go through the trouble of recomposing the frame. It can be easier to move the focus point to the appropriate area in the scene and then focus.

### Dynamic Scenes with a Gimbal

A gimbal head allows you to easily balance a long lens on a tripod while you pan and move with a subject like a bird or a race car. Companies like Wimberley, Induro, Jobu, Custom Brackets, Kirk, and Really Right Stuff (shown here) make excellent gimbal heads that range in price from $250 to $700.

Panning with a ball head is inherently unstable because the lens and camera are positioned above the pivot point. This means they naturally want to flop over. A gimbal, on the other hand, positions the weight of the lens just below the pivot point, which creates a very stable platform. This setup helps ensure stable pans while you shoot moving subjects.

With respect to AF for moving subjects, I recommend group-area or d-21 focus areas with AF-C. I also recommend turning off lens VR unless your lens has a tripod or active mode.

Gimbal heads are not very useful for landscape, travel, or portrait photography. A gimbal is very cumbersome when you want to flip the camera vertically or recompose a shot. Also, when you point the camera downward with a wide-angle lens mounted, the gimbal moves the camera backwards, so the focus distance changes, and sometimes the tripod gets in the way.

# Event Photography with Flash

# Important Camera Settings

| Function | Setting |
|---|---|
| AF servo | AF-S |
| AF area | Single (d-21 and AF-C if you use AF-ON) |
| Shooting mode | Single |
| Exposure mode | Aperture priority |
| ISO | 400 to 1600 |
| Shutter speed range | 1/30 second to 1/125 second |
| Lens VR setting | Normal |
| Focus tracking with lock-on | Long |

## Comments

Weddings, bar mitzvahs, fund-raisers, and social gatherings are fun to photograph, but they are also filled with stress. Most of the activities happen only once, so you can't afford to make a mistake. The last thing you want is bridezilla knocking on your door in the middle of the night demanding her money back because of your bad photography.

Photographing events usually requires you to shoot in dark reception halls, so you'll probably use flash to compensate. Most entry-level and pro-sumer Nikon DSLR cameras have built-in AF-assist illuminators on the front. The AF-assist illuminator briefly sheds light on the scene to help the AF system acquire focus. The downside of using an AF-assist illuminator is that it is very bright and somewhat obnoxious for participants at the event. Therefore, it is my practice to turn off the AF illuminator in the camera's custom settings menus.

Without the AF-assist lamp, your camera probably won't be able to focus in the dark. The solution is to use a flash that has a built-in AF assist capability. Higher-end flash units, like the Nikon SB-700 and SB-910, have a red window on the front that projects a red grid onto the scene to help the AF system. This grid is almost imperceptible, so it is a good alternative to using the bright white AF-assist lamp on your camera.

To use the AF-assist pattern on your flash unit, make sure your camera is set to AF-S mode. The AF-assist grid won't work in AF-C mode. Also, make sure the custom settings menus for your flash unit are set so the AF-assist grid will turn on when you activate AF.

I use back-button focus for most events, so I leave my camera set to AF-C and d-21. If you use front-button focus, I suggest you use AF-S and single-area AF.

Astrophotography

# Important Camera Settings

| Function | Setting |
| --- | --- |
| AF servo | Manual |
| AF area | N/A |
| Shooting mode | Single |
| Exposure mode | Manual |
| ISO | 100 to 6400 depending on desired result |
| Shutter speed range | 1/30 second to 1/125 second |
| Lens VR setting | Normal |
| Focus tracking with lock-on | Long |

## Comments

The AF system on your camera generally won't focus on stars. If you're lucky, you can sometimes focus on a bright planet like Venus, but most of the time you have to manually focus for astrophotography.

The key to accurate focus is to understand where the infinity mark is on your lens. Most Nikon lenses allow you to turn the focus ring beyond infinity. The proper way to set the focus to infinity is to position the infinity symbol so the middle of the sideways figure 8 is directly lined up with the focus mark on the lens.

To photograph stars or the Milky Way without blur and to get sharp stars, use the rule of 500 to estimate the exposure. Take 500 divided by the focal length of the lens to determine the exposure in seconds. For example, if you use a 24mm lens on a full-frame camera, you would use a shutter speed of 500 / 24 = 21 seconds. That's the longest shutter speed you should use to make sure the stars and Milky Way are sharp. Otherwise they'll look blurry from the rotation of the earth.

If your goal is to capture star trails, not pinpoints, your focus technique is the same as previously described. Take a sequence of photos over the course of a few hours, then use a star stacking software program to combine the star trails.

# Important Camera Settings

| Function | Setting |
|---|---|
| AF servo | AF-S |
| AF area | Single (d-21 if you use AF-C and AF-ON) |
| Shooting mode | Continuous high |
| Exposure mode | Aperture priority |
| ISO | 100 to 3200 or Auto ISO |
| Shutter speed range | 1/10 second to 1/2000 second |
| Lens VR setting | Normal |
| Focus tracking with lock-on | Off |

## Comments

Travel photography encompasses a wide range of photographic subjects, including landscapes, cities, people, and everything in between. Generally, the goal is to capture beautiful color while showing the local culture. Because the weight you can carry while you travel is often limited, I suggest taking a smaller camera and an all-in-one zoom lens.

Due to the nature of travel, you usually don't have much time to compose and focus your shots. A scenario that plays out time after time is when you walk down the street and see an interesting old car drive by. You have to turn quickly with the camera and shoot in the blink of an eye. To accomplish this, set your camera's AF system to be a bit more automated and use auto-area AF

or d-51 auto. Trust the camera to automatically select the AF point (or points); it will generally do a decent job of finding the correct subject. It isn't perfect, but you can get a shot fairly quickly. If you have more time for photography in your travels, use d-21 or single-area AF.

Because you'll likely handhold your camera for the majority of your pictures, pay close attention to the shutter speed. Use auto ISO and set the minimum shutter speed to 1/focal length (e.g., 1/30 second for a 30mm lens), or use the auto shutter speed function within auto ISO. Use VR on your lens, and set it to normal when you stand on the street, or set it to active if you shoot from a car or bus.

# Live View Autofocus

Most newer Nikon DSLR cameras have a Live View mode that you use for capturing video and still photography. Live View in early Nikon cameras, such as the D700 and D3, was very difficult to use. These early bugs have been worked out in newer cameras, like the D810, D750, D5500, and D4S, and now Live View is a breeze to use. As I'll explain in this chapter, even though focusing with Live View can be slower, it is definitely the most accurate way to focus.

There are many reasons to use Live View:

- Composing product and still images for magazines and advertising
- Obtaining critical focus for macro shots
- Composing images when the camera is low to the ground (figure 5-1) to avoid lying down to look through the viewfinder

Figure 5-1: If a camera does not have Live View, you generally have to get low to the ground to compose the shot (*guy on left*). With Live View, you can see your composition without having to be a yoga master (*two guys on right*).

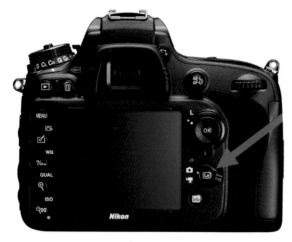

Figure 5-2: The Nikon D610 has two Live View modes: still photography and video. Press the Live View button to activate Live View mode. Rotate the switch to choose the photography or video mode.

- Composing images when you hold the camera overhead, like when you take a photo over a crowd of people
- Shooting video

## Activating Live View

Unfortunately, Nikon hasn't been consistent with how to activate Live View on their camera bodies. On some bodies you push a button, and on others you rotate a switch (figure 5-2). The following headings list the Nikon DSLR cameras that have Live View, and the text describes how to activate it.

### D600, D610, D7100, D7200, D800, D810, D4, D4S, D750
Press the Lv button on the back of the camera. Choose video mode or still photo mode by rotating the switch on the outside of the Lv button.

### Df
Press the Lv button on the back of the camera. The Df doesn't have a video mode, so Live View operation activates only the still photo mode.

### D3100, D3200, D3300
Press or rotate the Live View switch on the back of the camera.

### D5100, D5200, D5300, D5500
Rotate the Live View switch, which is located beside the exposure mode dial.

### D700, D300, D3
Rotate the release mode dial to Lv.

### D90, D300S, D3S
Press the dedicated Lv button on the back of the camera.

### D7000
Rotate the Live View switch on the back of the camera.

## The Differences between Focus Systems

Live View uses a different AF technology than regular AF on Nikon cameras. Live View uses contrast detection technology from the camera's imaging sensor, as opposed to the phase shift sensors used

Figure 5-3: The Live View AF sensor can be positioned anywhere on the screen. Here, the focus point (red box) is located at the lower left of a Nikon D750 monitor.

by the Multi-CAM AF system. Live View AF doesn't use predefined focus positions; focus points can be located anywhere in the screen, which corresponds to the sensor (figure 5-3).

Focusing with Live View is more accurate because you focus the lens with the actual plane of the imaging sensor. If the imaging sensor (CCD or CMOS) looks sharp, the resulting photo will be sharp. In traditional focusing with the Multi-CAM module, you must trust that the AF sensor is calibrated. When the AF sensor thinks the subject is sharp, that is how the image will be captured on the imaging sensor after the mirror flips up and the shutter curtain moves out of the way. Focusing on the imaging sensor with Live View removes the AF sensors and the mirror from the equation.

Multi-CAM AF is very fast and allows you to track moving subjects. Of course, you have to look through the viewfinder to keep the sensors on the

subject. Live View focus, on the other hand, is very slow in comparison and doesn't work well with moving subjects. It works best to help you focus on static scenes when the camera is on a tripod.

## Best Practices

Before I get into the nitty-gritty of each focus mode in Live View, here are some best practices for using Live View photography and video modes:

- For still photography in Live View mode, I recommend setting the Live View AF system to AF-S mode and normal focus area. These two settings result in the most accurate focus and is easiest to use.
- To initiate focus in Live View, press the shutter-release button halfway or press the AF-ON button. Look for the focus box to turn from red to green. When the box is green, the camera has achieved focus for the subject inside the box. When the box is red, the camera thinks the subject is out of focus.
- To obtain critical focus on the subject, press the zoom button on the back of the camera (figure 5-4). It allows you zoom in to the subject on the LCD monitor to really dial in the focus. At this high magnification, you can manually or automatically focus to make sure the shot will be crisp.

- For shooting videos, I recommend turning off the AF system. As you'll see later, the Live View AF modes that allow subject tracking are not reliable and often result in focus hunting, which makes it nearly unbearable to watch the resulting video.
- Live View automatically actives the VR system in your lens. Any time the Live View screen is on, your lens is actively reducing vibration. If you are using a tripod to shoot video, I recommend turning off VR. If you are handholding your camera in Live View mode, keep VR turned on to either the normal or active setting.

Figure 5-4: Zoom in to the Live View screen with the zoom button to help you achieve critical focus

## AF-Servo Modes and AF-Area Modes in Live View

There are multiple combinations of focus modes in Live View, and how you access the modes differs depending on which generation of Nikon camera you are using. Newer cameras, like the D750 and D4S, have many more Live View focus options than older cameras, like the D300S and D700.

### Newer DSLRs (D5500, D750, D800, D4S, etc.)

To change the AF mode in Live View, press the AF mode button and rotate the command dials (figure 5-5), just like in regular shooting mode. The main command dial changes focusing modes, and

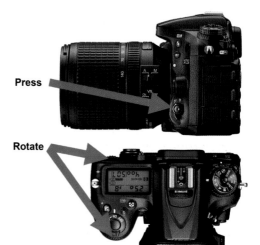

Figure 5-5: To change the AF mode in Live View on newer cameras, press the AF mode selector button while you rotate the main command dial and the subcommand dial

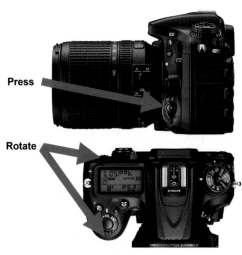

Press

Rotate

Figure 5-6: This Nikon D750 focus system is set to AF-F and normal area (AF-F and NORM at the top of the screen in yellow)

Figure 5-7: AF-S mode (at the top of the screen in yellow) in Live View on a Nikon D750

the subcommand dial changes AF-area modes.

### AF-F Servo

AF-F (figure 5-6) stands for full-time AF. This means the camera constantly focuses any time Live View is active. If the camera is in still photography Live View mode, AF-F focuses continuously until you press the shutter-release button. The focus locks when you press the shutter-release button either halfway or completely. If the camera is in video Live View mode, AF-F never stops focusing.

The camera uses whichever AF-area mode you choose—such as face priority, normal, wide, or subject tracking—and it will continuously focus based on the location of the focus sensor.

AF-F is difficult to use in still photography because it causes the lens

to continuously search for focus. As a result, some pictures are blurry and others are sharp. This mode is best suited for times when you can't attend to the camera and you want it to focus on *something*. For example, if you set up your camera in the corner of a room to video record an event, you can turn on Live View, then set the focus to AF-F and face priority. It will focus on any face (or faces) it finds while Live View is active. But don't do that. I know you won't be happy with the results.

In general, I do not recommend using AF-F mode for still photos or for video work.

### AF-S Servo

AF-S (figure 5-7) stands for single-servo AF. Fundamentally, it works the same as AF-S mode in regular photography mode. When you press the shutter-release button halfway, or when you press the AF-ON button, the camera

begins focusing. After it acquires focus, the servo stops and the focus is locked.

To set the camera to AF-S mode in Live View on newer cameras, like the D800, D7200, and D4, press the AF mode selector button while you rotate the main command dial. For entry-level cameras in the D3000 series and D5000 series, access the Live View AF settings by pressing the i button.

If you want to use AF in Live View, AF-S is the best mode. It is slower than AF-S with a Multi-CAM sensor, but it does a good job in Live View photography.

### Face-Priority AF Area

Face-priority AF-area mode seeks out and focuses on faces using Nikon's facial recognition technology. If there's one face in the scene, face priority works fine and will identify and focus on a single subject. If there are multiple faces in the scene and each face is at a different distance from the camera, the system starts jumping among the faces. The camera will identify all faces in the scene and put little yellow focus boxes over each face.

The camera has a hard time determining which face to use for primary focus (figure 5-8). To the casual observer, it looks like the camera can't choose from the closest face, the farthest face, or the most beautiful face. The camera manual says the focus system will

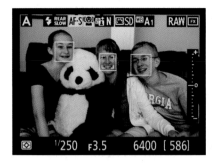

Figure 5-8: In face-priority AF mode, the camera searches for all faces in a scene. It then picks one to focus on, usually the closest face, as indicated by the double yellow box.

recognize up to 35 faces and will pick the closest face for the focus point. In my experience, the camera doesn't always pick the closest face; it picks the face that is the best defined and the easiest to recognize.

The truth is that the camera doesn't know which person in the scene is most important, so it often picks the wrong face. Imagine using Live View to video a wedding with face-priority focus area mode. You'll probably find that the camera focuses on Aunt Matilda rather than the bride.

Although you can't control, bias, or influence the location of the face-priority sensors, you can choose a sensor location if the camera is tracking multiple faces by pressing the multi-selector left, right, up, or down. The one face with the green box is being used for

Figure 5-9: Normal-area AF uses a smaller sensor, which allows for more precise focus. I recommend using normal-area AF for most Live View photography and video scenarios.

Figure 5-10: Wide-area AF uses a larger sensor, which results in less precise focus

active focus; faces with yellow boxes are not being used for focus.

Like most automated systems that try to make life easier for you, face-priority AF is often more trouble than it's worth. I don't recommend this AF-area mode for Live View video mode or photo mode.

### Normal-Area AF

Normal-area AF (figure 5-9) is the smallest and most precise AF area in Live View mode. I recommend using normal-area AF for most scenarios when you use Live View because the small focus area allows you to precisely focus in your composition. I use normal-area AF for video and still photography whenever I use Live View. In both video and still photography, I set the camera to AF-S. After I initially acquire focus, I either lock the focus or switch the lens

to manual focus for the remainder of the photo or video sequence.

Let's say you're taking a portrait and you want to focus on the subject's eye. The normal-area AF box is small enough that you can precisely pick the subject's eyeball, whereas the wide-area AF box might be too big to allow precision focusing. I have seen the wide-area AF box focus on the bridge of the nose or on the eyebrow, which means the eye is out of focus with a big f/1.8 aperture.

You can move this AF box anywhere on the screen by pressing the multi-selector on the back of the camera. Remember to unlock the multi-selector lock switch before you try to move the sensor.

### Wide-Area AF

Wide-area AF (figure 5-10) has the largest AF area in Live View mode. It can be useful when you're trying to photograph

a moving subject, like a person running or an automobile driving on a racetrack. As I mentioned before, focusing in Live View can be very slow, so trying to track rapidly moving objects is generally an exercise in futility. Because I rarely try to track moving subjects in Live View mode, I don't use wide-area AF.

Like the normal AF box, the wide-area AF box can be moved around the screen by pressing the multi-selector on the back of the camera. Again, just make sure the multi-selector lock switch is unlocked.

### Subject-Tracking AF Area

On paper, subject-tracking AF-area mode (figure 5-11) seems very useful because it tracks a subject as it moves around the scene. For example, if you photograph a person walking through a room, the Nikon AF system in Live View will follow the person after it identifies his or her color, shape, and form.

This mode works as long as the subject is well defined and the background is uncluttered. An example is a person walking in front of a blank white wall. In that case, subject-tracking mode has no problem tracking focus as the person moves throughout the scene. However, if the person walks in front of a cluttered background, subject-tracking mode begins to break down fairly rapidly and the camera begins to incessantly hunt for focus.

Figure 5-11: Subject-tracking AF-area mode on a Nikon D750. In this example, the focus point should continue to track the silver car as it moves around the scene. When the sensor is solid green, the camera is actively tracking that area.

Even when you use subject tracking in ideal conditions, this Live View AF mode tends to hunt as the subject moves around. Watching a movie on a big-screen TV that was taken in this mode can be very disconcerting for viewers, and it will actually cause some people to become nauseated.

For all these reasons, I do not recommend subject-tracking mode for still photography or video work.

### Older Cameras with Live View (D300, D300S, D3, D3S, D700, etc.)

The first Nikon cameras to use Live View were the D700, D90, D300, D300S, and D3. In the custom settings menus, these cameras give you the option to focus using Hand-held mode or Tripod mode.

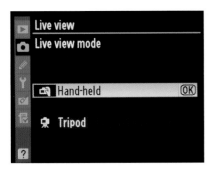

Figure 5-12: Select Live View mode from the Shooting Menu as shown here on a Nikon D700. You can choose Hand-held or Tripod mode.

The modes operate in completely different ways and are somewhat confusing.

The D300, D700, and D3 have Live View mode, but they don't shoot video, only still photos. The D300S and D3S were some of the first Nikon DSLR cameras to incorporate high-definition (HD) video and therefore allow video capture or still photo capture in Live View mode.

To select the Live View mode on these cameras, go to the menu system and chose Shooting Menu. Then choose Live View Mode (figure 5-12) to select Hand-held or Tripod mode.

### Hand-Held Mode

Hand-held mode assumes that you will photograph a moving subject. The confusing thing is that the camera flips the mirror down and uses the standard Multi-CAM AF sensors. This blacks out the monitor on the back of the camera while the system focuses with those sensors anytime you press the shutter-release button halfway. Then, when you let go of the shutter-release button, the mirror flips back up out of the way of the sensors, and you can see the scene on the monitor. At this point you can recheck the composition on the monitor.

When you want to take the photo, fully press the shutter-release button. The camera runs the shutter through a full cycle to take the photo. It also focuses again with the Multi-CAM sensors, but you can't tell if the sensors are in the correct position because the screen blacks out. Finally the mirror flips back up and displays the photo you just took on the monitor. If you want to see the live scene on the viewfinder, you have to press the shutter-release button halfway again. The process is tedious and confusing.

If you're confused, don't worry. I don't recommend using Hand-held focus mode when you use Live View on older Nikon cameras. The problem with this old-school mode is that it's difficult to keep switching between looking at the photo and Live View mode while you figure out which sensors are active. On these cameras, this mode is incredibly cumbersome and difficult to use. Stay with Tripod mode and you'll be much happier. Trust me.

### Tripod Mode

Tripod mode assumes the camera is mounted on a tripod and the subject is stationary. The AF operation in Tripod Live View mode is exactly the same as in new camera models. It uses the imaging sensor to acquire focus, and the general operation is the same as I described in the previous sections. I recommend that you use Tripod Live View mode on these cameras rather than Hand-held mode.

Figure 5-13: Use the zoom button on the side of your camera to look at the scene with a higher magnification so AF will be more accurate

## Video AF versus Still Photo AF

Focusing for video capture is quite an art, and it requires an increased level of skill over focusing for still photos. I do not recommend using AF when you shoot video. As I mentioned in a previous section, the Live View full-time AF (AF-F) and subject-tracking AF modes are very inconsistent and do not work well for tracking subjects in real time. Add to that the fact that both of them suffer from significant focus hunting, and you can see how using AF for video is a bad idea.

On the other hand, automatically focusing for still photography in Live View mode can be effective if you set your camera to AF-S mode and normal area. Generally, the subjects for Live View still photography will be stationary, so it's fine to use the contrast-detect AF

method in Live View because you have more time to focus.

To do a good job of focusing while you shoot video, you'll need to become an expert at manual focus control. This often requires using specialized equipment, such as a follow focus rig and a larger video monitor. I'll cover these details in the next chapter.

## Using Zoom Buttons to Achieve Critical Focus

One of the best techniques for achieving critical automatic focus in Live View is to use the zoom buttons (figure 5-13). Let's say you're photographing a flower and you want to focus on the stamen.

The approach I suggest is to compose the photo so you're happy with the framing, then use the multi-selector to move the AF box over the stamen. Next, press the zoom button on the side of your camera until you see the stamen larger on the screen.

To focus, either press the shutter-release button halfway or manually focus your lens until the stamen is in perfect focus.

# Achieving Great Focus in Video

As I mentioned in chapter 5, AF and video don't mix well in DSLR cameras. Unfortunately, your camera's Live View AF system isn't up to the task of reliably tracking subjects. Perhaps future DSLR video systems will have improved AF technology, but until that day comes, you'll need to master some additional gear if you want to focus well when you shoot video (figure 6-1).

## Difficulties with AF While Shooting DSLR Video

One of the reasons that traditional video cameras, like the Sony Handycam models, handle AF so well is that they have a massive DOF. These video cameras use smaller imaging sensors, which lead to a substantial DOF compared to a DSLR camera. This extra DOF means you don't have to worry as much about obtaining precise focus; if the camera misses focus a little bit, the extreme DOF will pretty much cover the mistake.

DSLR cameras, on the other hand, have much larger sensors, so they can create a very shallow DOF. This is especially true with lenses that have large apertures, like f/1.8 or f/2.8. In these cases, if the AF system misses the focus

even by an inch, the entire shot is ruined.

By its very nature, video captures subjects and scenes that move. The Nikon video AF modes don't work well for moving subjects because the

Figure 6-1: Most DSLR videographers use a video rig similar to this Zacuto rig (www.zacuto.com)

Figure 6-2: Even with accessory microphones, like this Røde microphone, your camera will pick up AF noise with just about every lens, including most AF-S models

mounted on the camera's hot shoe (figure 6-2).

The solution to the AF problem in video is to use manual focus. Most professional DSLR videographers use manual focus because it is the best way to achieve excellent results. You'd be hard pressed to find anyone shooting DSLR video with an AF mode. The rest of this chapter is dedicated to describing how to get great video results with manual focus on your DSLR.

## Pulling Focus

Pulling focus is a fancy term for focusing manually. More specifically, it is the act of manually changing the focus distance of the lens to follow the change in the subject's distance to the camera. Pulling focus simply means manually adjusting the focus throughout the duration of the video clip.

Pulling focus is sometimes called racking focus. Racking focus usually refers to a quick focus change, such as when there are two people in the frame and you rapidly shift the focus from one person to the other.

For small video productions, it is possible to pull focus by yourself, but you'll quickly realize that managing the camera functions is a full-time job. Juggling the many tasks involved in video recording—maintaining a good composition, zooming, tracking the

camera's AF system in video mode is entirely different than the AF system in still photo mode. AF-F (full-time autofocus) causes the camera to hunt for focus, which leads to focus breathing. This breathing causes the final video footage to rapidly grow and shrink on the screen, which is extremely difficult to watch.

Finally, any time the AF system is actively working, the lens elements and internal gears move, which is noisy. The microphones on your camera pick up the noise, which can sometimes overpower the ambient sound or the subject's voice. The noise is picked up even if you use accessory microphones

subject's movement, and managing the lighting, audio, and focus—is too much for one person to handle. Therefore, it is common for two or more people to work together on a video shoot. One person manages the camera settings, and the other pulls focus.

The camera isn't smart enough to know where you want to focus or when to change the focus to another subject while you shoot a scene. It doesn't know if person A or person B is talking.

As in still photography, the audience pays attention to the in-focus subject. In video work, you often change the point of focus between two people who are talking, or perhaps between a flower in the foreground and a mountain in the background. This is just about impossible with Live View AF and therefore should be done manually.

Learning to pull focus well is a skill that develops over time. You should practice regularly, just like playing the piano. The goal is that a viewer will not notice the focus changes. The shifts in focus need to be smooth, not abrupt. Focus changes need to follow the action, and they need to help tell the story.

Avoid these common focus-pulling mistakes:

- **Pulling at the wrong speed:** If you pull focus too fast, the footage will be jarring for the viewer. If you pull it too slow, the viewer gets frustrated and impatient. You should pull focus to match the mood and pace of the scene. If there is slow-paced dialog, change the focus slowly. If there is a bike race, change the focus rapidly (but smoothly).

- **Focusing on the wrong part of the scene:** If someone is talking, don't focus on the flowers in front of him or her. If the subject is a car, don't focus on the building behind the car. Always remember that viewers pay attention to whatever is in focus.

- **Not focusing on the closest eye:** Because DSLR cameras can be set up for a shallow DOF, you have to be careful to focus precisely. Be sure to focus on the eye that is closest to the camera, otherwise the footage will look funny.

- **Not fixing a focus mistake during the shot:** Inevitably, you will sometimes miss the focus, but you may not want to stop filming. Always fix the focus, even halfway through the shot. Nothing is worse than watching a blurry film.

## Follow Focus Rigs

The most basic way to adjust the focus while you record a video is to manually rotate the focus ring on your lens (figure 6-3). It's doesn't cost anything, and you can do it fairly well as long as your camera is mounted on a tripod and is somewhat stable.

Figure 6-3: Manually adjusting the focus by rotating the focus ring is simple and doesn't cost anything

Figure 6-4: A Zacuto follow focus system set up on a shoulder rig. When you rotate the handle, it turns a gear that meshes with a geared band on the focus ring. You can see the geared band around the lens.

This process is much more difficult when the camera is mounted on a shoulder rig or is in an awkward position. Sometimes it takes two hands to stabilize the camera, so someone else might need to rotate the focus ring.

Situations like these require you to use a follow focus rig (figure 6-4). This system is typically a geared mechanism that allows you to spin a dial that rotates the lens focus ring. It is generally designed so you can stabilize the camera with your right hand and change focus with your left hand.

Higher-end follow focus setups have a very smooth operation and allow for fine adjustments of the lens focus ring.

This fine adjustment is important when you shoot at large apertures with a limited DOF.

To judge the critical focus while you record, look at the camera monitor. It can be difficult to see on sunny days, so I suggest using a clip-on magnifier loupe, like the Zacuto Z-Finder (figure 6-5). It snaps over the back of the camera monitor and allows you to press your eye against it, just like a regular viewfinder in still photography. The advantage is that you get a full-screen view of the monitor so you can easily judge the focus and composition.

A better option for viewing and focusing is to use a larger seven-inch

Figure 6-5: The Zacuto Z-Finder is a clip-on magnifier that helps you judge focus and composition during video recording

Figure 6-6: An Ikan field monitor mounted on a Zacuto articulating arm

battery-powered field monitor, like the one in figure 6-6. Fundamentally, it is a TV monitor that displays the video feed. Attach the monitor to your shoulder rig or tripod, then focus by looking at the field monitor instead of your camera monitor. The cool thing about field monitors is they often use the same battery that your camera uses. The price of a monitor ranges from $250 to $2,000 but it is well worth the investment if you do a lot of video work.

## Presetting Focus Distance

As your focus skills improve, you'll quickly realize that you need a way to preset the focus for different distances in the scene. For example, if you are shooting a clip with two people talking, you'll want to rapidly and accurately switch the focus as the dialog bounces back and forth between the actors.

To accomplish this, you can measure the focus points ahead of time. After your camera is mounted on a tripod and the talent is in position, draw marks on the lens or on the follow focus rig. You can put tape on the lens and mark the tape (figure 6-7), or you can

Figure 6-7: Put tape on your lens and mark the focus distances with an ink pen

use an erasable grease pen on a white marking disk that is provided with many follow focus systems (figure 6-8). The marks allow you to hit the focus positions during recording, without looking at the monitor to check the focus.

## Using a Crew to Assist with Focus

Most people who are new to shooting video with a DSLR don't understand how difficult it is to consistently get great focus by themselves. Therefore, I suggest using a crew to help you on your video projects.

The first person in the crew is called the operator. The operator is responsible for general camera operation, including stabilizing, panning, and tilting; setting

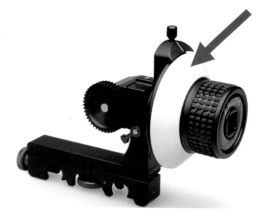

Figure 6-8: The Zacuto Z-Drive has a marking disk so you can mark focus distances with a grease pen

the white balance, exposure, and composition; and tracking the subject.

The second person in the crew is called the focus puller, or first assistant camera (1st AC). The sole responsibility

of the 1st AC is to maintain focus on the subject. This is traditionally one of the hardest jobs on a production set. If the 1st AC messes up, the entire shot is wasted and has to be redone. Production time is very expensive, so the person you choose to be the 1st AC must be top-notch.

Depending on the size and scope of your video production, you may need additional people on the set to help you with other things. For example, you will probably need someone to capture audio, someone to handle lighting, someone to be a director, and of course someone to deal with food catering!

# Other Considerations

Now that we've gone through most details of the Nikon AF system, it's time to look at other topics that are peripherally related to AF and impact your ability to effectively create sharp images. In this chapter, I'll cover a variety of topics, including detailed definitions, hyperfocal distance, lens quality issues, and how to fine-tune your AF system with an aftermarket product.

## Understanding Focus, Clarity, and Sharpness

Here are the technical definitions of focus, clarity, and sharpness.

### Focus

Focus is the point at which light rays converge on an imaging sensor and produce a clear visual definition of a subject (figure 7-1). In digital photography, an object is in focus if light from that object converges on an imaging surface, such as a CCD or CMOS imaging sensor.

An image is unfocused when light converges in front of or behind the focal plane and creates disks of blurriness (figure 7-1). The border between areas of in-focus and out-of-focus light creates what is known as circles of confusion. A circle of confusion is an optical spot caused by a cone of light from a lens that isn't in perfect focus (figure 7-2).

Figure 7-1: The image on the left is out of focus because the rays of light converged in front of the focal plane. The image on the right is in focus because the rays of light converged directly on the focal plane.

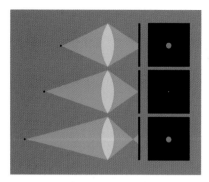

Figure 7-2: The top and bottom diagrams show out-of-focus objects that result in circles of confusion on the imaging plane (sensor). A subject appears to be in focus as long as the circles of confusion are smaller than the resolution of the human eye.

The larger the circle of confusion, the blurrier a photo looks.

### Clarity

Clarity is the *perception* of sharpness, or the *apparent* sharpness, in a photograph. It provides visual definition and visual separation among elements in a photograph.

Many software programs, like Adobe Lightroom, have a clarity slider that adds contrast to the midtones in an image. This tool improves the perception of sharpness by adding subtle halos around the edges or transitions of subjects in the scene. Halos are designed to increase the acutance in a photo and improve the perception of definition and clarity. Acutance defines the steepness, or abruptness, of an edge in a photographic image. A photo with low acutance has poorly defined edges, and

a photo with high acutance has well-defined edges.

If you are familiar with digital post-processing, you know that sharpening adds halos to the edges of a digital photograph; therefore, sharpening improves acutance in an image. The clarity tool is not as aggressive as sharpening (figure 7-3).

### Sharpness

Photographic sharpness is the result of acutance and detail resolution in an image. Sharpness is heavily influenced by sensor resolution, lens quality, tripod stability, field technique, image magnification, noise, grain, viewing distance, and post-processing technique.

Resolution is solely a function of the camera's imaging sensor and its ability to distinguish among closely spaced details (figure 7-4). A higher-resolution sensor will produce more detail than a lower-resolution sensor. For example, the imaging sensor in a Nikon D810 has a resolution of approximately 36 megapixels, or 4,912 × 7,360 pixels. On the horizontal axis, the sensor has 7,360 pixels. A Nikon D3S, on the other hand, has a 12-megapixel sensor with about 4,300 pixels on the horizontal axis. The D810 resolves almost twice the number of horizontal lines and therefore has a higher resolution.

Acutance defines how quickly image information transitions at the edges; it is a perceived element of sharpness. In

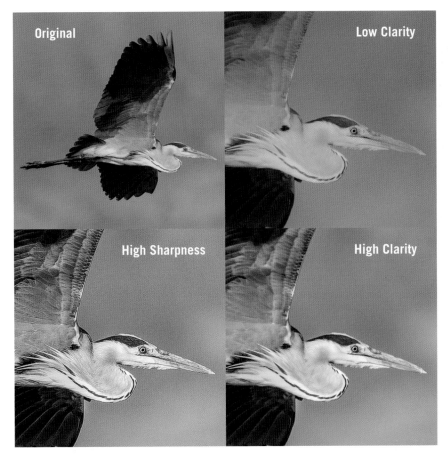

Figure 7-3: Because clarity is the perception of sharpness, you can use post-processing tools, like sharpening and clarity, to lighten the edges of an object and give it the appearance of being sharper. This figure shows the difference between high clarity and high sharpness.

Figure 7-4: Resolution is dictated by the sensor's ability to distinguish among closely spaced details. The left image has a higher resolution, and the right image has a lower resolution.

Figure 7-5: The top image represents low acutance, and the bottom image represents high acutance

other words, acutance can't really be measured. Low acutance results in soft transitions, and high acutance results in sharp, or abrupt, transitions (figure 7-5). The bird in the lower left of figure 7-3 has high acutance.

Acutance depends on the quality of your lens and your skill in post-processing. A sharper lens has a high acutance, as does a digitally sharpened photograph. Most lenses are sharpest at their middle apertures. This generally means that lenses resolve the most detail (lines per millimeter) and produce the highest acutance at about f/8. I'll talk more about this later in the chapter.

Post-processing and sharpening with software tools, like unsharp mask or smart sharpen in Photoshop, will increase the acutance in an image. One of the keys to producing great images is becoming adept at using these post-processing tools.

The viewing distance also impacts the perception of sharpness. For example, for large prints, billboards, and advertisements, the assumption is that the viewer will look at the image from quite a distance. Therefore, these prints are generally produced at a much lower resolution. If you were to look at the prints up close, you would see that the resolution is very low. On the other hand, if you look at them at the intended viewing distance, they will look adequately sharp.

Camera technique plays a significant role in the sharpness of an image. If you don't become an expert at AF, or if you don't hold your camera steady or use a fast enough shutter speed, you should expect to be disappointed with the sharpness of your images. The key is to use the proper shutter speed, work hard at obtaining accurate focus, and use other tools, such as a tripod, mirror lock up, and a cable release.

## Focus in Low-Light Environments

Nikon AF systems require adequate light to focus properly. When the light level drops, AF performance also drops, and at some point (usually around EV –1 or EV –2) the AF system completely ceases to function.

Here are a few tricks I've learned over the years to focus in low-light environments.

### Flash AF-Assist Illuminator (SB-910, SB-700, SU-800)

Recall from chapter 1 that the Nikon AF system requires light, contrast, and well-defined lines to focus. If you don't have all three of these elements, the AF system won't work. The only way to focus in the dark is to project either light or bright lines onto the subject.

Nikon's higher-end flash units have integrated AF-assist illumination grids to do just that. These flash units work with the camera's metering system to automatically detect when the light level is low. When the ambient brightness drops below the minimum requirement of the AF sensors, the flash emits a red grid pattern onto the scene (figure 7-6) that allows the Multi-CAM focus sensors to acquire focus.

Some older and lower-end Nikon flash units require you to use the middle AF sensor for the camera to detect the pattern. Higher-end flash units, like the Nikon SB-910 and SB-700, allow you to place the AF sensors in different positions. For example, you can place the focus sensor on the left or right of the frame, and the SB-910 will shift the red focus pattern to that location.

You can configure your flash unit so it will not fire (produce light) when you take a picture, but will only send

Figure 7-6: The red grid pattern from a Nikon SB-800 flash unit allows your camera to focus in a dark environment

out the autofocus assist lamp. You control this function from the custom settings menu for the flash unit, where you set the menu item called AF-Assist Illuminator to AF ONLY.

### Flashlights and Headlamps

The most basic, but sometimes the most effective, way to add light to a scene at night is to use a flashlight. I almost always travel with a flashlight or headlamp in my photo bag. This has become a very important tool for my photography during twilight and at night when I don't use a flash (otherwise I could use the AF-assist pattern from the flash unit, as previously described).

I often wear my headlamp (figure 7-7) and aim it at the scene while I simultaneously look through the viewfinder. This allows me to compose the shot while focusing on the subject with the camera's AF sensors. It also frees up

Figure 7-7: This Petzl TIKKA headlamp is a great tool to use in the field. It is tiny, lightweight, and runs on standard AAA batteries.

Figure 7-8: The AF-assist illuminator on the front of a Nikon D610

my hands to operate the camera controls and ball head on my tripod.

If you don't have a headlamp, a flashlight will do, but you'll probably have to hold the flashlight in your left hand while you activate AF with your right hand. This is a bit more difficult than a headlamp, especially if you have to recompose your shot.

### Built-In AF-Assist Illuminator

The built-in AF-assist illuminator (figure 7-8) is located on the front of most Nikon DSLR cameras, but it isn't included on high-end models like the D3, D3S, D4, D4S, or Df. It is designed to project a bright white beam of light onto the subject so the AF sensors can focus.

The built-in AF-assist illuminator works only if the AF system is turned on and if it is set to AF-S mode.

### Focus Indicator Dot in Viewfinder

The focus indicator dot is located at the lower left of the viewfinder (figure 7-9). Depending on the camera, it is either green or white. The dot provides a visual cue when the camera has acquired focus. When the dot is solid (i.e., not blinking), the subject is in focus.

Even when it is too dark for the AF system to automatically focus, the AF indicator still works. I've found that I can rely on the AF indicator dot in very dim situations. I've used it to manually focus on small light bulbs in the distance, bright stars and planets, and subjects with decent contrast.

Some Nikon cameras, like the D3000 series and D5000 series, have a single dot in the viewfinder. When the dot is solid, the subject is in focus. When the dot is blinking, the subject is out of focus. Other cameras, like the D750, D810, and D4S, have a dot with arrows on both sides. If the left arrow is highlighted, the subject is behind the current focus distance, so you have to focus farther away. If the right arrow is highlighted, the subject is between the current focus distance and the camera, so you have to focus closer.

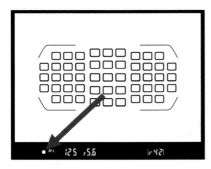

Figure 7-9: The focus indicator is located at the lower left of the viewfinder

### Measure Distance with a Tape Measure

As old school as it sounds, sometimes you have to use a tape measure and the distance scale on your lens. Most lenses have a distance scale on the focus ring or the lens barrel (figure 7-10). Lower-cost kit lenses don't have focus distance indicators, so this technique won't work with them.

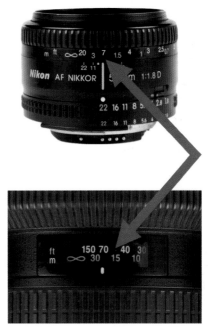

Figure 7-10: Focus scales on the Nikon 50mm f/1.8 lens (*top*) and the 200–400mm f/4 lens (*bottom*)

The focus plane indicator on your camera (figure 7-11) shows you the exact location of the imaging sensor inside the camera body. Use this mark, instead of the front of the lens, when you use a tape measure to find the distance between the subject and the camera. After you know the distance, rotate the focus ring on the lens to match the distance on the tape measure. Simple, right?

## Depth of Field and Sharpness

DOF refers to the range of distance in a photograph that appears acceptably sharp. A shallow DOF means that a

Figure 7-11: There is a focus plane indicator on the top of your camera. On pro cameras it is printed in white. On other cameras it is molded into the polycarbonate body.

Figure 7-12: A shallow DOF at f/1.8

Figure 7-13: A deeper DOF at f/16

small region of the photo is sharp, and a deep DOF means that a large region of the photo is sharp (figures 7-12 and 7-13).

The DOF is controlled by the lens aperture, which can vary from f/1.4 to f/64. Large apertures, such as f/1.4, f/2.0, and f/2.8, generally produce a very shallow DOF. Small apertures, like f/11, f/16, and f/22, generally produce a deep DOF.

For any DOF, whether shallow or deep, one third of the DOF occurs in front of the focus distance, and two thirds of the DOF occurs behind the focus distance (figure 7-14). Practically, this means if you want to maximize the DOF on an object, don't focus on the front of the object or the rear of the object; focus one third of the way into the object. For example, if you are photographing a group of people, don't focus on the closest person; focus one third of the way into the group to maximize the DOF for your aperture and lens combination.

There are lots of ways to calculate the DOF. One of the easiest is to download an app for your tablet or smartphone. If that doesn't work for you, refer to one of the numerous websites that will calculate the DOF for specific focal lengths and sensor sizes (DX versus FX sensors).

Another way to calculate the DOF is to use the DOF marks on the focus ring of your lens (figure 7-15). Not all lenses have a DOF scale.

Lenses generally produce their highest resolution (resolving power) at around f/8; the point of highest resolution is called the sweet spot. At apertures smaller or larger than f/8, the optical performance of the lens tends to degrade slightly. At small apertures like f/22, lenses suffer from light diffraction.

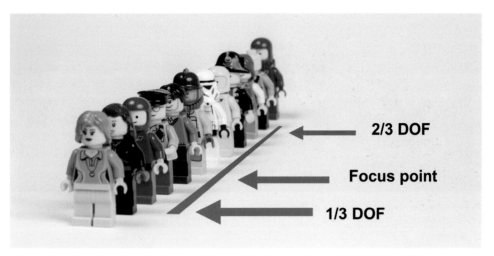

Figure 7-14: One third of the DOF occurs in front of the focus point; two thirds of the DOF occurs behind the focus point

Figure 7-15: The DOF scale on a 50mm f/1.8 lens. This lens is focused at 7 feet, and the aperture is set to f/22, so the DOF will range from approximately 5 feet to 19 feet.

At large apertures like f/2.8, they suffer from light aberration.

Practically speaking, if you want to take the highest-resolution photo of something with no depth (e.g., the words on a newspaper), use an aperture of f/8. This takes advantage of the highest resolving power of your lens and produces the sharpest photo of a flat object that your lens is capable of.

I use f/8 when I don't need to worry about the DOF, such as a photograph of a mountain range that is 10 miles away and doesn't have any foreground elements (figure 7-16). Even though the mountain range has depth, everything is effectively located at infinity, so I don't need to worry about the DOF encompassing the depth of the mountain range.

Figure 7-16: Because the Olympic Mountains in this photograph were many miles away, and because there were no foreground elements to worry about, I used f/8 to maximize the sharpness of my lens

An aperture of f/2.8 will not produce the sharpest image your lens is capable of, but it can aid in the *perception* of sharpness because of how it blurs the foreground and background. If the lens is focused directly on the subject, and the background and foreground are blurry, the subject appears to be very sharp (figure 7-17). I frequently use this shallow DOF technique to enhance the perception of sharpness in a subject.

I like to use this shallow DOF technique for portraits, wildlife, and macro shots to trick the viewer's mind into thinking the photos are very sharp.

Another tip is to shoot from a low perspective so the background is far away from the subject. This perspective gives better visual separation between the subject and the background. If you shoot from a higher angle, the ground is usually pretty close and not very blurry. When you shoot from a low angle, the background is often 20 or more feet

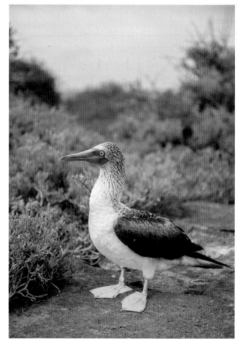

Figure 7-17: Because f/2.8 allows for a very shallow DOF, it helps with the perception of sharpness. I took this picture of a blue-footed booby in the Galapagos Islands with a Nikon D600 and a 70–200mm f/2.8 lens.

## Depth of Field and Hyperfocal Distance

In the previous section I talked about DOF. Remember that DOF is the range of distance in a photograph that appears sharp. Hyperfocal distance comes into play when you want the entire scene to be sharp, from the foreground to infinity. The term *hyperfocal distance* is defined as the focus distance that places the farthest edge of the DOF at infinity. DOF control matters in the following situations:

- A group photograph when you need everyone in sharp focus, but not necessarily the background
- A macro photograph of an insect when you want the head to be in focus, but not necessarily the body
- A flower photograph when you want the entire head of the flower to be in focus, but not the stem

Hyperfocal distance matters in the following situations:

- A landscape image when you want the entire scene to be sharp, from the flower in the foreground to the mountain in the background
- A cityscape when you want the image to be sharp from the cars in the foreground to the bridge in the background

Figure 7-18: This image has an aesthetically pleasing soft and creamy bokeh. It was taken with a Nikon 85mm lens at f/1.8.

away, and it will be very blurry, especially at f/2.8. This blurriness is called *bokeh*.

Bokeh is the aesthetic quality of the out-of-focus areas in a photograph. Bokeh can be described as creamy, structured, soft, or harsh. Generally speaking, photographers like soft, creamy bokeh (figure 7-18). The stronger the bokeh effect, the stronger the separation between the in-focus subject and the out-of-focus background.

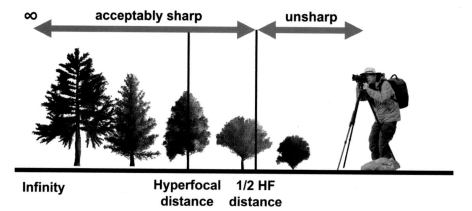

Figure 7-19: If you focus at the hyperfocal distance, everything from infinity to half the hyperfocal distance will be acceptably sharp

Focusing so the entire scene is acceptably sharp requires you to select the appropriate hyperfocal distance. This distance is defined as the focus point that places the farthest edge of the DOF at the *back* of the scene (figure 7-19). For a landscape photo, the back of the scene is infinity.

There are a variety of ways to calculate hyperfocal distance, including equations, smartphone apps, computer programs, and hyperfocal charts. Tables 7-1 and 7-2 are hyperfocal charts you can use for FX and DX format cameras.

## Focus Stacking

Macro photography with a longer lens, like the 105mm f/2.8 VR, almost always results in a very shallow DOF, even when you shoot at smaller apertures

| | Distances in Feet at Specified Focal Length | | | | | | |
|---|---|---|---|---|---|---|---|
| Aperture | 16mm | 24mm | 35mm | 50mm | 85mm | 135mm | 200mm |
| f/2.8 | 9.4 | 21.1 | 44.9 | 91.5 | 265 | 667 | 1,465 |
| f/4 | 6.6 | 14.8 | 31.4 | 64.1 | 185 | 467 | 1,025 |
| f/5.6 | 4.7 | 10.5 | 22.4 | 45.8 | 132 | 334 | 732 |
| f/8 | 3.3 | 7.4 | 15.7 | 32 | 92.6 | 234 | 513 |
| f/11 | 2.4 | 5.4 | 11.4 | 23.3 | 57.3 | 170 | 373 |
| f/16 | 1.6 | 3.7 | 7.8 | 16 | 46.3 | 117 | 256 |
| f/22 | 1.2 | 2.7 | 5.7 | 11.7 | 33.7 | 84.9 | 186 |
| f/32 | 0.8 | 1.8 | 3.9 | 8 | 23.1 | 58.4 | 128 |

Table 7-1: Hyperfocal chart for cameras with a full-frame (FX) sensor

| Aperture | Distances in Feet at Specified Focal Length | | | | | | |
|---|---|---|---|---|---|---|---|
| | 16mm | 24mm | 35mm | 50mm | 85mm | 135mm | 200mm |
| f/2.8 | 14.2 | 32 | 68.1 | 139 | 402 | 1,014 | 2,224 |
| f/4 | 10 | 22.4 | 47.7 | 97.3 | 281 | 710 | 1,557 |
| f/5.6 | 7.1 | 16 | 34.1 | 69.5 | 201 | 507 | 1,112 |
| f/8 | 5 | 11.2 | 23.8 | 48.7 | 141 | 355 | 779 |
| f/11 | 3.6 | 8.2 | 17.3 | 35.4 | 102 | 258 | 566 |
| f/16 | 2.5 | 5.6 | 11.9 | 24.3 | 70.3 | 177 | 389 |
| f/22 | 1.8 | 4.1 | 8.7 | 17.7 | 51.1 | 129 | 283 |
| f/32 | 1.2 | 2.8 | 6 | 12.2 | 35.2 | 88.7 | 195 |

Table 7-2: Hyperfocal chart for cameras with an APS-C (DX) sensor

like f/11 and f/16. When you photograph small objects like flowers and insects, the biggest challenge is not having enough DOF to sharply render the entire subject. Unfortunately, only the front of the flower will be in focus and the rest of the flower will be completely blurred.

A new method to overcome this DOF limitation is called *focus stacking*. Focus stacking involves taking a series of photographs, each focused at a different distance, and then using software to "stack" the sharpest region of each photograph and merge them into one final image. The end result is an image that has a great DOF.

There are many software packages that allow you to do this, including Photoshop, Helicon Focus, and Zerene Stacker. In figure 7-20, I used Photoshop

Figure 7-20: To produce an image with the maximum DOF, I shot 12 images of this scene, each of which was focused on a different face. I then brought the images into Photoshop and used the function called Auto-blend Layers to produce the final composite. Compare this image to figure 7-13, which I shot at f/16.

to create an image that has sharp focus from front to rear.

There are a couple approaches to focusing when you shoot the sequence of images. The first technique is to manually rotate the focus ring of the lens between each shot, so you effectively move the focus plane along the length of the subject. For example, if you are photographing a bug, start the photo sequence by focusing on the eyeballs, and then move the focus point to the neck, thorax, abdomen, wings, and tail. At the end of the sequence you may have 10 or 20 shots that you can merge together in post-processing.

Another approach is to change the focal point by physically moving the camera back and forth on a focusing rail. The difficulty here is that moving the camera back and forth leads to fairly significant changes in the composition of the image, and the software might have a more difficult time merging the photos. My suggestion is to try rotating the focus ring first.

Make sure to use the exact same camera settings—aperture, ISO, shutter speed, and white balance—for each image on your sequence. This will avoid weird results when you execute the focus stacking process in software.

Notice that I do not recommend using AF for focus stacking. It is too difficult to precisely move the focus distance down the length of a macro subject when you use the AF sensors. Use only manual focus mode for focus stacking.

One of the neat things about using focus stacking is that you can shoot a sequence of images with the lens aperture wide open and still maintain the nice out-of-focus bokeh behind the subject. After you stack the images, the subject looks sharp from front to back, and the background is nice and blurry from the bokeh achieved by using the large aperture.

You can also use focus stacking for landscape photography to increase the DOF. If setting the focus for the hyperfocal distance doesn't provide enough DOF for a scene, take a few pictures at various focus distances and use stacking software to get an extreme DOF.

## User-Defined Menus for Different Scenarios

On higher-end Nikon cameras, you can program menu banks with specific settings for different shooting scenarios. Cameras like the D810, Df, and D4 series have four customizable menu banks: A, B, C, and D (figure 7-21). Mid-tier cameras, like the D7000, D7100, D7200, D750, D600, and D610, have two customizable user modes: U1 and U2 (figure 7-22).

Most of the camera's custom settings menu items can be configured differently in each user-defined bank. For example, in one bank you could set the AE-L/AF-L button to operate as an AF-ON button, and in another bank you could set the AE-L/AF-L button to

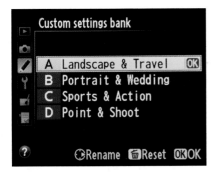

Figure 7-21: The Nikon D800 has four menu banks: A, B, C, and D. I named each of my banks based on the subjects I typically shoot.

Figure 7-22: Cameras like the D7000, D610, and D750 have two user groups: U1 and U2

operate as an AE-L (hold) button. It's a good idea to tailor the AF system to behave differently for various subjects.

For example, you could configure one bank of settings for landscape photography and another for sports, or your could set up one bank for team sports and another for individual sports. Each bank would have different combinations of AF settings that mimic my recommendations in chapter 4. Setting up your banks can be a big time-saver and allows you to keep your mind on the scene rather than the settings.

Here are some recommendations for setting up your menu banks (A, B, C, D) or user modes (U1, U2) for different scenarios:

- For individual sports, set up a bank or U1/U2 that includes group-area AF with Focus tracking with lock-on set to a short delay.
- For portraits, set up a bank or U1/U2 for AF-S mode and single-point AF.

- For football, set up a bank for AF-C, back-button focus, and d-21.
- For bird-in-flight photography, set up a bank for AF-C, back-button focus, and group-area AF.

## Techniques to Improve Sharpness While Handholding

Here are a few tips to help you improve your handholding technique as it relates to focus and image sharpness.

### Increase Shutter Speed on High-Resolution Cameras

For higher-resolution cameras, like the 36 megapixel D800/D810 and the 24 megapixel D750, D610, and D3X, be sure to use faster shutter speeds than you would with 12 megapixel or 18 megapixel cameras. With lower-resolution cameras, it is OK to use the traditional shutter speed rule of 1/focal length. With higher-resolution 24 megapixel and 36 megapixel cameras, I

recommend that you increase the shutter speed to 1/(focal length × 2).

Lower-resolution cameras are slightly more forgiving of camera shake because their pixel pitch is larger than in high-resolution cameras. If you wobble a tiny little bit while you shoot with a 12-megapixel camera, like the D700, the sensor might not pick up any blur because the wobble might be contained within the width of a pixel. On a high-resolution camera, like the D810, the pixels are more densely packed, so the same tiny wobble might span two pixels and cause blur in the photo.

### Focus and Recompose

When you use the focus and recompose method, make sure you don't lean forward to focus then lean back to take the photo. This will cause the focus distance to change after you acquire focus and will lead to a blurry photo.

The correct technique is to focus on the subject, lock the focus (use AF-L or let go of the AF-ON button), then recompose by pivoting the camera. The goal is to keep the focal plane (i.e., the image sensor) at the same distance from the subject when you recompose the photograph.

### Burst Technique

Handholding becomes difficult when the shutter speed drops below about 1/30 second because of blur caused by camera movement. One technique that works well for many photographers

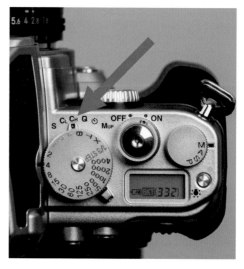

Figure 7-23: Set your camera's frame rate to continuous high, then shoot a burst of photos. The odds are that one image in the burst series will be sharp.

is to shoot a burst of photos at a high frame rate, such as continuous high (figure 7-23), even if you want only one picture.

When most people take a picture, they press the shutter-release button fairly quickly, which introduces a bit of camera movement. When you take a burst of three to five photographs in continuous high frame rate, the initial movement when you press the shutter-release button ruins the first photo, but sometimes the second, third, or fourth photos are relatively sharp. The last photo is often blurry because you lift your finger off the shutter-release button, which again causes subtle movement.

### Roll Your Shutter Finger

At shutter speeds of 1/30 second or slower, be careful when you release the shutter so you don't introduce extra movement into the camera system. My suggestion is to gently roll your index finger over the shutter-release button when it is time to take the picture. Don't stab the shutter-release button or press it rapidly.

### Proper Stance

The best stance when handholding your camera is with your feet about shoulder width apart and with your knees slightly bent. Tuck your elbows into the sides of your body while you cradle the lens in your left hand. Use your right hand to gently control the camera buttons; don't let your right hand support much camera weight.

When you pan with the movement of a subject, twist your whole torso instead of turning your head.

## Lens Quality and Impact on Sharpness

It's a common misconception that lower-cost lenses are automatically less sharp than more expensive lenses. In many cases, this is simply not true. Although it is true that some kit zoom lenses aren't as sharp as expensive f/2.8 zooms, the truth is that most modern lenses are very sharp, especially in their middle apertures.

If you look closely at photographs taken at f/8 from two modern lenses, regardless of their cost, it would be nearly impossible to tell the difference. You would be more likely to see the differences in lens quality in photographs taken at the extremes of the aperture ranges, such as f/3.5 or f/22. A low-cost kit lens, like an 18–55mm lens, won't be as sharp at its maximum aperture of f/3.5 as the $2,000 24–70mm lens at its maximum aperture of f/2.8. However, if you set both lenses to f/8, you probably won't be able to see a significant difference in sharpness.

In terms of AF, most lower-cost zoom lenses are very slow to focus in comparison to the faster f/2.8 and f/1.4 lenses. Slower focusing can cause your final images to be out of focus simply because you might not be patient enough to wait until the camera achieves the best focus. Keep in mind that slow focus speed does not necessarily mean poor focus accuracy. Given enough time, even the slowest-focusing Nikon kit lens will focus accurately.

## How to Check Your DSLR for AF Accuracy

There is a relatively simple way to see if your Multi-CAM AF module is operating accurately. This method doesn't cost anything, so I think everybody should do this for each lens they own. After this test, if you find that your lens is not

Figure 7-24: Set up your camera so the lens is perpendicular to the paper. Take two photographs, one with the Multi-CAM AF system and the other with Live View.

focusing properly, use the Nikon AF fine-tuning utility that I describe in the next section.

To determine if your camera or lens has an AF issue, mount your camera on a tripod and photograph a stationary subject. I suggest that you photograph something flat, like a piece of paper with text printed on it. Tape the paper to the wall and set up the tripod so the lens is perpendicular to the paper (figure 7-24).

Next, initiate AF and take a picture. This will be your reference shot. You will compare this photograph to the next image, which you'll take with Live View focusing. Make sure to take both photographs with the same aperture, focal length, and ISO settings.

For the second picture, activate Live View mode and focus the lens based on what you see on the camera monitor. For the best results, zoom in on the monitor to 100%, and focus the lens manually to make sure the subject is in perfect focus. This image will have the best focus possible because you are focusing on the camera's imaging sensor rather than using the AF module (i.e., the Multi-CAM 3500). If the image is in focus on the monitor, then the image is in focus. It's as simple as that.

Now, download the two images to a computer and compare them side-by-side in a program like Lightroom or Photoshop. If the images are equally sharp, you do not have an AF problem.

| Camera | AF Fine-Tune Utility? |
|---|---|
| D3000, D3100, D3200, D3300 | No |
| D5000, D5100, D5200, D5300, D5500 | No |
| D40, D40X, D50, D60 | No |
| D70, D80, D90, D100, D200 | No |
| D2X, D2Xs, D2H, D2Hs | No |
| D7000, D7100, D7200 | Yes |
| D600, D610, Df | Yes |
| D750, D700, D300, D300S | Yes |
| D800, D800E, D810, D810A | Yes |
| D4, D4S, D3, D3X, D3S | Yes |

Table 7-3: AF fine-tune utility in specific camera models

But if the first photo is a little bit blurry, the focus module probably needs to be fine-tuned, which you can do with the technique I describe in the next section.

## How to Fine-Tune AF

All lenses have some small variance in their focus accuracy. Nikon recognizes this and provides an in-camera function to help you calibrate the focus for individual lenses. This process is called AF fine-tuning; you can find it in the setup menu of your camera (figure 7-25).

Not all Nikon DSLR cameras have the built-in AF fine-tune utility. Table 7-3 shows which cameras have the menu and which ones don't.

Some photographers swear by AF fine-tuning, and others don't worry

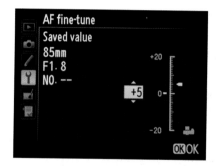

Figure 7-25: The AF fine-tune menu in a Nikon D800

about it at all. I'm in the latter camp and haven't really found a need to calibrate the focus of my lenses. Calibration should be reserved for lenses that you know for sure tend to focus in front of or behind the subject.

The process of fine-tuning your lens requires that you focus on a focus target then check the image to see if the lens

Figure 7-26: LensAlign focus calibration system. Image courtesy Michael Tapes Design (www.lensalign.com).

focused in front of or behind the target. There are a number of commercial products that help you fine-tune the focus. Products like LensAlign (figure 7-26) and SpyderLENSCAL work well and come with clear instructions. You can also use a ruler that is resting on a stack of books at an angle.

Here is how to use LensAlign:

1. Put the lens you want to test on your camera, and mount your camera on a tripod
2. Set up the LensAlign about 25 to 50 times the focal length away from your camera. If you are testing a 50mm lens, place the LensAlign 2,500mm (about 8 feet) away. For longer lenses, like 200mm, something like 25 times the focal length makes sense.
3. Align your camera so that the imaging sensor is parallel with the front surface of the LensAlign
4. Open the lens aperture to its largest setting, such as f/1.8
5. Focus on the LensAlign target. The LensAlign has two sections: the AF target (the checkerboard pattern); and the DOF rulers on the side of the AF target. Compose a photograph of the LensAlign so it includes both the target and the rulers.
6. Use a cable release to take a picture, and use mirror lock up to reduce camera shake
7. Download the photo to a computer and examine the DOF ruler in the image to see if the lens is back focusing or front focusing. Remember that the DOF is one third in front of the focus point and two thirds behind the focus point. If the AF target behind the zeroes on the DOF ruler is in focus but the zeroes on the DOF ruler are out of focus, your lens is back focusing. If the AF target in front of the zeroes is in focus, your lens is front focusing.
8. If you need to adjust the focus, open the camera's setup menu and select AF fine-tune
9. Use the adjustments on the camera screen to move the focus toward the back or front by a few steps (figure

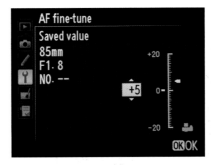

Figure 7-27: Adjust the setting toward the positive end of the scale if your lens is front focusing. Adjust it toward the negative end of the scale if your lens is back focusing.

7-27), depending on where your lens focused on the rulers

10. Repeat steps 5 through 9 until the lens perfectly focuses on the AF target

AF fine-tune works better on prime lenses than zoom lenses because zoom lenses often have different front-focus or back-focus tendencies, depending on the focal length. If you check the focus accuracy on a 24–70mm lens, it might accurately focus at 24mm, back focus at 50mm, and front focus at 70mm.

Finally, even though I said you should test the lens at 25 to 50 times the focal length, you should really test the lens at the approximate distance at which you'll use it. Sometimes lenses are accurate at the minimum focus

**Use Caution with Third-Party AF Lenses**

Whenever you use a lens from a third-party manufacturer, make sure you completely understand how the AF switches and controls on the lens interface with your camera. Some lenses have a focus-locking switch that physically prevents the AF gear system from being rotated. If you turn this switch on and mount the lens on a camera with an older-style motor drive in the body, you might damage the camera body's AF motor.

Other lenses, like those from Tokina, utilize a focus clutch (figure 7-28), which is a physical ring that you slide forward or backward to engage or disengage AF. If the clutch is disengaged, the lens is in manual focus mode. If the clutch is engaged, the lens is in AF mode. If the clutch is engaged and the camera tries to rotate the mechanism inside the lens, the motor can be damaged.

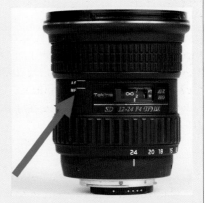

Figure 7-28: Rather than using a focus switch, Tokina lenses have a focus clutch that you slide to the MF position for manual focus mode

distance, but they might be inaccurate, toward the front or back, at 12 feet. For example, if you do this calibration on an 85mm f/1.4 lens, set it up about 8 feet to 10 feet from the target because this is the focus distance you will probably use for portraits.

## Using Third-Party Lenses on Nikon Cameras

Although most third-party AF lenses that are sold with Nikon mounts work fine on most Nikon cameras, sometimes a specific lens won't work properly with AF on some Nikon cameras. Each third-party manufacturer has to reverse engineer the Nikon AF system to figure out how to integrate its lenses with the current Nikon technology.

Nikon regularly updates the firmware for their camera bodies, and some of these updates impact the AF system. If an update changes how the AF system operates, a third-party lens might be rendered inoperable and you'll be left with a lens that won't work with your camera's AF. Furthermore, incorrect use of some third-party lenses could damage your camera, so be sure you know how the lens works in conjunction with your camera, and use it cautiously.

# Glossary

**aberration**

For the purposes of this book, the term is used in relation to chromatic aberration and refers to the refraction of different wavelengths of light at slightly different angles that causes colored fringes in the photograph. These colored fringes cause a reduction in the overall image quality.

**acutance**

The subjective perception of sharpness related to edge contrast in an image.

**AF-A**

Automatic autofocus. The camera automatically chooses either AF-S (single servo) or AF-C (continuous servo).

**AF-C**

Continuous-servo autofocus.

**AF-D**

A designation on certain Nikon lenses that means they electronically translate distance information to the camera.

**AF-F**

Full-time autofocus.

**AF-S**

Single-servo autofocus; also silent wave motor focus.

**AF servo**

Autofocus servo, motor mode. Defines how the autofocus motor works on the camera. See AF-C, AF-S, AF-A.

**aperture**

The adjustable opening, or f-stop, of a lens.

**aperture priority**

An exposure mode in which the photographer sets the aperture and the camera determines the appropriate shutter speed.

**autofocus**

A camera's built-in system designed to automatically focus the lens on a subject.

**bokeh**

The aesthetic quality of the out-of-focus areas of a photograph.

**bracketing**

Taking multiple images of a scene at various exposure values, generally for the purpose of later merging the images in software to create a single image with an increased dynamic range and/or increased depth of field.

**CCD**

Charge coupled device. A type of imaging sensor in a digital camera. See CMOS.

**circle of confusion**

An optical spot caused by a cone of light from a lens that is not in perfect focus.

**CMOS**

Complementary metal oxide semiconductor. A type of imaging sensor in a digital camera. See CCD.

**composition**

The placement and arrangement of visual elements in a photograph.

**CSM**

Custom settings menu.

**depth of field (DOF)**

The areas in front of and behind the main subject that are in acceptably sharp focus.

**diffraction**

The bending of light rays as they pass through a lens, possibly resulting in the reduction of sharpness. Different wavelengths of light will bend differently, which keeps light rays from the subject from coming together at a single focus point. Diffraction increases as the aperture is reduced (higher f-number) and can become noticeable in a print made at a small aperture.

**DSLR**

Digital single-lens reflex camera.

**dynamic range**

The range of brightness reproduced in a digital file or in a photograph.

**exposure**

The amount of light collected on the imaging sensor in a camera.

**field monitor**

A viewing screen used as an alternative for the small monitor on the back of a DSLR for video work.

**focus**

The state or quality of having clear visual definition.

**follow focus**

A focus mechanism used to control the focus ring on a lens during video capture.

**f-stop**

A term that describes the aperture of a lens. See *aperture*.

**FV**

Flash value.

**HDR/HDRI**

High dynamic range/high dynamic range imaging. Images that are created by blending multiple exposures of the same scene, each with different exposure values, to create a new image with an increased dynamic range.

**HDSLR**

A single-lens reflex camera that also captures high-definition video.

**hyperfocal distance**

The closest distance a lens can be focused at any given aperture while objects at infinity are acceptably sharp.

**ISO**

A standardized number indicating an imaging sensor's sensitivity to light.

**manual exposure mode**

An exposure mode on a camera in which the photographer chooses both the aperture and the shutter speed.

**manual focus mode**

A focus mode on a camera in which the photographer manually focuses the lens.

**matrix meter**

A light metering system in Nikon cameras. The matrix meter has hundreds or thousands of segments that analyze the scene for brightness and exposure.

**megapixel**

One million pixels.

**noise**

Color and luminance artifacts found in digital image files. Generally, noise is more obvious with higher ISOs, longer exposures, and in shadow regions of photographs.

**panorama**

A photograph with a wide view. In digital photography, a panorama is composited in software from a sequence of individual photographs.

**pixel pitch**

The distance, measured in microns, between the center of two adjacent pixels.

**programmed auto exposure**

An exposure mode in which the camera automatically adjusts both the aperture and the shutter speed.

**pulling focus**

The act of changing the focus on a lens to maintain image sharpness on a subject during a video shoot.

**racking focus**

The technique of shifting the focus of a lens from a subject in the foreground to one in the background, or vice versa.

**resolution**

The total number of pixels on an imaging sensor, such as 36 million pixels.

**sharpness**

The quality of details that are captured in a photograph. Sharpness describes the clarity of detail in a photograph.

**shutter**

A mechanism in a camera that controls how long the sensor is exposed to light.

**shutter priority**

A metering mode in which the photographer chooses the desired shutter speed, and the camera automatically sets the aperture.

**shutter speed**

The length of time the shutter remains open during an exposure.

**SRS**

Nikon's scene recognition system.

**SWM**

Silent wave motor. An autofocus motor built into the lens that is designed to provide the best of both worlds with respect to autofocus speed and manual focus flexibility.

**USM**

Ultrasonic motor. Used in autofocus systems.

**VR**

Vibration reduction. An image stabilization technology used to improve sharpness in a photographic image.

# Index

**Symbols**
3D   6, 8, 15–18, 22–23, 25–26, 39, 56,
51-point   6, 15, 17, 19, 21–23, 25
    51-point system   11–12, 20, 29

**A**
A-M   83
A/M   84–86
Acutance   170, 172
Adventure sports   133
AE-L/AF-L Button   41, 48, 55, 58, 61, 66–67,
    70, 73, 87, 183
Aerial photography   123
AF-A   6–8, 38–39, 42, 52, 72
AF activation   47
AF-assist illuminator   52–53, 143, 173–174
AF-C   6–9, 14–15, 19, 21, 25–26, 38–39, 42–43,
    45, 52, 57, 61, 70–74, 79–80, 183
AF-C priority selection   42–43, 73–74
AF-D   88–89, 95
AF-F   6–9, 153, 158, 162
AF-I   88
AF-L   41, 48, 55, 58, 61, 66–67, 72–73, 87, 97,
    183–184
AF fine tune   185, 187, 188–189
AF-ON button   7–9, 11, 15, 20, 26–27, 41,
    47–49, 55–56, 61, 66, 69–70, 73–74, 80,
    84, 88, 91, 101, 109, 113, 115, 127, 133,
    135, 143, 147, 151, 153, 183–184
    Assign AF-ON Button   55
    Assign AF-ON Button (vert.)   55
    Assign AF-ON for MB-DXX   55
    Assign MB-DXX AF-ON   56, 68
AF point illumination   48–50
AF-S
    Single Servo   6–8, 11, 19, 26–27, 34, 38–39,
    42, 52, 57, 61, 70–72, 74, 80, 105, 115, 117,
    127, 133, 135, 143, 147, 151, 153–155, 158,
    174, 183

SWM   34, 84, 89, 96
    AF-S priority selection   44
AF mode selector   37–38, 56, 70, 84, 152, 154
AF module   5, 9, 11–12, 14, 29–30, 80, 185–186
AF tracking   14, 80, 88
Aperture   28–32, 47, 65, 75, 96, 155, 161, 164,
    172, 176–178, 180, 182, 185
Architectural photography   7, 19, 21, 44, 72,
    76, 127, 141
Assign Fn button   60, 65–66
Assign Fn button (vert.)   63
Assign preview button   65–66
Assign AE-L/AF-L button   48, 66
Assign sub-selector   66
Assign sub-selector center   67
Assign multi-selector (vert.)   68
Astrophotography   44, 50, 145
Auto-area AF   6–8, 15, 26, 27, 38–40, 51, 56,
    62, 119, 133, 135, 147
Autofocus mode restrictions   57
Auto ISO   76–77, 101, 103, 105, 107, 109, 147

**B**
Back-button AF   41, 43, 48, 55–57, 66, 69–75,
    97, 105, 109, 115, 117, 133, 143, 183
Bands (music and rock)   109
Basketball   25, 51, 107, 111
Beep   57, 87–88
Birds in flight   8, 15–16, 20, 22, 26, 57, 76, 81,
    85, 93, 96, 113, 141, 183
Bracketing   68, 139
Built-in AF-assist illuminator   52, 143, 174
Burst technique   184

**C**
Cable release   96–97, 103, 172, 188
CCD   5, 9, 151, 169
Center AF Area   44–45
Clarity   44, 169–171

CMOS   151, 169
Concert photography   109
Continuous High   49, 80, 101, 184
Continuous Low   49
Contrast   5–6, 11–14, 25–28, 35, 42–44, 52,
    129, 170, 173–174
Contrast detection AF   150, 158
Cross-type sensor   12, 13, 14, 29

**D**
Dance   109
DOF (Depth of Field)   65, 113, 115, 117,
    119, 121, 123, 127, 131, 137, 139, 161,
    163–164, 175, 176–182, 188
Diopter   69
Distinct lines   5, 27, 29, 52, 129
Dynamic-area AF   15-22, 25, 38–39, 45, 52,
    54, 62, 101, 103, 105
    d-9   21
    d-21   22
    d-39   22
    d-51   22
    Dynamic-area AF display   50
DX   76, 80–81, 176, 180–181

**E**
Event photography   52, 142
EXPEED processor   25, 27
Exposure modes (P, S, A, M)   78–79, 90
Extension system   94
Extension tubes   29, 31, 33–34

**F**
Face-priority AF area   154–155
Flash   7, 53, 56, 61–62, 88, 107, 117, 135, 142,
    173
Flashlight   129, 131, 173–174
Focus (defined)   169
Focus indicator dot   174
Focus limit switch   86
Focus point brightness   49
Focus point illumination   48–49
Focus point wrap-around   50–51
Focus selector lock   39–40
Focus speed   35, 95, 185
Focus stacking   94, 121, 180-182
Focus tracking with lock-on   21, 23, 45, 62

Follow focus   158, 163–166
Football   22–23, 35, 76, 100, 183
Function button   60–63, 65–66
Frame rate   43, 49, 79–80
FX   80–81, 176, 180

**G**
Group-area AF   6, 7, 8, 15, 23, 24, 25, 26, 39,
    141, 183
Group-area AF display   50

**H**
Handholding   75, 77, 85, 152, 183–185
Headlamp   129, 173–174
HDR Imaging   138
Hyperfocal distance   61, 65, 72, 115, 137, 141,
    169–180, 182

**I**
IF lenses   93–94
Info screen   7, 58–59, 62
Infrared remote control   97
ISO   6, 62, 68, 76–79, 182, 186
    Auto   77
    Noise   6, 77

**L**
Landscape photography   7, 12, 19, 21, 40,
    44, 47, 50, 52, 54, 57, 60–61, 72, 74, 76,
    78–79, 85, 114, 123, 141, 147, 179, 180,
    182–183
Lenses   10, 29, 30, 33, 35, 52, 62, 75, 77, 83,
    88–89, 90, 93–96, 155, 164, 175, 189–190
    Quality   6, 169, 170, 172, 176–178, 185, 187
    Switches   83–87
Light   27–29, 31–34, 49, 52, 58, 169, 172, 177
Limit AF-Area Mode Selection   56, 57
Live View   9, 59, 60, 64–65, 90, 149–158, 161,
    163, 186
    Hand-held mode   156–158
    Still photo mode   150, 158, 162
    Tripod mode   156–158
    Video mode   7, 150–151, 155, 158, 162
Lock switch   66, 155, 156
Long exposure   6, 33, 77, 96, 127

**M**

M   84

M/A - M   83–86, 89

Macro photography   7, 19, 21, 44, 47, 72, 76, 86, 96, 120, 131, 141, 149, 178–180, 182

Manual focus   28, 37–38, 42, 44, 49, 84–85, 103, 121, 129, 137, 139, 155, 158, 162, 182, 189

   Lenses   89–90

Matrix meter   16, 23, 25–26

Megapixel   170, 183–184

Memory recall   87

ML-L3   97

Multi-CAM   5, 6, 9, 11–12, 14, 29, 31, 81, 88, 90, 151, 154, 157, 173, 185–186

Multi-selector   17–18, 38–41, 48, 50, 51, 52, 58, 59, 60, 63-67, 154–156, 159

Multi-selector center button   58–59, 63–64, 67

**N**

Neutral density filters   31

Night photography   44, 50, 58, 128, 173

Normal area AF   155

Number of focus points   51

**O**

OK Button   17, 58–60, 63

**P**

Panoramas   136, 139

Parfocal lenses   94–95

Phase detection   9–10

Plays and theater photography   28, 134

Playback zoom   68

Preview button   65–66

Polarizing filters   31–32, 47, 94

Portraits   7, 12, 19, 21, 25, 44–45, 47, 50, 52, 60, 70, 72, 74, 76, 78, 86, 95, 116, 141, 155, 178, 183, 190

Pulling focus   162

**R**

Rangefinder   9, 44, 47

Release button to use dial   67–68

Remote trigger   96

RF lens   94

**S**

Single-area AF   See AF-S

Single servo   See AF-S

Scene recognition system (SRS)   15–16

Servo   6–9, 11, 15, 18–19, 21, 26, 38–39, 44–45, 70, 73, 152–154

Sharpness (defined)   169

Shutter speed   6, 75–77, 90–92, 172, 182–185

Single-direction sensor   12–13, 29

Single point AF   6–8, 17-21, 38–39, 54, 57, 62, 183

Store by orientation   53–54

Street photography   118, 147

Subject-tracking AF area   156, 158

Sub-selector   17, 40–41, 66, 67

Switch   58

SWM (Silent Wave Motor)   *see AF-S*

**T**

Teleconverters   29, 31–32, 47, 113

Tennis   22, 104

Theater photography   134

Track and field   22, 102

Travel photography   12, 86, 141, 146

**U**

U1/U2   60, 182, 183

Underwater photography   130

User menus   60, 182, 183

**V**

Volleyball   110

Video autofocus   7, 9, 60, 149–158, 161–167

VR   35, 76, 90, 92, 152

   Switches        88, 91, 93

**W**

Wide-area AF   155–156

Wildlife photography   22, 35, 40, 42, 45, 50–52, 54, 57, 93, 95, 124, 178

**Z**

Zoom buttons   64, 68, 151–152, 158–159

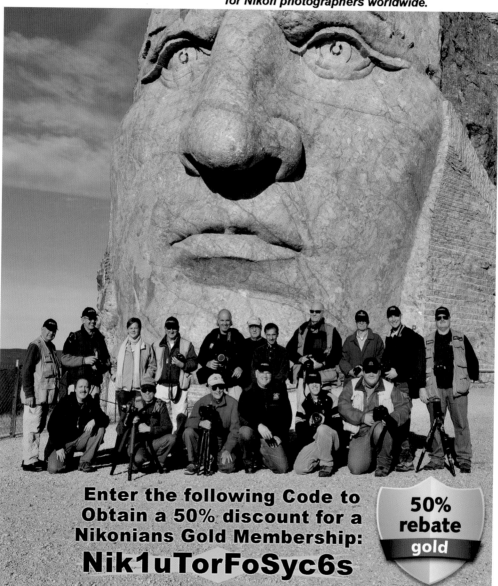